THE TWO ART
HISTORIES

CLARK
STUDIES
IN THE
VISUAL
ARTS

THE TWO ART
HISTORIES

The Museum and the University

Edited by Charles W. Haxthausen

Sterling and Francine Clark Art Institute
Williamstown, Massachusetts

Distributed by Yale University Press, New Haven and London

This publication is based on the proceedings of the Clark Conference
"The Two Art Histories: The Museum and the University," held
April 9–10, 1999, at the Sterling and Francine Clark Art Institute,
Williamstown, Massachusetts. For information on programs and
publications at the Clark, visit *www.clarkart.edu.*

© 2002 Sterling and Francine Clark Art Institute
All rights reserved. No part of this book may be reproduced without
the written permission of the Sterling and Francine Clark Art Institute,
225 South Street, Williamstown, MA 01267

Curtis R. Scott, *Senior Manager of Publications*
David Edge, *Graphic Design and Production Manager*
Judy Spear and Alison Rooney, *Copy Editors*

Printed by the Studley Press, Dalton, Massachusetts
Distributed by Yale University Press, New Haven and London

ISBN 0-931102-44-8 (Clark)
ISBN 0-300-09775-1 (Yale)

Printed and bound in the United States of America
10 9 8 7 6 5 4 3 2 1

Frontispiece and divider page illustration: Detail of the frontispiece to Francis van Haer,
Annales Ducum seu Principum Brabantiae Titiusque Belgii (Antwerp, 1623), engraving
by Cornelis Galle I after Peter Paul Rubens. Sterling and Francine Clark Art Institute,
Williamstown, Massachusetts. Purchased with funds donated by Stephen Paine

Library of Congress Cataloging-in-Publication Data

Clark Conference (1999 : Sterling and Francine Clark Art Institute)
 The two art histories : the museum and the university / edited by
Charles W. Haxthausen.
 p. cm. — (Clark studies in the visual arts)
 Based on the proceedings of the Clark Conference "The Two Art Histories : the
Museum and the University," held Apr. 9–10, 1999, at the Sterling and
Francine Clark Art Institute, Williamstown, Mass.
 Includes bibliographical references.
 ISBN 0-931102-44-8 (pbk. : alk. paper)
 1. Art—Historiography—Congresses. 2. Art criticism—Congresses. 3. Art
historians—Attitudes—Congresses. 4. Art museum curators—Attitudes—
Congresses. I. Haxthausen, Charles Werner. II. Title. III. Series.

N380 .C58 1999
701'.18'0722—dc21

2002021174

Contents

Foreword

Clark Studies in the Visual Arts is an anthology of papers delivered at the annual Clark Conferences. It also includes subsequent reflections on the issues that arise there. The conferences themselves are designed to confront the philosophical, social, and political questions provoked by the study of visual representation, not only within the discipline of art history but also with relevance to its neighboring disciplines in the humanities. In providing an international forum for scholars and museum professionals to discuss and debate the role of the visual arts in culture, the Clark supports conferences and publications that are timely, relevant, and even controversial.

When Charles Haxthausen, Director of the Williams College Graduate Program in the History of Art, proposed the subject of *The Two Art Histories* as the first Clark Conference, it had a special appeal to John Onians, the first Director of Research and Academic Programs at the Clark, and me. Its pairing of museum and university not only mirrored the dual mission of the Clark—which is both an art museum and a center for research and higher education—but it also established a dialectic between two of the most powerful and often conflicting institutions. This focus on the large issues is continued in the next three volumes to be published in the series, *Compression vs. Expression: Containing and Explaining the World's Art,* edited by John Onians; *Art History, Aesthetics, Visual Studies,* edited by Michael Ann Holly and Keith Moxey; and *The Art Historian: National Traditions and Institutional Practices,* edited by Michael F. Zimmermann. We have every expectation that this intellectual commitment will continue in both subsequent conferences and publications.

Michael Conforti
Director, Sterling and Francine Clark Art Institute

Introduction

Charles W. Haxthausen

In her inaugural issue as editor of the *Art Bulletin,* H. Perry Chapman announced a new feature of this journal, then in its eighty-second year: "the addition of substantive exhibition review essays that consider the entire curatorial, scholarly, and scientific enterprise surrounding significant exhibitions." This new policy, she explained, "acknowledged the importance of exhibitions as sites of innovative art historical scholarship," and would, she hoped, "help to foster closer relations between the academy and the museum."[1]

 That exhibitions can constitute major, indeed path-breaking contributions to scholarship—not only in their catalogues but in their choices of themes and their installations—may seem a point beyond dispute. Yet the fact remains that when the *Art Bulletin* had previously dealt with exhibitions at all, it almost always took the form of reviews of their catalogues. Her acknowledgement that "closer relations between the academy and the museum" were desirable brought to mind an editorial by one of her predecessors, Richard Brilliant, which had appeared some eight years earlier and had addressed the widening gap between these two branches of the discipline. "If temperament, inclination, and chance play significant parts" in the art historian's choice of career between the museum or the university, he wrote, "the activities of those careers seem to be taking their practitioners further and further apart. The demands of their respective roles, the arenas of their primary activity, and the public addressed by them in their professional capacity have become increasingly distinct, in a manner reminiscent of C. P. Snow's 'two worlds.'" Even though both groups of art historians claimed to have an "educational purpose," the fulfillment of that purpose took very different forms and was determined by "the different conception of scholarship peculiar to each."[2]

 Brilliant's observation addressed a situation of which many art historians, whether of the academy or of the museum, are conscious, yet up to now surprisingly little has been written about this phenomenon of "two art histories" with their different audiences, different values, different conceptions of scholarship and, in some cases, mutual suspicion of each other's professional practices. Of course there are now, as before, many art historians of either kind who resist this division and regularly cross the lines. They include Brilliant himself, who, in

an afterword to this volume, writes of his own multifaceted engagement with museums—as teacher, consultant, catalogue author, and curator. Still, the split he described in his editorial nonetheless remains a fact of contemporary art history, and it was this phenomenon that inspired the present volume.[3] The sixteen essays are revised versions of papers presented at a two-day conference, "The Two Art Histories: The Museum and the University," held at the Clark Art Institute in Williamstown in April 1999. The large audience of nearly three hundred people and the spirited exchanges provoked by the papers confirmed that this was indeed a worthy, even urgent, topic, although, judging from the constitution of the audience, one of greater import to museum professionals than to their academic counterparts.[4]

As I began approaching colleagues in Europe and the United States about participating in such a project, I received enthusiastic responses and expressions of gratitude that the topic was finally to be the focus of intradisciplinary critical scrutiny. Among these responses were two letters of regret, both from museum professionals, that trenchantly exemplified some of the issues that inspired the undertaking, and vindicated its timeliness. A curator from Britain wrote:

> It is a subject I feel quite strongly about. . . . Unfortunately, so much art history in universities seems to me quite divorced from the real subject of art and has become an unsatisfactory ersatz vehicle for sociology, history, psychology and God knows what else. Fewer and fewer people coming out of university seem to know what a work of art is. A response needs above all to be based on a genuine love and pleasure of art.

The second letter, by a prominent German museum director, took a different tack:

> In this country the gap between the museum and the university seems to be even greater than in the United States. We, by which I mean the curators of this institution and above all myself, are too busy with management to find any time for keeping up with the literature or at least to follow, more or less, the discussion in our respective fields. Administration, fund-raising, organizational matters are our primary concerns. Ten or fifteen years ago in Germany this

was not the case, but now everything revolves around such issues as how one can find such and such a sponsor for such and such a project or how we can attract a public and in what numbers for what project, etc. To think of doing one's own work, work with some claim to scholarship, is out of the question. The ethos that was instilled in us at the university has dissolved into a nebulous cloud, even as it remains as a memory, but there are after all only so many hours in a day and the pressures from all sides have grown to such a degree that we can think of ourselves only as a service industry, and one of the pillars of museum work, namely research, has somehow come up short. That may not be true of all museums of the Federal Republic, but it certainly applies to the majority.

The writer then named some instances of successful collaborations between German art history departments and museums, but each case involved a university-based scholar serving as guest curator in the museum. He could not, he concluded, think of any examples of a "profound collaboration" between the museum and the university.

These two letters articulate viewpoints that many may find extreme, but such perceptions and sentiments nevertheless constitute part of the reality of contemporary art history and are therefore a factor in the relationships between the two branches of the profession. On the one side is the perception that university-based art history has ceased to be interested in the aesthetic dimensions of the art object; if there is a love of art to be found there, it has become a love that dares not speak its name, at least not in the halls of academe. On the other hand is the view that museums have become part of the entertainment industry, that the social, economic, and political conditions of museum work, the unrelenting quest for money and audiences, make serious, critical scholarship an impossibility. The implication of the second letter is that when scholarship does enter the museum today, it must be imported from the university, through borrowed expertise or through the influence of the university scholar on the curator—that the university, not the museum, is where the real art historical work is done. It is surely symptomatic of this attitude that when, in September 1998, the Getty organized an international conference to examine, in the words of the brochure, "the productive tension between art and history . . . how objects are constructed, how they acquire and produce meaning," it drew its speakers

exclusively from universities and research institutes. The museum was represented solely in the person of a session chair, one with a joint academic appointment.[5]

The tensions between the two branches of the discipline have undoubtedly been exacerbated by the critical spirit of so much recent art history. Since the 1970s Erwin Panofsky's humanist conception of the art historian, as someone who respects and affirms tradition and embraces its values,[6] has been challenged by a scholarly practice that approaches tradition more skeptically—in a spirit of "suspicion," to use the French philosopher Paul Ricoeur's term. Indeed, Ricoeur's distinction between two schools of interpretation fits here. Those of the first school—which corresponds to Panofsky's conception—approach interpretation as "a recollection of meaning"; they are motivated by "care or concern for the object," by the goal of letting the object "reveal" or manifest its meanings. The "school of suspicion," on the other hand, understands interpretation "as a demystification, as a reduction of illusion."[7] Such revisionist scholarship approaches art not primarily as a source of aesthetic delight or a deposit of the highest human values, but asserts that art has also been an instrument of power; it has, for example, shaped and affirmed insidious notions of gender, class, racial, and national difference. Where Panofsky's humanist scholar approaches tradition as "something real and objective which has to be studied and, if necessary, reinstated,"[8] many contemporary revisionists wish "to change the present by means of how we re-represent the past."[9] It is the view of many art historians that little of this critical spirit has found its way into the museum, that on the contrary, "museums have for the most part done everything in their power to ignore it."[10]

One product of this revisionist turn has been a critical—a *suspicious*—examination of the museum itself as an accomplice of commerce and power, which has led many in that institution to feel themselves the object of a "museophobic discourse."[11] The critique of the museum goes back to the nineteenth century, but it has entered a new phase with art history's recent revisionist turn. The works of Michel Foucault and, to a lesser extent, Theodor W. Adorno, have had important influences on this discourse. As Neil Harris has observed of this trend, "The museum, condemned decades earlier for its irrelevance and distance from contemporary life, was now discovered to be a theater for the performance of hegemonic rites, a central instrument for promoters of modern values and systems of discipline."[12]

Our goal for *The Two Art Histories* is to move the discussion into a new and, we hope, less contentious phase, to contribute to a more nuanced under-

standing of the respective practices and goals of the two art histories and of how each of them is engaged in the production and dissemination of art historical knowledge. We seek not only a more refined comprehension of how and why they differ and how different agendas, values, and constituencies shape their respective practices, but also how and under what circumstances and conditions those practices can and do mutually enrich one another and how they might do so more productively in the future. The choice of authors reflects this agenda. Among the authors, most of the academics have at some point collaborated closely with museums (and not only by writing catalogue essays); the museum professionals have distinguished themselves by producing exhibitions of scholarly import and ambition. As a group they have blurred the boundaries between the two art histories.

It was decided early on that any discussion of this issue should be carried out comparatively; we wanted to see to what extent different national cultures and national histories have contributed to the relationship between the museum and the university and to what extent sources of funding, educational policy, and the training of art historians and museum professionals have been factors. We thought it best to focus on no more than three countries, to have a critical mass of speakers from each of those countries, and to have each country represented in each of the sessions of the conference. Hence, we have four authors from Germany, five from the United Kingdom, and seven from the United States. We recognize that we could just as easily—and just as productively—have focused on, say, France, Italy, and the Netherlands.

The topic of the two art histories raises many issues, and we could not hope to deal with all of them here. In his afterword to this volume, Richard Brilliant detects a "cultural chauvinism" in the book's emphasis on exhibitions of modern Western art to the exclusion of other periods and cultures.[13] The purpose of this enterprise, however, was from the outset a limited one: to offer a range of perspectives, both curatorial and academic, both European and North American, on a historical period where the tensions between the two art histories seemed most acute. What we sought above all was a diversity of viewpoints on a practice centered on a shared field of objects, and achieving that, we believed, regrettably necessitated sacrificing historical and geographical breadth.

Consistent with the focus on Germany, the United Kingdom, and the United States, the book begins with a range of perspectives on the issue from three academics and three museum professionals (two directors and a curator).

Together these contributions introduce a range of issues, some of which are taken up by later contributors.

One of the striking elements that emerges from the essays in this volume is that for all sixteen authors the chosen arena for debate is the museum. Those representing the museum have little to say about the practices of the academic art history department, yet all of the academics focus on the museum and, in particular, on the temporary exhibition, the institutional space in which the two art histories most often encounter one another—not only because university-based art historians visit exhibitions, but also because they contribute to their catalogues, speak at the conferences or lecture series organized around them, and in some cases even function as guest curators.

As Steven Deuchar, a museum director, writes, it was such a guest cura-torship that brought the tensions between the museum and the academy into the open in Britain. The occasion was a 1982 Tate Gallery exhibition devoted to the eighteenth-century British landscapist Richard Wilson, curated by the American art historian David Solkin. His critical, social-historical approach to Wilson's landscapes, beloved by the patrician classes who commissioned or collected them, unleashed a torrent of controversy and a hostile response to the intrusion of a leftist academic into the sacred precinct of the museum, hitherto reserved for a cult of aesthetic celebration. Deuchar's essay focuses on the Wilson exhibition and three other London exhibitions of the 1980s in which academics also served as guest curators, bringing the critical concerns of the "new art history" into a conservative museum culture—a culture in which a press intolerant of such approaches is a powerful ally of what Deuchar calls the "traditional curatorial lobby"—that was ill prepared to accept them. After a series of such exhibitions, the two camps became polarized, and signs of a reaction became evident by the early 1990s. The resistance of what Deuchar calls a "celebratory curatorship" to any approach in which aesthetic quality becomes subordinate to an attempt at broader historical understanding is, in his view, not to be underestimated.

Deuchar observes that in their debates the two camps occupy what turns out to be a surprisingly "narrow strip of land." Ivan Gaskell, a curator at the Harvard University Art Museums, carries this idea further. Not only is the museum as much a site of art historical scholarship as the university, but the ostensible boundaries between museums, which by necessity must associate directly with the agents of power and commerce, and academics, who often assert their moral disdain for that world, are in fact false boundaries. Joseph Alsop called art history

and art collecting "the Siamese Twins," because art historians define the categories and establish the canon for the collector, and collecting is inevitably linked to commerce.[14] Gaskell expands this domain of interdependency: dealers, collectors, curators, independent scholars, conservators, editors, and academics, he argues, are all part of the same system, "woven together in complex nets of shared interest and competition, respect and contempt." However removed academics may feel from the marketplace, however disinterested their scholarly motives, what they say and write can be deployed to serve the interests of commerce. Given this, Gaskell believes that more magnanimity, more mutual respect between curators and academic art historians is in order, but in the end, as a curator, he confesses to his own paranoia.

Andreas Beyer, a German academic, addresses another kind of interdependence, not always explicitly acknowledged by academic art historians: the decisive role of the exhibition as a powerful medium of scholarly discourse. To be sure, even the most conservatively curated exhibition can generate new insights, new directions in scholarship. Yet Beyer is interested in the exhibition as a compelling medium of scholarly argument and of visual demonstration, as a discourse that functions by *showing* rather than by writing, and in this it is, he proposes, a more effective means of disseminating knowledge than are articles or books. This fact is usually overlooked because of the transience of exhibitions; their strongest arguments—visual arguments by means of installation—cannot be captured by catalogues nor properly experienced through installation photos. He cites one compelling example—an exhibition of Michelangelo's drawings —to show how the written scholarship sometimes remains ineffectual until it can be demonstrated by exhibition. Beyer also believes that art historians need to pay more attention to the exhibition installation—not merely the contents of the exhibition's catalogue—as a scholarly medium; he calls for an intensified dialogue between exhibition organizers and academics, and cites as a classic example the great Italian scholar Roberto Longhi's *Viatico per cinque secoli di pittura veneziana*, his response to an exhibition he visited at Venice's Museo Civico Correr in 1945. In this text Longhi scrupulously followed the layout of the exhibition, "alternately jeering, moaning, mumbling, and praising," as he offered his close critique of the exhibition's choices and hanging. Written for the orientation of his students at the University of Florence, this slender book remains "the document of a lively encounter between the university and the museum."

Dawn Ades, an academic who has frequently used the exhibition as a medium for her scholarship, offers a particularly compelling example of the role of the exhibition in presenting what would otherwise remain largely invisible within our culture. Her example is modern Latin American art, which "occupies a peculiar position, being both part of but also distinct from Western artistic traditions and the modernist canon"; in Europe as well as the United States, this art is weakly represented both in museum collections and in art history curricula. Most are familiar with little beyond the Mexican Muralists and, perhaps, magical realism. Ades's essay reviews various exhibitions that have attempted to remedy this neglect and concludes with a discussion of her own exhibition, *Art in Latin America: The Modern Era 1820–1980,* shown at London's Hayward Gallery in 1989. Such exhibitions, especially when presented in major venues like the Hayward, can force us to look at the overlooked and serve to remind us of the parochialism of our histories. As exhibitions they reach a larger audience, and through the evidence of the original works, force themselves upon our attention more effectively than texts. Still, despite such efforts, Latin American art remains largely confined to a ghetto, rather than being integrated into the dominant narratives of modern art history.

In surveying the contentious relations between the museum and the university, Steven Deuchar questions whether "'the two art histories' can in fact remain for long implacably at odds in the museum arena, for pressures on both fronts to improve the level and tone of public engagement are mounting." This relation of art history to the public, rather than the intradisciplinary tensions between the museum and the university, is the topic of the contributions by Sybille Ebert-Schifferer and Barbara Stafford. Ebert-Schifferer looks at the many formats in which art historical scholarship—often highly diluted for easy consumption—reaches the general public. Even as increasingly large numbers of people yearly visit institutions and monuments that have been served by art historical research (not merely museums and exhibitions but historical sites), most visitors have little sense of the specialized professional discipline that goes into such installations. The rigorous professional practice of art history, which makes a substantial contribution to the German economy, tends to "disappear completely behind its products," she argues; and this threatens to erode public support, which, in a country where cultural institutions draw heavily on state and local funding, could lead to an underestimation of its importance and ultimately threaten the preservation of cultural heritage.

If Ebert-Schifferer is concerned about the gap between art history and its public as a threat to cultural patrimony, Barbara Stafford addresses the consequences of that gap with regard to contemporary visual culture, increasingly dominated by the new digital media in a "visual-communication monoculture in which the future seems not to have a past." The problem for Stafford is not that art history hides its products, but that it does not even begin to address the implications of this new culture. She proposes that, in this neglect, both museum and university art historians have been at fault, failing to educate the public to a discerning historical understanding of visual formats in this dawning era of "e-collage," the smooth amalgamation of mixed media, the "hypermeld" of dematerialized images that has been spawned by the World Wide Web. She proposes a joint education project of the two art histories: "The general representational poverty of computer graphics and Web design—the new individualized mass media—presents an opportunity to collaborate and reformulate our troubled relationship."

Because the temporary exhibition is the form in which museums are best able to transcend the limitations of their own collections to construct art historical narratives, the exhibition as discursive medium is a topic crucial to any examination of the relationship between these two domains of disciplinary practice. As Alan Wallach has written, "exhibitions can tell complex stories *spatially*. A successful exhibition is not a book on the wall, but a carefully orchestrated deployment of objects, images, and texts that gives viewers opportunities to look, reflect, and to work out meanings."[15] How do those stories relate, substantively and rhetorically, to those told exclusively by means of texts and reproductions? Can they and should they be as effective in conveying precise meanings? To what extent do institutional factors—above all the search for financial support and large audiences—influence *which* stories are told in exhibitions? The second group of essays addresses these questions.

Richard Kendall, an independent scholar who has curated several important Degas exhibitions, makes a case for what might be called a mixed-media form of scholarly argument. In *Degas: Beyond Impressionism*, he used the exhibition as his medium to examine the oeuvre of the artist after 1890, a neglected period for which there was sparse literature. Kendall poses the question: "to what extent can the juxtaposition or separation of individual pictures and sculptures communicate new notions about them?" Yet he distinguishes between issues that were most effectively dealt with in the catalogue (Degas's dealings with

the art market, for example) and questions best served by visual and spatial demonstration in galleries devoid of explanatory wall text. This installation demonstrated Degas's obsessions with certain motifs, the "incestuous" relationship between his renderings of a chosen motif in various media, and re-created the kind of visual dialogue that existed between these works in Degas's own studio, a densely crowded environment that was itself an inspiration for further works. As Kendall's illustrations reveal, this was an installation in which the conventional exhibition design was rejected for the sake of the strongest possible visual argument. To this end vitrines might be taller than usual, the works placed in tight juxtaposition. "Although historical and critical discussion remained confined to the catalogue, audiotape, and leaflet, an alternative mode of argument, conducted in purely visual terms, was in effect offered to visitors."

In his essay, Mark Rosenthal observes that catalogues do not always complement their exhibitions so carefully. Today, many "catalogues" are in effect books—collections of essays by scholars with some expertise on the subject—published on the occasion of an exhibition. Most often, the authors had nothing to do with the organization of the exhibition and their texts may have little to do with the works actually shown; the curator's contribution may even be a modest one and might itself deal with only a single aspect or a limited number of the works on display. In any case, the curator's strongest argument is to be found in the choice of works and the relationships that become evident through the installation. Using his 1996 Guggenheim exhibition *Abstraction in the Twentieth Century* as an example, Rosenthal relates how, through the kinds of comparisons made possible across the expanses of the Guggenheim's spiraling ramps, one could discover surprising relationships between early- and later-twentieth-century artists that provoked a rethinking of the history of the genre. The panoptic, omnidirectional character of this discourse is something that cannot be matched by any text. "Some purposes," Rosenthal asserts, "are best served through the viewing of a body of work, rather than through the vehicle of the written word." At the same time, he notes how some exhibitions may function in ways not anticipated by their curators, contradicting the arguments made in the catalogue and wall labels.

Kendall and Rosenthal write about the exhibition as instrument and product of curatorial scholarship; Patricia Mainardi complicates the issue in her essay, reminding us that museums also need to attract audiences to their exhibitions and that the predilections of these audiences often influence not only which

exhibitions are done but also the kind of tales they tell. Here she is concerned less with the different narratives of specific exhibitions than with the metanarrative that underlies those endlessly repeated Impressionist exhibitions that have become a staple of American museum culture. Part of the appeal of such shows, Mainardi suggests, is that they repeat "the typical American success story wherein perseverance and hard work are rewarded with eventual vindication and financial success." Art ostensibly rejected by the critics comes to be admired with time as the artist who worked in poverty is rewarded after his death with high prices. In their retelling of such edifying narratives, many Impressionist exhibitions not only contribute nothing new to our understanding of the movement, they pointedly ignore the findings of art historical scholarship. This illustrates a fundamental difference between the two art histories, Mainardi argues: it is unimaginable that such an account of Impressionism would be published, yet it is endlessly repeated with minor variation in museums. She suggests that the schism between the two art histories has developed in part because of the museum's unwillingness to abandon this "heroic mode (of metanarrative) endemic in modernism," even as university historians have become intent on deconstructing it.

Eckhart Gillen is concerned with a different type of exhibition—the exhibition not as argument but as *essay*. He uses a quotation from Alfred Lichtwark[16] to define his meaning: "serious in intent but quite loose in form . . . not scholarly according to German academic standards, but merely stimulating, letting ideas be guessed at rather than expressing them directly." He explores the historical context of two such major exhibitions, held in Berlin at the beginning and end of the twentieth century, with reference to questions of national identity: the landmark 1906 *Deutsche Jahrhundertausstellung* (Exhibition of a century of German art) from the years 1775 to 1875 and his own 1997–98 show, *Deutschlandbilder* (Images of Germany). The earlier exhibition sought to strike a blow against a parochial nationalism by selecting and presenting a century of German art according to transnational aesthetic criteria, as partaking of a "world language of art." *Deutschlandbilder*, on the other hand, reintroduced the question of national identity in surveying German art, both East and West, from the Nazi seizure of power in 1933 to the present. The goal, however, was not to reaffirm the idea of a national art, but to examine the encounter of German art with the aberrations of German history—fascist and communist dictatorship, the Holocaust, political division, and terrorism. Both exhibitions suggest the potential of such visual essays to alter not only our thinking about artists and art

movements but our more general historical understanding.

The example of *Deutschlandbilder*, which drew 150,000 visitors during its four-month run and was the subject of over one thousand articles in the German-language press, points out differences in exhibition practice between Germany and the United States, for the use of the art exhibition as a medium for investigating the intersection of art history with political and social history is exceedingly rare in the U.S. One of the rare instances in which this was attempted in a major venue was *The West as America*, shown at the National Museum of American Art in 1991 and curated by William H. Truettner. In this exhibition, Truettner adopted the critical approach of much recent academic scholarship in examining nineteenth-century representations of the American frontier, arguing that paintings by artists such as Albert Bierstadt and Frederic Remington "represented not an objective account of westward expansion but highly charged rhetoric that glossed over some of the darker moments in United States history." In his essay, Truettner articulates assumptions about the experience and capacities of viewers that motivate such an approach. Where the typical museum professional views the museum's mission as a fundamentally aesthetic one, offering pleasure to passive consumers, Truettner sees the engagement of viewers as more complex. Artistic merit, he argues, is still an issue, but "only one of several that viewers apply to investigating how aesthetics and history interact. . . . Works of art viewed in this way sacrifice an enduring status; their meanings are open to continual revision, to the unpredictable." The problems and dilemmas that curators face in trying to promote this kind of engagement among viewers are the subject of Truettner's essay. Despite the difficulties—and the risks of attacks from press and public, of alienating corporate donors—Truettner believes that exhibitions that link art with history have a better chance of achieving one of the stated goals of museums today, namely broadening audiences.

French Impressionism is an area in which the conflicts between the two art histories have been particularly evident, at least in the United States. The Impressionist exhibition has become the staple of the American art museum, its "cash cow," in Patricia Mainardi's acerbic phrase, and at the same time French Impressionism has been the subject of some of the most important critical scholarship, particularly for feminism and the social history of art. No other movement has received such close scrutiny in the museum, has been the object of so many specialized exhibitions, while other periods and aspects of art history are seldom examined or remain completely neglected. Claude Monet, for example,

has been the object of an almost obsessive focus, with exhibitions on *Monet at Giverny, Monet in Holland, Monet in London, Monet in Rouen, Monet at Vétheuil, Monet in the Mediterranean, Monet and Bazille, Monet in the Nineties,* and most recently, *Monet and the 20th Century.*

Richard Brettell critically examines the consequences of such "dissections" for art historical knowledge. "Every generation," he writes, ". . . must once again reassemble the most significant part of the oeuvre of canonical artists, so as to reassess the relevance and power of this material to contemporary audiences, or to test current hypotheses of modes of interpretation." He considers the relative merits—and artificiality—of presenting an oeuvre as a synchronic whole or in parts, either thematically or chronologically determined. Yet Brettell also acknowledges that the dissections of the museum may differ from those of the academy; therefore the image of Impressionism created by the museum exhibition and that created by university-based scholarship may overlap, but they are not absolutely identical. For example, in the realm of feminist scholarship, "the academy," he notes, has "made advances that are essentially unrecognized by museum publications." Precisely the critical edge of feminist studies of Impressionism unsettles those who see the museum as a space for aesthetic celebration rather than for interrogating the function of art within culture.

It is precisely the museum's exclusion of the critical perspectives of feminist scholarship that is the topic of Griselda Pollock's contribution. Museum art historians, she claims, "are frankly embarrassed by a subject about which they remain recalcitrantly ignorant." The focus of her essay, however, is not the curatorial neglect of feminist scholarship on Manet, Degas, and others, but the marginalization of women Impressionists, and specifically of Mary Cassatt. Citing the recent retrospective seen in Boston, Chicago, and Washington, D.C., Pollock notes not only that the exhibition was not accompanied by the scholarly symposia that mark other Impressionist exhibitions, but that her work was presented timidly by curators who were "unsure of how to sell a woman artist whose canonical place they doubt." In the remainder of her essay, Pollock offers her own concept for an exhibition of Cassatt that would treat her as a central figure within the Impressionist movement. Significantly, as an academic scholar, Pollock finds herself "drawn more and more to the model of the exhibition" as an effective medium for her own feminist intervention. Here there is a link with William Truettner's notion of active viewership and with Richard Kendall's "argumentative spaces." She concludes her essay by describing, room by room, her own virtual

exhibition of Cassatt's art that would escape the "tyranny of chronology." In the end, she concludes, her show must remain in the virtual realm because it is incompatible with the dominant culture of the exhibition.

Gary Tinterow, a Metropolitan Museum curator who has been involved in a number of major Impressionist exhibitions, questions whether it is reasonable to expect museums to reflect the "new art history" in their exhibitions. His essay exemplifies the gap between the two art histories at its most extreme, and he is representative of the view among many museum professionals that academics are mostly concerned with theory and social history and too little concerned with objects and their aesthetic quality. He uses his own blockbuster exhibition, *Origins of Impressionism*, curated with Henri Loyrette (then at the Musée d'Orsay), to explain why he believes "it is so difficult to incorporate within a museum exhibition much of what is currently being done in the academy." He disputes the perception among many academic critics of the museum that such shows are done primarily as revenue-producing crowd pleasers. The project, he asserts, was "fundamentally a curatorial exercise," an "experiment whose outcome was by no means certain." Tinterow employs Stephen Greenblatt's distinction between *resonance* and *wonder* to clarify what he sees as the different tasks of university and museum art historians. As Greenblatt defines it, *resonance* denotes "the power of the displayed object to reach out beyond its formal boundaries to a larger world, to evoke in the viewer the complex, dynamic cultural forces from which it has emerged"; *wonder*, on the other hand, is inspired by "the power of the displayed object to stop the viewer in his or her tracks, to convey an arresting sense of uniqueness, to evoke an exalted attention."[17] Tinterow believes that *wonder* is what museums do best, even as they do attempt to achieve *resonance* through their installations and wall texts.

John House is a British academic who, like Dawn Ades, has worked closely with museums in the organization of exhibitions, and his article explores the potential and limitations of the Impressionist blockbuster exhibition as a medium for revisionist scholarship. He writes of his own show, *Landscapes of France*, shown at the Hayward Gallery in 1995, which aimed to present the familiar works of Impressionist landscape in a fresh, more historical way, by exhibiting them together with the work of their non-Impressionist rivals shown at the Paris Salon during the period 1860 to 1890. House did not slavishly follow this idea, however; he concedes skewing his initial concept as he selected the works for the exhibition, being guided by his own aesthetic responses to the works and their

likely impact in his exhibition, excluding some that were highly successful in their time but that would seem dull to our eyes. As it turned out, even this modified revisionist project ran into trouble in the show's American venue, the Museum of Fine Arts, Boston. Not only was the title changed to *Impressions of France* to tap into that art's seemingly limitless market appeal, but the balance of Impressionist to Salon paintings, evenly divided in the London show, was in Boston also shifted to favor the Impressionists by almost two to one, a ratio that corresponded to the respective attendance figures for the two venues, with the Boston viewership doubling that in London. This suggests, House ruefully concludes, that Impressionist pictures, not a revisionist argument made through the medium of an exhibition, are what the public wanted.

Germany has been immune to the insatiable appetite for Impressionism that has become a salient feature of American museum culture. Yet that country has a long and fascinating relationship—or, in Michael Zimmermann's words, "a tormented friendship"—with French Impressionism. Berlin's Nationalgalerie, under its director Hugo von Tschudi, was the first museum anywhere to purchase works by Manet and Cézanne, and acquired a number of other Impressionist works as well, thanks to the support of a number of collectors.[18] Berlin also had in the dealer Paul Cassirer an important and respected promoter of Impressionism, and in Julius Meier-Graefe one of its most brilliant and passionate advocates. During the early years of the twentieth century museum directors in other German cities also showed initiative in acquiring this art when it still aroused considerable opposition in conservative nationalist circles. However, unlike their counterparts in the United States, German museums never developed into treasure houses of Impressionism, in large part because of the country's political course from 1933 to 1945. Modern collections—and many collectors—were dispersed under the Nazi regime, and the internationalist culture that had made Germany a nation passionately receptive to modern art was suppressed and destroyed. When, after World War II, Germany rediscovered Impressionism, it approached it in a markedly different spirit, partly under the influence of the philosopher Martin Heidegger. The scholarly discourse on the movement now took on an idiosyncratically German cast that distinguished it from the more cosmopolitan attitudes of the early part of the century. Even today, Zimmermann suggests, many Germans seem to have an equivocal relationship to Impressionist painting that is in striking contrast to the favor it enjoys among its adoring American public.

The purpose of this volume, as stated at the outset, is to broach a topic that has received little attention in print. It remains to be seen whether it will contribute in some way to a greater mutual respect—and greater cooperation —between academic art historians and museum art historians. Many may conclude that the essays in this volume merely expose the fault lines more clearly.[19] Yet they also stimulate thinking about the forms and formats in which the two major branches of the discipline encounter one another, and rethinking those formats of intradisciplinary encounter might be a way to build a more productive collaboration between the academy and the museum. In any case, the essays in this volume and the afterword that concludes it show that the topic of the relations between the two art histories is an enormously complex and an emotionally charged one and merits further examination.

I wish to thank Michael Conforti and John Onians for their advice, encouragement, and support at every stage of this undertaking. I am also grateful to Brian Boucher, who served as my able, discerning, and indefatigable research assistant as I was conceiving this project.

1. H. Perry Chapman, "Editor's Note," *Art Bulletin* 82, no. 3 (September 2000): 406. The journal implemented this policy two issues later with a ten-page review of *The Splendor of Eighteenth-Century Rome*, jointly organized by the Philadelphia Museum of Art and the Museum of Fine Arts, Houston. Wendy Wassying Roworth, "Rethinking Eighteenth-Century Rome," *Art Bulletin* 83, no. 1 (March 2001): 135–44.

2. Richard Brilliant, "Editorial: Out of Site, Out of Mind," *Art Bulletin* 74, no. 4 (December 1992): 561.

3. There were two sessions at the 2001 annual meeting of the College Art Association, held in Chicago from February 28 to March 3: "Braving (and Bridging) the Great Divide: The Academy and the Museum," chaired by Sylvia Yount and sponsored by the Association of Historians of American Art; and "Art History: In the Museum and the University," chaired by Clare Kunny and sponsored by the CAA Museum Committee.

4. More information about the series of art history and visual studies conferences at the Clark is available online at http://www.clarkart.edu/research_and_academic/.

5. Quoted from the program of the conference "Art/History: Object, Meaning, Judgment," cosponsored by the Getty Research Institute and the Getty Grant Program, September 16–19, 1998.

6. Erwin Panofsky, "The History of Art as a Humanistic Discipline," *Meaning in the Visual Arts* (Chicago: University of Chicago Press, 1982), 3–4.

7. Paul Ricoeur, *Freud and Philosophy: An Essay on Interpretation*, trans. Denis Savage (New Haven: Yale University Press, 1970), 27, 28, 32–35.

8. Panofsky, "The History of Art," 4.

9. Griselda Pollock, *Vision and Difference: Femininity, Feminism and the Histories of Art* (London: Routledge, 1988), 14.

10. Alan Wallach, *Exhibiting Contradiction: Essays on the Art Museum in the United States* (Amherst: University of Massachusetts Press, 1998), 118.

11. See Ivan Gaskell's essay in this volume and his review of three books that are, in his view, representative of this discourse in *Art Bulletin* 77, no. 4 (December 1995): 673–75.

12. Neil Harris, "The Divided House of the American Art Museum," *Daedalus* 128, no. 3 (summer 1999). Interviewing applicants for the Williams College Graduate Program each spring, I have heard more than one candidate with aspirations toward a curatorial career relate how a mentor has counseled discretion in revealing that ambition to directors of graduate studies, lest one be judged deficient in intellectual seriousness and, possibly, harm one's prospects for admission.

13. Richard Brilliant was invited to participate in the conference, but was unable to do so because of a prior commitment. However, he generously agreed to contribute an afterword to the present volume. In preparing it, he read the complete transcript of the conference proceedings, which includes the lively discussion, as well as the final version of the essays published here.

14. Joseph Alsop, *The Rare Art Traditions: The History of Art Collecting and Its Linked Phenomena Wherever These Have Appeared*, Bollingen Series 35 (New York: Harper and Row, 1982), 107–36.

15. Wallach, *Exhibiting Contradiction*, 121.

16. Alfred Lichtwark (1852–1914) was Director of the Hamburg Kunsthalle from 1886 to 1914.

17. Stephen Greenblatt, "Resonance and Wonder," in *Exhibiting Cultures: The Poetics and Politics of Museum Display*, ed. Ivan Karp and Steven D. Lavine (Washington, D.C.: Smithsonian Institution Press, 1991), 42.

18. Peter-Klaus Schuster, "Hugo von Tschudi und der Kampf um die Moderne," in *Manet bis van Gogh: Hugo von Tschudi und der Kampf um die Moderne*, exh. cat., ed. Johann Georg Prinz von Hohenzollern and Peter-Klaus Schuster (Berlin: Nationalgalerie; Munich: Bayerische Staatsgemäldesammlungen–Neue Pinakothek, 1996), 26.

19. One curator remarked to me toward the end of the conference: "At first I didn't understand the point of this symposium, but now I understand: These guys [i.e., academic art historians] really *hate* us."

THE TWO ART HISTORIES
Perspectives

Whose Art History? Curators, Academics, and the Museum Visitor in Britain in the 1980s and 1990s

Stephen Deuchar

About a year ago I started work as director of something that did not then, and does not as I speak today, yet exist: Tate Britain. It is what the current Tate Gallery at Millbank in London will become from the year 2000 (when Tate Modern opens downriver at Bankside) and so we are now at work attempting to invent a new museum within walls that currently house an old one. Tate Britain will be new in that it will show, at its core, British art exclusively, but it will also aim to break new ground through display programs and publications that present and interpret art in ways that are connected harmoniously—if our mission is accomplished—both with current strands of art historical debate and with the collective imagination of the Tate's unusually wide public.[1] This dual objective—some would say two conflicting objectives—and its relationship to the recent history of sometimes exasperated discourse between museums and universities in Britain (particularly over the role and style of exhibitions) make the question posed by this conference especially significant for me.

But would I be wrong to conclude, from surveying the last twenty years' debate over what kind of art history museums should present, that there is actually a relatively limited number of areas under contest, with only a small cast of generic protagonists?[2] First, I espy the connoisseur proclaiming the sanctity of art as a transforming presence against the challenge of theory (and, worse, "ideology") coming from the academy. Then, I spot the academics wearily denying any objective aesthetic values independent of cultural context, whose revelation is (of course) most reliably entrusted to those from beyond the object-bound perspective of the museum. I see, too, the educators, sensing and resenting their distance from the curatorial soul of the museum, arguing for public understanding through the accessibility and experience of art rather than through its definition by curator or obfuscation by academic. And there also goes the director, driven insanely by the twin market forces of corporation and populace toward the blockbuster and the gift shop and away, according to those who bear the true cross, from the cause of scholarly enlightenment. A number of minor additional characters feature in this passion play: the curator turned academic, the academic turned curator (both claiming 360-degree vision; both obviously unpredictable

rogues), and so on. Forgive such caricature, but I have been surprised to discover in how essentially narrow a strip of land this crowded area of debate lies and how determinedly the protagonists seem to deny more than token entry to the constituency with whom we might have thought museums most concerned: their visiting publics.[3]

Of course the diversity of those publics—clearly including academics and curators of all persuasions—defies easy generalization, and it is a truism (so obvious it is often overlooked) that no two museums' publics are identical in either character or constitution.[4] I do not know if most visitors to the National Portrait Gallery in Washington, for example, have everything or little in common with those of, say, Harvard University's Fogg Art Museum—but I would certainly be wary of any curatorial prescription purporting to work a cure for both. So, in reviewing here some of the tensions between academic and curatorial philosophy in British museums over the past two decades, with reference to a few selective examples (mostly British art, mostly London exhibitions, and mostly eighteenth- and nineteenth-century ones at that), I do not pretend to be either comprehensive or objective as I ponder the lessons of the past and their possible relevance to Tate Britain's future.

In the early 1980s three potential challenges to traditional curatorial practice in Britain began to emerge. First, a political imperative we came to call Thatcherism began, on the one hand, to squeeze public funding for the arts and, on the other, to demand more tangible outputs in terms of the work rate and effectiveness of those receiving and spending it. Second, partly but not exclusively in response, there arose a more overtly populist and commercially driven approach to display and exhibition-making (led, for example, by the "experience"-focused initiatives of, say, the Museum of London or the Natural History Museum), proposing an apparently viable alternative to purist curatorial doctrine in which the object was mostly left "to speak for itself." Third, the so-called "new art history," which was slowly taking hold in British university departments, began to knock on museum doors and await a response.[5]

At the Tate Gallery the first two challenges were steadily registered, but in 1982 the third was manifested more sharply, and somewhat improbably, in a striking exhibition of works by the eighteenth-century British landscape painter Richard Wilson, selected and interpreted in what was quickly recognized as an important scholarly catalogue by the American art historian David Solkin.[6] Having commissioned the show from the recognized Wilson scholar of the day,

the Tate was faced with the discovery that, while at work on the project, his academic stance had moved politically leftward, leading him to understand and explore Wilson's classicizing views of English landscape in relation to the economic, political, and moral monopoly that the patrician classes sought to enshrine through the art they acquired. Acknowledging the didactic thrust of a show whose tenor had perhaps been detected at too late a stage to change it, the Tate braced itself for a response: it was the first time the new art history had been apparently (if inadvertently) welcomed into the galleries of a national museum.[7]

Much has been said and written about the public row that ensued: it was actually a sort of dress rehearsal, in English costume, for the 1992 *West as America* drama in Washington.[8] Many of us remember with particular clarity a strident editorial in *Apollo* lambasting Solkin as a Marxist terrorist hell-bent on destroying all at once the reputation of Wilson, the value of the aesthetic, the pleasures of the spectator, and, as I recall, the British establishment itself.[9] But tellingly, the editorial's repeated acerbic reference to the guest curator as "the Doctor" betrayed a fundamental objection to the intrusion of a contemporary academic agenda into the hallowed world of the museum—the former identified implicitly with the politically subversive, the latter with no less than the maintenance of civilized society. Ignored in this debate, the citizens meanwhile responded with their feet, by staying away in droves; it was in fact one of the more poorly attended Tate shows of its era.[10] Those who had opposed its tone and purposes could cite this bad box office in support of the less academic, even antiacademic, curatorial stance they knew and preferred, and the newer kinds of art history were to take a lower profile in the Tate's exhibition program for some time to come.

But any consequently implied elision of the more narrow kind of object-focused scholarship with wider public interest is surely a flawed idea—or at least it is flawed unless it can be substantiated.[11] And most of the comparatively little detailed, qualitative visitor research that is undertaken by art museums suggests that issues of input, taxonomy, comparison, and provenance (if I may thus distill the curator's core interests) are further from the public heart than those of output, meaning, purpose, and wider cultural resonance (essentially closer to the university position).[12] There is obvious irony in the probability that few university academics would admit very much concern with "what the public wants," while many curators, by contrast, would show the same concern quite readily. It is further ironic that those museums whose exhibitions and displays moved in a more overtly populist direction at this time, partly for financial reasons, may in some

way have come closer through their provision of "context" to the dominant strand within the academy that questioned the traditional assertion of the object's inherent importance as opposed to acknowledging its value as culturally determined.[13]

Three other British exhibition projects in the 1980s are worthy of brief mention in relation to this. The 1986 exhibition of works by the nineteenth-century genre painter William Mulready at the Victoria and Albert Museum,[14] organized by Marcia Pointon, followed the "Wilson" model of asking the visitor to accept and explore what we might call the artifice as well as the art of Mulready's pictorial construction of contemporary life. It managed to combine a scholarly catalogue text with labels and graphic panels that were, as a prominent reviewer noted, "rather didactic" but nonetheless seemed to elicit "unusual concentration [in the way] tourists, students and other visitors consumed the show."[15] But one correspondent, taking up the cudgels on behalf of the old curatorial lobby, took strong exception to what he saw as an encouragement to "read rather than look." He criticized the exhibition's challenge to what he called "the duty" of exhibition texts to their public ("to identify what is *in* a picture, not to read things into it"), deplored what he saw as "political glosses" inherent in all the suggested readings, and supposed that the museum must have been hoodwinked into hosting such a thing in the first place. Pointon had the last word: "Does he really think," she wrote, "that his own implied acceptance of some kind of neutral transmission of essential and commonly recognized knowledge via the exhibition is in any way less political, or that the letter he has addressed to the Editor of this Magazine is not in itself a political act?"[16]

With each faction conscious of its politics and claiming its own conception of art history the more appropriate for the public arena of the exhibition, the debate showed few signs of being able to move in a new direction—or one in which real public interest might be addressed, rather than appropriated casually as an intellectual position. In 1987 the entrenchment may even have advanced a degree further. At one end of the spectrum, the Tate's *Manners and Morals* exhibition was, despite its mildly racy title, a broadly traditional survey of early-eighteenth-century British art, its catalogue focusing honestly away from the revolution in understanding that new scholars in the field had brought about.[17] With wall texts that seemed to some observers to suggest a hesitancy about the show's premises, as well as an assumption that its visitors were familiar with the subject matter already, it provoked the wrath of some critics. "Can such a cavalier

attitude towards the public," asked one, "be attributed to sloth, arrogance or timidity in the face of negative feedback of the Wilson exhibition?"[18]

At the other extreme was the Barbican Centre's *Edwardian Era* show of the same year, entailing an ambitious attempt by a team of academic guest curators to prove that the oil painting's gloss on life should be viewed only in context of evidence that revealed, with a directness rare to "era" exhibitions, poverty as well as wealth, strife as well as "style," and much of the politics of gender.[19] The flamboyant assembly of such a range of material far beyond fine art, breaking most art gallery rules in its deployment, caused varying degrees of apoplexy from museum traditionalists. According to one, it was "feminist claptrap . . . a lurid example of the way in which public art exhibitions, supported largely by public funds, are increasingly being used as political platforms for left wing views."[20] Again, the public was cited as the loser in an attempt to place an academic agenda, rather than a conventional curatorial one, at the forefront of a public exhibition. Meanwhile, problems with the installation of the show (it opened without some of the exhibits and captions in place) allowed the old museum's lobby a discreet smile at the embarrassed plight of the academic intruders operating in its space.[21]

The Edwardian Era had been the most ambitious attempt to date to unite contemporary academic concerns with an exhibition for contemporary public consumption; possibly by consequence of several hostile press reviews, strong early visitor numbers tailed off—despite the apparent enthusiasm of those who did come, and notwithstanding an adventurous display strategy, which associated the show (curiously enough) with some of the more commercially driven projects of the 1980s.[22] Perhaps thus emboldened, the Tate's 1991 exhibition of works by John Constable followed *Manners and Morals* in its choice to sidestep certain strands of contemporary academic debate; the gallery staff meanwhile prepared for a blockbuster response from a public whose warmth for *Constable* was proven.[23] As it happened, though the quality of the show's selection was widely praised, the greatest heat generated was probably in the conference organized to accompany it, wherein art historians old and new locked horns to debate issues that had by now become wearisomely familiar: an alleged alliance of corporate sponsorship, heritage-industry bluebloods, and anti-intellectual aesthetes pitched against a supposed league of academia, theoreticians, and the loony left.[24] There was no indication that the public (who did not, incidentally, turn up quite so wholeheartedly as they had for the Tate's previous *Constable* exhibition of 1976) thought much of this controversial rhetoric relevant to them at all.[25]

Since that winter of polarization in the debate of the early 1990s, have there been any signs of spring? Certainly there have been discreet attempts to bring one on, in the form, for example, of some small, experimental Tate exhibitions, of which one, *Picturing Blackness* of 1996, bravely sought to tackle an issue as sensitive and widely relevant as the depiction of racial difference in British art.[26] It also invited contributions from the visiting public by means of a comment book, which produced an impassioned critical response.[27] Not all of it was sympathetic—and perhaps the experiment ultimately failed—but the book demonstrated unusually broad public engagement with both the issues within and the intellectual underpinnings of the project.[28] In similarly adventurous vein, there was in 1995, at the National Gallery, London, an intriguing exhibition focusing on Constable's iconic painting *The Cornfield* of 1826.[29] This came close to building real linking bridges between the three islands of interest—academic, curatorial, and wider public—that had remained so isolated, despite claims to the contrary, for so long. The exhibition presented *The Cornfield*, one of the most popular and often-reproduced Constables, in specific relation to a wide variety of those reproductions—from the mezzotints of David Lucas published in 1834 to the embroidered cushions, cake tins, and jigsaw puzzles that were to be the vehicles for its wider infiltration into the national consciousness during the course of the nineteenth and twentieth centuries. Conceived and organized by Colin Painter, an art school principal, the project attempted to tease out the history and resonances of the picture's popularity through gentle descriptions of its meanings and associations for a range of private individuals—those who owned the reproductions forming the material basis of the show. The project challenged some deeply held curatorial convictions about what constitutes quality and significance in art, daring to introduce into the National Gallery reproduction in significantly lower-life forms than the habitual prints after, or casts of, originals. Though evidently a popular show with the public, and praised for its originality and audacity by academic commentators, it was ultimately rejected by the influential newspaper art critics along with the traditional curatorial lobby—a generally close alliance in the Britain of the 1980s and 1990s.[30] So the *Sunday Telegraph* could declare this "the naffest exhibition for a long time. It would be an eyesore anywhere; in the context of our finest picture collection it is a scandal."[31] Disinclination to consider the purpose and impact of an exhibition on grounds other than the writer's view of the aesthetic merit of its content is hardly a rare thing in art journalism. But, tellingly, in the National Gallery's own extensive

British School catalogue, published just two years later, neither Painter's book nor any of its propositions was mentioned in the ostensibly exhaustive seven-page entry given to *The Cornfield*, suggesting the exhibition was finally seen more as a sideshow than a contribution to real scholarship.[32]

The "safe" exhibition or display, conceived within traditional curatorial parameters and according to established curatorial tastes—the rules of the hanging, the length of the wall texts, the exclusion of the awkward, the do's and the don'ts—regardless of either its ultimate communicative powers or academic robustness, is a cultural staple. It will remain in demand as long as the subjects are perceived to have some sanctioned cachet, and as long as looking at art in exhibitions is sold effectively by museums—and supported by critics—as being about discerning quality and saluting beauty as the exclusive priority, thus promising a kind of spiritual experience that is no doubt more readily alluring to more people than the idea of some academic lesson. Apart from the many instances of exhibitions that are marketed at that level but actually operate more multifariously (the Boston-Royal Academy show of Claude Monet in 1998 is one),[33] the norm of what we might call celebratory curatorship is a powerful animal despite, strictly speaking, its inherent conceptual absurdity. Whereas the public would always be strongly suspicious of histories or biographies that glossed over dark episodes or presented their subjects only in the most admirable light, museum audiences are asked regularly to find truth and objectivity in exhibitions that, for example, omit any works falling below a constructed aesthetic standard, regardless of their potential to elucidate the wider nature of the art or artist in focus. As we progress in our understanding, we must certainly consider whether we are prepared to admit a degree more originality and cerebral rigor into the way we plan our selection and packaging of art for popular consumption.[34]

If, as I have recounted, Thatcher's Britain in the 1980s encouraged much of the museum profession toward a kind of harassed conservatism in more or less open conflict with the new art history and the left, how in essence has the landscape now changed in the world of New Labour in the late 1990s? Recent policy initiatives not only to extend access to national collections but also to broaden it (by implication, to make museums less the preserve of relatively narrow cultural and ethnic groups) seem real; they appear—on one level, at least—quite different from the closet commercialism of those 1980s populist exhortations to push up visitor numbers.[35] That there is now ready suspicion for any cultural undertaking conceived with major profit as an apparent motivating factor is clear—witness

the occasionally cynical reception of *Monet's* much-hyped launch in Britain, a trend ultimately overtaken by the generally positive critical reception of the show and its scholarship.[36] Nevertheless, the ethic of measurable output has survived (in museums as elsewhere) and indeed strengthened in the new political climate, and in this respect at least there is a discernible community of interest between museums and university departments. The 1980s legacy of customer focus has made contemporary academia far more responsive to its "market"—be it students for courses, buyers for books, or audiences for exhibitions. In tandem, the absence in the politics of 1990s Britain of an empowered right with a philistine agenda for the arts has removed much of the sense of purpose from a self-conscious academic left, and the likelihood of serious ideological confrontation between academy and museum in the sphere of exhibitions these days does seem remote. In relatively still (if not stagnant) waters such as these, I wonder if the "two art histories" can in fact remain for long implacably at odds in the museum arena, for pressures on both fronts to improve the level and tone of public engagement are mounting. It is true that many are today still slow to concede the need for change, as some of my examples have shown, and that moving on to respond practically to this imperative may entail the abandonment of some familiar languages, and dearly held practices, of display. Certainly at the Tate some new alliances between academics and curators have been forged to create exhibitions intended to acknowledge the critical faculties and imaginative potential of their visiting, broadening publics as a priority higher than any automatic adherence to curatorial convention.

––––––––

In the end, a responsive alertness to new art historical advances *and* a profound commitment to communicating effectively and innovatively with a wider public can be regarded as the fundamental challenge for the future. This proposition might be perpetually, inherently, problematic, but for anyone operating in the museum sphere, curator or academic, it should now be recognized as a core professional mandate.

1. On October 6, 1999, the Tate Gallery in London announced that its Millbank site would be relaunched on March 24, 2000, as Tate Britain, and that its new Bankside site would, on May 12, 2000, become Tate Modern. There has been a major reorganization of the Tate's staff structure to accommodate this expansion in London. The exhibitions, displays, and interpretation programs are more closely integrated than before, and their conceptual development is led by a new group of curators at each site, working closely with a separate group of the curators of the central collections.

2. I would suggest that the key texts in this debate (in the area of my focus) over the last decade or so have been: "Art History and the 'Blockbuster' Exhibition" (editorial), *Art Bulletin* 69, no. 3 (September 1986): 358–59; "The Museum and the University" (collected articles), *Museum*, no. 1 (1987); "On Art History and the 'Blockbuster' Exhibition" (discussion by S. J. Freedberg, Gervase Jackson-Steps, and Richard E. Spear), *Art Bulletin* 70, no. 2 (June 1987): 295–98; Peter Vergo, ed., *The New Museology* (London: Reaktion, 1989); Neil MacGregor, "Scholarship and the Public," *Museum Management and Curatorship* 9, (1990): 361–66 ; "Scholarship in Museums" (editorial), *Burlington Magazine* 32, no. 1052 (November 1990): 759; "Out of Site, Out of Mind" (editorial), *Art Bulletin* 74, no. 1 (January 1992): 551; Sarah Faunce and Flora S. Kaplan, "Growing Pains," *Museum News* (January/February 1992): 49–51; "Theory and Practice," *Museum News* (January/February 1992): 36–39; Judith Kelly, "Working Together," *Museums Journal* (July 1992): 32–33; Mark Haworth-Booth and Maurice Howard, "Exchanging Objects for Projects," *Museums Journal* (April 1993): 18–19; Charles Saumarez-Smith, "The Practice of Research at the Victoria and Albert Museum," *Museum Management and Curatorship* 12 (1993): 349–59; Deborah J. Johnson, "Is Art Central to Art History (and Other Debates)?," *Museum Management and Curatorship* 12 (1993): 91–94; "Art History and the Museum" (editorial), *Burlington Magazine* 137, no. 1107 (June 1995): 355; Ivan Gaskell, "Writing (and) Art History: Against Writing," *Art Bulletin* 78, no. 3 (September 1996): 403–6; Lucie Carrington, "The Great Skill Overkill," *Museums Journal* (February 1996): 21–24; Görel Cavalli-Björkman, "Research in Museums, a Necessary Good!," *Art Bulletin of the National Museum, Stockholm* 4 (1997), 79–80; and Per Hedström, "Museums-Research-History and Theory of Art: Report from a Conference at Nationalmuseum, 14 November 1997," *Art Bulletin of the National Museum, Stockholm,* 81–86. My thanks to Martin Myrone for many of these references.

3. Philip Wright, "The Quality of Visitors' Experiences in Art Museums," *New Museology* (1989): 119–48, deserves recognition as the classic text on the potential discrepancy between museum practice and public interest.

4. See, for example, Nick Merriman, "Museum Visiting as a Cultural Phenomenon," *New Museology* (1989): 149–71.

5. For an account of the new art history's progress in seventeenth- and eighteenth-century British art studies during the 1980s, see Michael Kitson's introduction to Ellis Waterhouse, *Painting in Britain, 1530–1790* (New Haven: Yale University Press, 1994), xi–xxvii.

6. David H. Solkin, *Richard Wilson: The Landscape of Reaction,* exh. cat. (London: Tate Gallery, 1982).

7. See Neil MacWilliam and Alex Potts, "The Landscape of Reaction," *History Workshop: A Journal of Socialist and Feminist Historians,* no. 16 (autumn 1983): 171–75.

8. William H. Truettner, ed., *The West as America: Reinterpreting Images of the Frontier, 1820–1920,* exh. cat. (Washington, D.C.: Smithsonian Institution Press, 1991). For the "West as America" controversy, see Alan Wallach, "The Battle over 'The West as America,'" in *Exhibiting Contradiction: Essays on the Art Museum in the United States,* ed. Allan Wallach (Amherst: University of Massachusetts Press, 1998), 105–17.

9. "Une tenebreuse affair," *Apollo* 117, no. 125 (January 1983), 2–3.

10. The Wilson exhibition attracted 12,006 visitors and averaged 211 per day. This compares with, for example, 112,517 and 1,324 for *Gainsborough* in 1980–81.

11. "Scholarship and the Public."

12. See Wright, "Quality of Visitors' Experiences," esp. 122–32.

13. One example of an exhibition that attempted to break new ground at both a scholarly and a popular level was the National Maritime Museum's *Armada* exhibition of 1988. See M. J. Rodriguez-Salgado et al., *Armada 1588–1988* (Harmondsworth, U.K.: Penguin, 1988).

14. Marcia Pointon, *Mulready,* exh. cat. (London: Victoria and Albert Museum, 1986).

15. Joany Hichberger, "William Mulready at the V&A," *Burlington Magazine* 78, no. 1001 (September 1986): 691–92.

16. Alastair Laing (letter), "Labelling Mulready at the V&A," *Burlington Magazine* 79, no. 1005 (January 1987): 28; Marcia Pointon (response), *Burlington Magazine* 79, no. 1005 (January 1987): 29.

17. Elizabeth Einberg, *Manners and Morals: Hogarth and British Painting 1700–1760,* exh. cat. (London: Tate Gallery, 1987).

18. Celina Fox, "A Wasted Opportunity at the Tate," *Apollo* 127, no. 311 (January 1988): 45–46.

19. *The Edwardian Era,* exh. cat., ed. Jane Beckett and Deborah Cherry (London: Phaidon, 1987).

20. Robin Simon, "Sorry Elgar, You're out of Tune," *Daily Mail,* 31 October 1987.

21. For example, William Feaver, "Strange Slowing Down," *Observer,* 15 November 1987.

22. For example Patricia Morison, "Short on Art, Long on Cant," *Daily Telegraph,* 13 November 1987.

23. Leslie Parris and Ian Fleming-Williams, *Constable,* exh. cat. (London: Tate Gallery, 1991).

24. See Martin Postle, "Not a Happy Lot: Constable Symposium at the Tate," *Apollo* 134, no. 355 (September 1991): 209.

25. *Constable* at the Tate in 1991 attracted 169,412 visitors, an average of 1,783 per day; *Constable* at the Tate in 1976 had attracted 313,659 visitors, an average of 3,872 per day.

26. Paul Gilroy, *Picturing Blackness in British Art, 1700s–1990s,* exh. cat. (London: Tate Gallery, 1995).

27. The comment book was administered by, and is now held by, the Tate's education department.

28. See Bridget Baldwin and Alison Cox, "Comments Books: Hot Air or Hot Stuff?," *Engage* 1 (autumn 1996): 3–7.

29. Colin Painter, *At Home with Constable's Cornfield*, exh. cat. (London: National Gallery Publications, 1996).

30. Traditional curatorial distaste for Painter's exhibition was articulated by, for example, Tim Hilton, "Constable's Wallpaper Period," *Independent on Sunday*, 25 February 1996.

31. John McEwen, "The Naffing of Constable," *Sunday Telegraph*, 10 March 1996.

32. Judy Egerton, *The British School* (London: National Gallery Publications, 1998), 50–57.

33. Paul Hayes Tucker with George T. M. Shackelford and MaryAnne Stevens, *Monet in the 20th Century*, exh. cat. (New Haven: Yale University Press, 1998).

34. It is surprising how urgently relevant Wright's argument in "The Quality of Visitors' Experiences in Art Museums," published in 1989, still seems in 1999.

35. For an articulation of the philosophy behind Labour arts policy in late 1990s Britain, see Chris Smith, *Creative Britain* (London: Faber & Faber, 1998).

36. For an example of the suspicion of *Monet*'s commercial motivations, see the satirical editorial of *Private Eye*, 22 January 1999: "Huge queues are already forming for the world's biggest exhibition of Money. Money has been collected from all over the world . . . [They are] only in it for the Monet." For a contemptuous view of its popularity, see, for example, A. N. Wilson, *Evening Standard*, 25 January 1999: "What is going on here? Am I motivated by good old intellectual snobbery, the simple certainty that none of the 600,000 boobies who are buying tickets for this exhibition could tell the difference between a good painting and a boiled potato? I don't know, but I long for it all to be over."

Magnanimity and Paranoia in the Big Bad Art World

Ivan Gaskell

This essay examines two professional groups dealing with art: people in universities and colleges, and people in art museums.[1] Everything about this inquiry is potentially contentious. Even the terms we might most conveniently apply—such as *professor* and *curator*—are so loaded as to be of no use if we are to try to establish equality of consideration. I have chosen, therefore, as neutral a terminology as possible, describing the one group as university scholars and the other as museum scholars.

University scholars and museum scholars share curiosity about art and its circumstances. Curiosity itself need not be institutionally circumscribed. It can lead in directions that are at times mutually harmonious and at times radically divergent. There is no predicting whether disagreements that arise will necessarily be between university scholars and museum scholars. We are just as likely to find representatives of both professional groups on either side of a given issue. So wherein lies the difference between the two groups? I believe it to be chiefly a matter of practice, as dictated by their respective peculiar institutional responsibilities.

Theoretical and historical exploration leading to the formulation of principles of interpretation is no more exclusively the domain of university scholars than is critical engagement with works of art as objects of current experience the exclusive domain of museum scholars. Institutional responsibilities, however—of teaching, on the one hand, and those of curatorship, on the other—favor attempts to satisfy curiosity in manners that are distinct. For instance, university scholars habitually exploit the boundless availability of images through reproduction. This leads them to construct hypotheses with reference to works that may not all be familiar to them at firsthand. Ideas thus formulated are often first tested by means of paired slides, projected simultaneously.[2]

There is no doubt that this photographically based technique is an enormous spur to wide-ranging and often highly productive thought about art. The inquiries of museum scholars, by contrast, are likely to be directed by confrontations with tangible objects, and by the particular questions typically asked of them with respect to the care of those objects within the institutions to which they belong. These questions commonly concern origin (often authorship), condition, physical history, previous ownership, and interpretation by means of

display rather than description. But just as the university scholar can likewise be stimulated by works of art themselves, so the museum scholar can use the entire repertory of reproductions to test hypotheses.

Despite the vast amount of common ground that they share, there is, nonetheless, an institutional disposition to differentiation, and that difference is, ultimately, as follows. While the university scholar uses reproductions and descriptions, albeit often in the light of direct experience of the works reproduced, to create interpretations in teaching and publications, the museum scholar uses works of art themselves to create visual discourse—which may be interpretative—in galleries.

The question arises: are the institutional conditions in which one type of scholar works more favorable to the free pursuit of scholarship than the institutional conditions in which the other type of scholar works; and, if so, are those less-favorable conditions such that the free pursuit of scholarship is vitiated? Conventional wisdom holds that the tenure system at universities permits a freedom to those thus favored that they would not obtain without it. Museum scholars do not enjoy tenure in the same sense as their academic peers.[3] I am not sure, though, that tenure is quite the panacea that it is sometimes assumed to be, so I leave the topic aside, unresolved. It seems incontestable that there are considerable opportunities, relatively free of outside pressure, for pursuing scholarship in the humanities at American universities. While comparable opportunities in art museums are certainly not as extensive, scholars there enjoy untrammeled access to, and use of, objects in their care, and often they benefit from on-the-spot advice of conservators and scientists. As for the distinct pressures that lead to self-censorship in both instances, they seem no more evident in one kind of institution than in the other. Furthermore, in neither need administration be more, or less, of a burden. Given the requisite conditions and qualifications, fine scholarship is produced consistently in both universities and art museums.

Wherever budding scholars may end up—at universities or museums —they share a great deal of their education; their Ph.D.s come from the same institutions. It might be only natural, however, that those who teach to this end would view positions such as the ones they themselves occupy as the most covetable and thus the type to be sought by their pupils most enthusiastically. This can all too readily develop into a jealousy regarding sites of scholarship, a desire to have acknowledged that only their own type of institution—a university—can truly can be the locus of scholarship. Such defensiveness on the part of university

scholars can be compounded by a fear that those who seek to satisfy their curiosity at other kinds of institutions, such as art museums, may do so employing methods and terms of reference that lie beyond existing art historical boundaries. Those who confer Ph.D.s may wish to claim that it is their exclusive prerogative to extend those bounds of scholarship.

Similarly exclusive attitudes can be found among museum scholars. They may value, for instance, their ability to dispose of considerable sums of money (within the conventions of the institutions in which they operate) for the acquisition of works of art. They may value their entry into kinds of society inaccessible to most university scholars. They should bear in mind, though, that these prerequisites are rarely the consequence of personal qualities independent of their positions. Therefore, both university scholars and museum scholars have every reason to cultivate magnanimity—generosity of spirit—with respect to one another and, in addition, to other members of the art world. This can be seen to be particularly apposite when we consider the place of scholars—whether university or museum—in the larger art world.

———

Made up of seemingly disparate institutions and interest groups, the art world actually functions as a complex system with numerous interdependencies. The institutions include not only colleges, universities, and art museums but also auction houses, commercial galleries, and publishers. As well as university scholars and museum scholars, the interest groups include art-museum professionals of various kinds, auction-house personnel, dealers, collectors, agents, runners, conservators, amateur and freelance scholars, editors, analytical scientists—even artists. Many within these groups like to have as little to do with each other as possible, but they are woven together in complex nets of shared interest and competition, respect and contempt. They are all equally part of the same system, discretely defined.

Obviously, this commonality does not prevent any art-world figure from being part of another system simultaneously. For instance, university scholars are also part of the general institutional system of academic inquiry—a world that is itself amenable to sociological examination, as has been demonstrated in the example of France.[4] But just as professors of physics, say, may be part of the institutional system of academic inquiry, so can they be part of the military-industrial

complex through the funding that supports their research. University scholars concerned with art may be less obviously entwined in nonscholarly networks than some of their scientist colleagues, yet there are such scholars who benefit financially from their association with dealers, or who on occasion act as *marchands-amateurs* themselves.

As for what is considered proper behavior on the part of any given cultural subset of the international art world, the boundaries vary. For instance, an American university scholar who charged consultancy fees for opinions on the authorship of works of art would be doing nothing wrong. An American museum scholar who did the same thing would have crossed the line. In Russia, by contrast, museum scholars have acted as paid consultants to auction houses without prejudicing their positions, something unthinkable in America. What is acceptable differs from place to place.

———

I offer two examples to demonstrate the interdependency of all participants in the international art world. The first derives from my own continuing study of the art of Johannes Vermeer and concerns attribution; the second concerns theory.

In recent years only one candidate has been seriously advanced for Vermeerhood: *Saint Praxedis*, a painting that can be traced back to 1943 in a New York private collection, its earlier history being unknown.[5] It was included in an exhibition of Florentine Baroque art organized by Howard Hibbard, a professor of art history at Columbia University, and held at the Metropolitan Museum between April and June of 1969. The graduate student who catalogued the paintings, Joan Nissman (now a successful dealer), attributed *Saint Praxedis* to Felice Ficherelli in the exhibition catalogue;[6] at the same time, she noted the signature and date "Meer 1655" and suggested cautiously that it might be the earliest dated work by Vermeer. Before the close of the exhibition, the dealer Spencer Samuels acquired *Saint Praxedis* and published it in an advertisement supplement for the June issue of the *Burlington Magazine*, describing it there unequivocally as "*St. Praxedis* by JAN VERMEER of Delft. Signed and dated 1655." Referring to an enthusiastic review of the Florentine Baroque exhibition in the same issue of the magazine, the advertisement copy incorporates the arguments of the reviewer, Michael Kitson of the Courtauld Institute of Art at London University.[7] It is

thus clear that Samuels had had access to Kitson's positive opinion of the new putative Vermeer prior to its publication.

Saint Praxedis found little favor as a Vermeer, however, and Samuels's gamble in acquiring it did not pay off for many years.[8] The painting next surfaced when Samuels opened a new gallery in New York in November 1984. In a catalogue entry describing it confidently as by "Jan Vermeer van Delft,"[9] the owner disclosed that the opinions of two conservation specialists—Hermann Kühn[10] and Stephen Rees Jones—had been sought. This carefully prepared unveiling of the painting after fifteen years in seclusion led to renewed attention. In 1986 the respected Vermeer specialist Arthur K. Wheelock, Jr., curator of northern Baroque paintings at the National Gallery of Art in Washington, D.C., published the first major scholarly study of *Saint Praxedis*. He had examined the painting early in 1984 (at which time it was not actively on the market)[11] and concluded: "It deserves to be recognized as an important addition to the body of Vermeer's work."[12]

Whether or not as a result of Wheelock's published opinion, Barbara Piasecka Johnson purchased the painting in 1987.[13] A considerable number of works from the collection of the Polish-born Johnson, including *Saint Praxedis*, were exhibited in Warsaw in 1990,[14] and a year later it was shown in Kraków along with the Ficherelli prototype.[15] Both exhibitions and their publications were the responsibility of the Institut IRSA and its director, Józef Grabski. IRSA publishes the journal *Artibus et Historiae,* in which Wheelock's crucial article had appeared, and Grabski——also a leading adviser to Johnson—is its editor. What interests were at stake, and how and when they became intermeshed, cannot be ascertained from published sources, yet it must be uncontentious to assume that it was understandably to the advantage of the dealer, the promoter, and the new owner to establish the Vermeerhood of *Saint Praxedis*. Whether or not Wheelock's disinterested scholarship was unwittingly caught up in the pursuit of other agendas that involved the new owner and IRSA is impossible to determine.

The way was clear for Wheelock to include *Saint Praxedis* in the great Vermeer exhibition held in Washington and The Hague in 1995–96.[16] In the eyes of many scholars, however, *Saint Praxedis* cannot be said to have survived the comparison with securely attributed early Vermeers.[17] Although the work has its defenders as a Vermeer, it was dismissed from his oeuvre—rightly or wrongly—by some reviewers, including Christopher Brown in the *Burlington Magazine*, and by all who considered it in the proceedings of the symposia held during the exhibition.[18]

The point at issue here is not whether the work actually is or is not by Vermeer. Rather, the point to stress is that a candidate for Vermeerhood *can* be found and *can* have a decent run at achieving it. Were another candidate to be found—and it is part of the mystique surrounding Vermeer that this is far from being out of the question—we might expect a similar bewildering mixture of high scholarship and dealers', collectors', and publishers' maneuverings to accompany the discovery.[19] For in this case there are intersecting interests involving university scholars (as conceivers of pedagogical exhibitions and as reviewers), museum scholars (as exhibition organizers and as attributers), conservators (as mythically imbued objective scientists), dealers (as business people trying to steal a march on their competitors and make a profit), editors (as controllers of the medium by which discussion occurs and decisions are ratified), and collectors (with agendas of their own).

Let us not be deluded into thinking that anything faintly disturbing about this case can be blamed solely on the corrupting power of commerce. *All* the parties—dealers, collectors, museum scholars, conservators, academics, and editors—*together* constitute the system as it functions. Given that all are equally responsible, we cannot lay blame for supposed compromising of the intellect at the door of a single party. Those who discuss art professionally but who, like some university scholars, fancy themselves outside of this system delude themselves. They play as great a role in fostering confidence and credulity as anyone else involved in the art world, where, as in any capitalist market, confidence and credulity go hand in hand.

———

I take as my second example some of the work of the influential university scholar Norman Bryson. We might think that a book such as his *Looking at the Overlooked: Four Essays on Still Life Painting* (1990) might be at the furthest possible remove from the values we have seen in play in the case of *Saint Praxedis*. Bryson surely had no more wish to be associated with the commercial aspects of the art world when he wrote that book than did Arthur Wheelock when he wrote his article on *Saint Praxedis*. Indeed, Bryson's notion of value in art is firmly critical and interpretative.

In *Looking at the Overlooked* Bryson points out the ambivalence of repute accorded to the still life in Western culture since the time of Pliny—how

it is indeed admitted to the realm of art and its criticism, "only to be relegated *to the lowest rank*," while often commanding high prices nonetheless.[20] His concern is principally to enhance the theoretical and critical discussion of the genre, not its market value. But a discussion that in itself has little direct impact on the market can be absorbed swiftly into the complex dialogue in which the market functions. Sophisticated exegesis arguably contributes to sanctioning the desire for works of this type by those who acquire them. Even if this is not so much the case for private collectors, it is for at least some museums. Moreover, the ideas in Bryson's book found further dissemination in the museum sphere by means of a traveling exhibition of still-life paintings titled "In Medusa's Gaze" (December 1991–May 1993). Bryson wrote the lead catalogue essay of the same name,[21] his university scholarship thereby heightening the status accorded to works in the collections of the museums concerned. The status of those works in turn contributes to that of others in private collections and on the art market. Even the most theoretical university scholarship can hardly claim to be insulated from the rest of the art world.

In Bryson's case, as in many others, this intrinsic absence of detachment is equally apparent in his involvement with contemporary art. By contributing essays to catalogues and other books, Bryson has complemented with the authority of his own reputation those of contemporary artists whose products are actively part of the market. These include Mary Kelly (1990–91),[22] Cindy Sherman (1993),[23] Thomas Struth (1997),[24] Mark Dion (1997),[25] and, most recently, a number of Chinese artists under the curatorial aegis of Gao Minglu (1998–99).[26] His work in this field represents a thoroughly laudable engagement with current artistic activity. Yet it is as much a part of the complex reticulation of the art world, in which the movement of any filament affects all the others, as was the work of Hibbard, Kitson, and Wheelock in the case of *Saint Praxedis*. University scholars, even those of a theoretical bent who may explicitly eschew art museums and commerce, can therefore be seen to play a vital a role in the system in its entirety, including those parts of it they may find uncongenial.

———

In conclusion, I want to explode the magnanimity I have been striving to achieve throughout all I have said thus far. I want to expose in my own position the deep paranoia I share with at least some of my fellow museum scholars, thereby revealing

something of what we are up against when we try to establish common respect and grounds for collaboration in the art world.

An evening garden party at a sumptuous private house that followed the recent grand opening of an exhibition revealed all manner of affinities and disapprobations in the art world. On that warm evening, as torches flared along garden paths and candles flickered on patio tables, the university scholars—there only because a symposium accompanied the opening—gathered at one end of the pool, while the museum scholars gravitated to the other. A gentle susurration of voices and occasional laughter complemented the chirping of the crickets and the tinkle of wine glasses. Then the dealers arrived. Most were there because a number of the works in the exhibition were on the market. They had been to another, more animated, party first and introduced a raucous jollity that many dealers enjoy when in one another's company. The three groups remained relatively cohesive, but from time to time exchanged ambassadors.

I had been with the museum scholars, naturally enough. Our talk was of how curators are perceived, and we agreed that in this complex world of art, we are at the very bottom of the heap. However much they might pretend otherwise—and some do not pretend at all—everyone else in the art world holds curators in contempt. Even within their own institutions, this is the case. We noted that trustees abhor curators because they are hired servants who only cost and spend money. We agreed that directors detest curators because increasingly they see scholarship as an expendable luxury. Conservators look down on curators, we averred, because conservators claim that they alone possess the intimate arcana of the making of works of art. Beyond museums it is the same. Dealers malign curators because the only money they dispose of is not their own. Collectors despise curators because people with Ph.D.s (rather than professional degrees) exist to be despised. Last, we concurred that academics revile curators because, deep down, not to be an academic means moral failure. Everyone—we were quite certain—despises curators.

Yet we were confident that there is another side to the coin. Everyone needs curators. They are indispensable. Curators are alone as a group in having scholarly dealings with every other type of person in the art world. Curators guarantee the values of the works with which everyone in that world is concerned. Curators—no one else—make visible those works of art that alone sanction the status of all the rest. Curators are hierophants imbued with the power of aesthetic transubstantiation. They reveal and conceal. They guard the mysteries.

No wonder—we slumped again—they are so despised. And to confirm it all, we—the curators—could not help but notice that the servers had stopped offering *us* champagne, and *we* were sitting at the *shallow* end of the pool.

1. This paper was written under the auspices of the Clark Fellowship Program of the Sterling and Francine Clark Art Institute in the summer of 1998. The discussion of *Saint Praxedis*, attributed to Johannes Vermeer, is included in my book *Vermeer's Wager: Speculations on Art History, Theory and Art Museums* (London: Reaktion, 2000), on which I was engaged at that time. I owe a particular debt to Michael Conforti. I presented a longer version of this paper at the Williams College Art History Faculty Colloquium in September 1998 at the invitation of its chair, Samuel Y. Edgerton, Jr. My thanks go to the members of the colloquium and of the Clark Art Institute for their comments; and I should like to express gratitude also to Arthur K. Wheelock, Jr., for correcting certain of my misconceptions. This paper is dedicated with affection and respect to the memory of Jan Bialostocki.

2. Elizabeth Bakewell et al., gen. eds., *Object, Image, Inquiry: The Art Historian at Work* (Santa Monica: Getty Art History Information Program, 1988), for example, 61: "So many of my books or writings originated in lectures, and the lectures had slides. [The publication process] usually starts with slides" (original brackets).

3. Museum scholars are not invulnerable when working at the mercy of administrators overzealous in their exercise of power. A case in point, breaking all conventions of civil behavior, is that of two senior curators, scholars of high international repute in endowed chairs, who were among eighteen staff members summarily dismissed from the Boston Museum of Fine Arts in June 1999. This incident demonstrates that while university scholars' tenure can, at least in relative terms, constrain the ambitions of those who would subvert it, museum scholars depend immediately on directors' individual conceptions of responsible and ethical conduct.

4. Pierre Bourdieu, *Homo Academicus*, trans. Peter Collier (Stanford: Stanford University Press, 1988).

5. *Florentine Baroque Art from American Collections*, catalogue of paintings by Joan Nissman, intro. (and cat. of drawings and sculpture) by Howard Hibbard, exh. cat. (New York: Columbia University Press, 1969), 44–45, no. 39, ill. fig. 22; Arthur K. Wheelock, Jr., ed., *Johannes Vermeer*, exh. cat. (Washington, D.C.: National Gallery of Art; The Hague: Royal Cabinet of Paintings, Mauritshuis, 1995), 89 n. 6.

6. Nissman noted the probable existence of more than one version of this subject by Ficherelli and referred to the example from the Fergnani Collection, Ferrara, published in connection with an exhibition at the Palazzo Strozzi in Florence (Mina Gregori, ed., *70 Pitture e sculture del '600 e '700*

fiorentino, exh. cat. [Florence: Vallecchi, 1965], 49, fig. 18). It is this Fergnani version with which the painting under discussion has since often been compared.

7. Michael Kitson, "Current and Forthcoming Exhibitions: Florentine Baroque Art in New York," *Burlington Magazine* 111 (1969): 409–10.

8. See Wheelock, *Johannes Vermeer*, 86 and n. 5 for an account of opinions published between 1969 and 1986. See also Arthur K. Wheelock, Jr., *Vermeer and the Art of Painting* (New Haven: Yale University Press, 1995), 190 n. 8.

9. Michael Hunt Stolbach, *Spencer A. Samuels Inaugural Exhibition: Master Paintings, Drawings and Sculpture*, exh. cat. (New York: Samuels, 1984), no. 14, color plate.

10. In 1968 Kühn had published the most detailed technical analysis yet of the material constituents of Vermeer's paintings ("A Study of the Pigments and the Grounds used by Jan Vermeer," *National Gallery of Art: Reports and Studies in the History of Art* 2 [1968]: 154–202).

11. Private communication; see also Paul Richard, "To Vindicate a Vermeer: The National Gallery's Arthur Wheelock and His Public Belief in 'St. Praxedis,'" *Washington Post*, 20 May 1987, D1.

12. Arthur K. Wheelock, Jr., "*St. Praxedis*: New Light on the Early Career of Vermeer," *Artibus et Historiae* 14, no. 7 (1986): 71–89.

13. Józef Grabski, ed., *Opus Sacrum: Catalogue of the Exhibition from the Collection of Barbara Piasecka Johnson*, exh. cat. (Vienna: IRSA, 1990), 272; Wheelock, *Johannes Vermeer*, 86. The National Gallery of Art had considered acquiring the painting but had declined to do so, an occurrence in art-museum procedure that is not uncommon and does not in itself detract from the work concerned (see Richard, "To Vindicate a Vermeer," D8).

14. Grabski, *Opus Sacrum*, 272–77, no. 48 (entry by Arthur K. Wheelock, Jr.).

15. Józef Grabski, ed., *Jan Vermeer van Delft (1632–1675): St. Praxedis, an Exhibition of a Painting from the Collection of Barbara Piasecka Johnson*, exh. cat. (Vienna: IRSA, 1991). The book includes Lionel Koenig, "Scientific Analysis of the 'St. Praxedis' Paintings by Vermeer and Ficherelli" (22–27).

16. Wheelock, *Johannes Vermeer*, 86–89, no. 1.

17. I discussed this painting while examining it with a number of scholars attending the Vermeer symposium at the National Gallery of Art in December 1995, and I do not recall a single one who was convinced by the attribution.

18. Ben Broos, "Vermeer: Malice and Misconception," in *Vermeer Studies (Studies in the History of Art, 55; Center for Advanced Study in the Visual Arts Symposium Papers, 33)*, ed. Ivan Gaskell and Michiel Jonker (Washington, D.C.: National Gallery of Art, 1998), 30; Marten Jan Bok, "Not to be Confused with the Sphinx of Delft: The Utrecht Painter Johannes van der Meer (Schipluiden 1630–1695/1697 Vreeswijk?)," in Gaskell and Jonker, *Vermeer Studies*, 75; Jørgen Wadum, "Contours of Vermeer," in Gaskell and Jonker, *Vermeer Studies*, 214–19.

19. *A Lady Seated at the Virginals* (in the Baron Rolin collection in 1970) has been accepted as by Vermeer, though without commentary (Lawrence Gowing, *Vermeer*, 3rd ed. [Los Angeles: University of California Press, 1997], 157 and pl. 80), and is being examined discreetly by specialists.

20. Norman Bryson, *Looking at the Overlooked: Four Essays on Still Life Painting* (London: Reaktion; Cambridge: Harvard University Press, 1990), 136.

21. *In Medusa's Gaze: Still Life Paintings from Upstate New York Museums*, essay by Norman Bryson, catalogue by Bernard Barryte, exh. cat. (Rochester, N.Y.: Memorial Art Gallery of the University of Rochester, 1991), 6–30. Beginning in December 1991, the exhibition was shown at the Memorial Art Gallery of the University of Rochester; the Munson-Williams-Proctor Institute Museum of Art, Utica; the Everson Museum of Art, Syracuse; the Herbert F. Johnson Museum of Art, Cornell University, Ithaca; the Albany Institute of History and Art; and the Albright-Knox Art Gallery, Buffalo.

22. Norman Bryson, "*Interim* and Identification," in *Mary Kelly: Interim*, exh. cat. (New York: New Museum of Contemporary Art, 1990), 27–37 (shown also between 1990 and 1991 at the Vancouver Art Gallery, and the Power Plant, Toronto).

23. *Cindy Sherman, 1979–1993*, text by Rosalind Krauss, essay by Norman Bryson (New York: Rizzoli, 1993).

24. *Thomas Struth, Portraits*, texts by Thomas Weski, Norman Bryson, and Benjamin H. D. Buchloh, exh. cat. (Munich: Schirmer/Mosel, 1997; exhibition at the Sprengel Museum, Hannover, 1997–98).

25. *Mark Dion*, texts by Lisa G. Corrin, Miwon Kwon, and Norman Bryson (London: Phaidon, 1997).

26. Gao Minglu, ed., *Inside/Out: Contemporary Chinese Art*, with essays by Norman Bryson et al., exh. cat. (San Francisco: Museum of Modern Art, 1998); exhibited also at the Asia Society Galleries, New York.

Between Academic and Exhibition Practice:
The Case of Renaissance Studies

Andreas Beyer

Rarely do we find the two domains of art history—museums and exhibitions, on the one hand, and the university and academic research, on the other—housed under one roof, as is the case in Williamstown (the Clark Art Institute with the Williams College Graduate Program in the History of Art) and in Washington, D.C. (the Center for Advanced Studies in the Visual Arts at the National Gallery of Art). More typically, institutional constraints on both sides keep art history neatly divided into a so-called practical branch and a more theoretical, academic branch. Consider, for example, the J. Paul Getty Museum in Los Angeles, where the strict separation of curatorial and research departments is part of the governing philosophy.

I cite an example from my own recent experience, when I was invited to contribute to an exhibition catalogue. Up to the day of the all-too-early deadline, it was not at all clear which objects would actually be seen in the show, particularly in the gallery for which I was assigned to write an introductory essay. To be on the safe side, the curators asked me simply to write about all those objects that were on the initial list to be requested—some eighty pieces!—so that at the very last moment my text could be cut and tailored to all the works of art that would actually be included. Needless to say, the strategy did not work. An essay cannot be assembled in such an arbitrary way. It has its own rules, as has the often uncontrollable machinery of lending. Instead of composing a proper *musée imaginaire*, I opted not to participate but to await the opening of the exhibition and then to review it. I mention this not because I want to complain about a system that sets its own requirements. Rather, I share the experience to emphasize that the exhibition (and sometimes museums) and academic work involve different tasks. To put it in an admittedly too-simple formula: exhibitions and museums show, academics write.

It is symptomatic of this division that what I at first planned to present here was—inevitably—destined to fail: I intended to examine some of the major exhibitions on Renaissance art of the last few years and then to point out the specific sequential spatial organization that made each of them so uniquely compelling. But the lack of visual documentation prevents us from showing the lasting

impact of an exhibition. Undeniably, the leading achievements in recent art history scholarship have been made through exhibitions; we have only to recall the great shows dedicated to Giulio Romano[1] and Raphael[2] in Mantua. They were notable for bold attributions: in a monographic show some ten years ago, for example, Giulio Romano was identified as the architect of Veronese palaces hitherto attributed to Michele Sanmicheli, and a number of works until recently firmly by the hand of Giulio Romano—including the Hertz Madonna and the Spinola Madonna—are now given to his teacher, Raphael. However debatable these reattributions may be, it is mainly because of them that the shows in Mantua and elsewhere represent a significant contribution to scholarly knowledge. As centennial celebrations, they seem to follow their own logic reminiscent of a self-oiling machine; no doubt the next commemoration will see some of the reattributions changed again. Most important in furthering academic research, however, is that all these added contributions, whether based on connoisseurship or new documentation, came to light through visual presentation. Even as corrections, additions, and confirmations continue to fill the literature, none will ever have as profound an impact on public opinion and technical knowledge as does the exhibition itself.

Another case in point is Alexander Perrig's pugnacious commentary on Michelangelo's drawings—printed nearly a quarter of a century ago by a marginal German publishing firm[3]—which provoked scholarly and public debate only after a recent show in Saarbrücken.[4] Such examples confirm the rhetorical power of visual exposition, its *Anschaulichkeit* (the word is untranslatable). Moreover, the response of visitors and critics—all too often underestimated—often strongly confirms revisionist opinions of this kind.

Likewise, an exhibition on nature and antiquity in the Renaissance, held in Frankfurt in 1986,[5] made it possible for the viewer to reestablish the visual evidence of an elusive history of humanist culture and artistic purpose. Far from functioning as a period room, this ephemeral reconstruction of a *studiolo* containing small bronzes of the period brought to life the unique world of Renaissance erudition and the arts. What was so visually evocative in the sculpture groupings has proved to be irretrievable, alas; the record that remains of it in the catalogue is no more than academic rhetoric, and not a single photograph of the exhibition's eloquently orchestrated hanging has survived.

The same is true of an exhibition organized by Henry Millon for museums in Venice, Berlin, Paris, and Washington, D.C., in 1994—an epoch-making show

on Renaissance architectural models.[6] Evident only in the setting itself, the specific quality of the objects—their incisive and persuasive character—helped to underscore the original function of these examples of microarchitecture. No book, no catalogue, no text could replace the impact of their appearance. In each venue, distinctive space and surroundings revealed different interpretations of the same material.

The difficulty of reconstructing installations is apparent in a few recent attempts. The first "documenta" of 1955, which Walter Grasskamp succeeded in replicating nearly four decades later, demonstrates how fragmentary the record was.[7] After detailed detective work to reassemble the list of the objects exhibited, it required painstaking effort to reconstruct the precise sequences of the show, its visual syntax. This success has not been achieved at Karl Friedrich Schinkel's Altes Museum in Berlin, where the exact position of the sculptures is nearly impossible to determine;[8] and only by chance has a curator found a way to carry out a reliable reconstruction of the original mid-eighteenth-century hanging of the paintings of the Dresden collection in the converted stable at the Jüdenhof, the forerunner of Gottfried Semper's 1855 Gemäldegalerie.[9]

There is no doubt that the sequence of works of art, their distribution, their hanging or positioning, even their illumination and wall color—in short, the manner of their display—are the essential preconditions to enable them to express something. Making the case by means of pictures, sculptures, or drawings is the closest possible approximation to a genuinely consistent art historical approach. Communication is achieved not *with* the art but through the works displayed, through the act of *showing*.[10] The problem then is that even the most coherent concept of a visual and contextual framework gets split up in the catalogue into items and numbers. Only occasionally has there been an attempt to investigate the scholarly technique that shapes judgments and determines research in such projects. *Stationen der Moderne*, held in Berlin in 1988–89, represents an effort to document the important art shows of the twentieth century in Germany.[11] Out of twenty examples—from the 1910 exhibition of the Brücke artists in Dresden up to the Fluxus and neo-Dada show of the early sixties—no more than a few could be presented in some true measure according to their visual infrastructure.

This failure points up the need to intensify the dialogue between exhibition practitioners and academics; it also challenges the manner in which they make arguments within their respective mediums. Such a confrontation can be

seen in an exhibition that has survived not because of its small catalogue—which is negligible—but because it had a visitor who angrily and emphatically critiqued the show in a sort of anticatalogue. I refer to an exhibition held in 1945 at the Museo Civico in Venice, spanning five centuries of Venetian painting,[12] and to Roberto Longhi's response.[13] The term used in his title (*viaticum*—the last communion, given to the dying) alludes to the provisions for a journey, a pilgrimage from the fourteenth century up to the undisputed master of the Venetian Baroque, Giambattista Tiepolo.

The exhibition had been installed immediately following the liberation (1945), as if, after the heroic times of Italian Fascism—with its dubious preference for Tintoretto—it was now necessary to find the way back to the delicate Madonnas of Bellini, the complex dramas of Carpaccio, the fathomless color harmonies of Titian.[14] Longhi (who then taught at the University of Florence) took his Tuscan students to Venice and wrote the *Viatico* as their orientation to the show. A prose text of scarcely a hundred pages with a catalogue appended, it offers an enduring lesson, surviving as the document of a lively encounter between the university and the museum.

Following the layout of the exhibition meticulously, Longhi comments on the paintings displayed and also on those that were not—frescoes in nearby churches and cloisters, paintings in remote collections—and thus interweaves the exhibited offerings with his personal eidetic patrimony. Had he been allowed to rehang, Longhi would have reorganized the works and generated an entirely different narrative, but since he was prevented from interacting physically, he could only confront the exhibition's message with his own written ideas on the subject.

Longhi's text portrays a partisan of the arts in conversation with himself. The effectiveness of his dialogue lies in the witty, irreverent remarks he makes and his obvious reluctance to explain his judgments academically. What makes the book so breathtaking—so disarming and instructive at the same time—is the author's capacity (and willingness) to react to the visual experience. Alternately jeering, moaning, mumbling, and praising, Longhi's descriptions are purely individual. His *equivalenze verbali* made him, along with Heinrich Wölfflin, the protagonist of a literature concerned with the essence of artistic manifestation. Basing his perceptions on intuition, he speaks in graphic images that are expressed often as a series of adjectives, generating a rapid-fire rhythm that lacks discursive form. In his commitment to overcome what is ineffable in academic

discussions of art,[15] Longhi was advancing the goal of his teacher, Pietro Toesca, who had reduced the problem to the formula *parole non possono dire* ("words cannot tell"), as he endeavored to articulate what might be called a visual philology.

Longhi's method in the *Viatico* and elsewhere can be disconcerting. Nonetheless, there is plausibility in his assertion that Giorgione is the Manet, Titian the Renoir, and Bassano the Monet of Venetian painting. Statements such as this are erudite abbreviations of more detailed metaphors, helping to communicate otherwise inexpressible experiences by pointing to aesthetic affinities. Through his own twentieth-century vision, Longhi established a contemporary visual philology that goes beyond the limitations of academics' neutral koine (lingua franca). Paradoxically, the eloquence of his sensual language brings home to us the realization that works of art do not in fact speak.

Even in its deviations from the exhibition organizers' judgments (particularly Longhi's rejection of the eminent role attributed to Tiepolo, or his early praise of Lorenzo Lotto), the *Viatico* is the true catalogue of that legendary exhibit in Venice. Here, exhibition practice and academic writing—and Longhi considered his prose to be such—converge in a mutual effort: to show, to indicate, to make visible. This act of pointing or showing comes about through *ekphrasis,* a translation of the visual into graphic descriptive speech such that the listener or reader is transformed into a spectator.[16] In fact linguistics has proved that most of the Indo-Germanic verbs for "saying" and "pointing out" (that is, showing) have a common root. In Sanskrit it is *dic* (to show, let see); in classical Greek, *deiknymi* (I show); in Latin, *dico* (I say).[17] If any speaking (or writing) on art therefore is synonymous with "pointing out" then the most reliable koine of art history may be a gesture. How, if not by acquisition, collecting, framing, presentation, and disposition, can we comprehend a museum or an exhibition? And how can we discuss art in writing without first having activated the dynamic force of language by *ekphrasis*? As we become more fully aware of the power of pictorial content—confronted by the increasing illustration of all printed matter, along with the availability of images in unprecedented quality and numbers—we are compelled to acknowledge the widening arena in which theory and practice must converge.

1. *Giulio Romano*, exh. cat. (Milan: Electa, 1989).

2. Konrad Oberhuber and Achim Gnann, eds., *Roma e lo stile classico di Raffaello 1515–1527*, exh. cat. (Milan: Electa, 1999).

3. Alexander Perrig, *Michelangelo Studien* (Frankfurt: Peter Lang, 1976); English trans.: Alexander Perrig, *Michelangelo's Drawings: The Science of Attribution* (New Haven: Yale University Press, 1991).

4. Ernst-Gerhard Güse and Alexander Perrig, eds., *Zeichnungen aus der Toskana: das Zeitalter Michelangelos,* exh. cat. (Munich: Prestel Verlag, 1997).

5. Herbert Beck and P. C. Bol, eds., *Natur und Antike in der Renaissance*, exh. cat. (Frankfurt: Liebieghaus–Museum Alter Plastik, 1985). See also the review of the exhibition by Andreas Beyer in *Kunstchronik* 39, no. 7 (1986): 241–45.

6. Henry Millon and Vittorio Magnago Lampugnani, *Rinascimento da Brunelleschi a Michelangelo: La Rappresentazione dell'Architettura*, exh. cat. (Milan: Bompiani, 1994). See also the review of the exhibition by Andreas Beyer in *Kunstchronik* 47, no. 11 (1994): 691–96.

7. Walter Grasskamp, "Documenta, or: How Is Art History Produced," in *Thinking about Exhibitions*, ed. Reesa Greenberg, Bruce W. Ferguson, and Sandy Nairne (London: Routledge, 1996), 67–78.

8. Tilmann Buddensieg, "Lustgarten und Exerzierfeld: 'Griechenlands Blüte' und preussisches Elend," in *Berliner Labyrinth, neu besichtigt: Von Schinkels Unter den Linden bis Fosters Reichstagskuppel* (Berlin: Verlag Klaus Wagenbach, 1999), 171–200 and 219–23 (see n. 19, p. 220, for further literature).

9. Gregor J. M. Weber, "1798 in der Königlichen Gemäldegalerie zu Dresden," *Dresdner Hefte, Beiträge zur Kulturgeschichte*, no. 58 (1999): 8–15.

10. Ivan Gaskell, "Writing (and) Art History: Against Writing," *Art Bulletin* 78, no. 3 (1996): 403–6.

11. *Stationen der Moderne. Die bedeutenden Kunstausstellungen des 20. Jahrhunderts in Deutschland*, exh. cat. (Berlin: Nicolai, 1988).

12. "Mostra di cinque secoli di pittura veneta," exh. cat. (Venice: Museo Civico, 1945).

13. Roberto Longhi, *Viatico per cinque secoli di pittura veneziana* (Florence: Sansoni, 1946); see the German translation and newly illustrated version: *Roberto Longhi: Venezianische Malerei* (Berlin, 1995).

14. Gustav Seibt, "Tizian ist der Renoir der Renaissance: Roberto Longhis Essay zur Venezianischen Malerei," in *Das Komma in der Erdnussbutter, Essays zur Literatur und literarischen Kritik* (Frankfurt: Fischer Taschenbuch Verlag, 1997), 140–45.

15. Eduard Hüttinger, "Stilpluralismus im Werk von Roberto Longhi: Ein kunsthistoriographischer Versuch," in *Porträts und Profile: Zur Geschichte der Kunstgeschichte* (Saint Gall, Switzerland: Erker, 1992), 206–32; Andreas Beyer, "Roberto Longhi (1890–1970), Kunst, Kritik und Geschichte," in *Altmeister moderner Kunstgeschichte*, ed. Heinrich Dilly (Berlin: Dietrich Reimer Verlag, 1990),

251–65; introduction by Cesare Garboli to Roberto Longhi, *Il Palazzo Nonfinito: Saggi inediti 1910–1926* (Milan: Electa, 1995).

16. Gottfried Boehm, "Bildbeschreibung: Über die Grenzen von Bild und Sprache," in *Beschreibungskunst—Kunstbeschreibung. Ekphrasis von der Antike bis zur Gegenwart*, ed. Gottfried Boehm and Helmut Pfotenhauer (Munich: Wilhelm Fink Verlag, 1995), 23–40; Andreas Beyer, "'Die Kunst ist deshalb da, dass man sie sehe, nicht davon spreche. In welcher Sprache sollen wir sprechen?' Zur wissenschaftlichen Koiné der Kunstgeschichte," in *Wirtschaft & Wissenschaft*, no. 3 (1997): 2–9.

17. Boehm, "Bildbeschreibung," 39.

Constructing Histories of Latin American Art

Dawn Ades

The original title of my talk at the Clark Art Institute, "Anthropophagy and the Missionary Stew: Constructing Histories of Latin American Art," was prompted by the Brazilian José Oswald de Andrade's "Anthropophagite Manifesto" of 1928.[1] De Andrade harnessed the trope of cannibalism, which has colored perceptions of the New World since the moment of contact with Europe, to the idea of a radically eclectic modern art and literature. He proposed that modern Brazil should "devour its colonizers," ingest the strength of the cultural other, and fuse it with her own indigenous cultures. He also recognized that "contemporaneity" in Brazil was not just the time of modernity as it was for the technologically advanced countries of Europe, that cultures were mixed and not pure, and that history was not a linear narrative. His manifesto and the movement that accompanied it were the first manifestations of a rich history of modern art in Brazil, where local appropriations or resistance to the "missionary" forms of canonical modern art coexist with quite distinct and original practices. All too often, this art remains invisible to historians and curators of twentieth- and twenty-first-century modern art outside Latin America.

Latin American art is a field probably unfamiliar to most art historians in Europe and the United States, whether from the museum or the academy. It is meagerly represented here in departments of art history and museum collections, although the respective situations are not identical. The political geography has favored bursts of collecting activity such as that led by Nelson Rockefeller for the Museum of Modern Art in the early 1940s, for which there is no equivalent in Britain, and a more global view of art history in the United States has stimulated active scholarship within universities.[2] Interest in the subject has been confined in the United Kingdom to a few academic departments and a handful of independent curators. By contrast with the objects of study of most art history courses, there are very few works by Latin American artists in public collections in the United Kingdom.[3] Thus the invisibility of Latin American art in art history curricula has been reinforced.

On both sides of the North Atlantic, however, exhibitions of Latin American art over the last few decades have raised interest in the subject and questions about the ways its histories are being written, revised, and received, both within and outside Latin America. There is a growing realization that the

dominant treatment of modern art, taking Europe and New York as its axis, is narrow and parochial. While processes of globalization have broadened awareness of contemporary art practices in general, there are particular issues in relation to historical modernism within Latin America that make it a special case, whose absence from the classic accounts of modern art are a real impoverishment.

If the desire to open up art from Latin America to greater appreciation and study is widely shared, there is no agreement on the methods of doing so. Exhibitions, fruitful meeting grounds for art historians and curators, offer a variety of different routes. But do exhibitions of "Latin American" art simply reinforce its separateness? How can curators be persuaded to include artists from Latin America in their thematic or period-based exhibitions—of Constructivism, say? Is it better to focus energy on monographic shows? The problem is how to make a permanent difference: the Brazilian artist Helio Oiticica has just yet again been "rediscovered" as a result of the Rio section of Tate Modern's *Century City* exhibition,[4] having first exhibited in London in the 1960s and seen again in major exhibitions in London and Paris in the 1970s and '80s. It is not as if the critical categories of modernism—Minimal Art, or Conceptualism—exclude him. Yet he has nonetheless been so invisible that specialists in abstract and minimal art were simply unaware of him. This is not a matter of individual failure but of deeply entrenched assumptions about the parameters of the subject.

The idea of an "alternative modernism" in Latin America, to use Oriana Baddeley and Valerie Fraser's useful phrase from their book *Drawing the Line: Art and Cultural Identity in Contemporary Latin America*, can lead to a sweeping rejection of abstract or constructivist art, seen as belonging to an international arena contaminated by Cold War policies. They explain, "Because our interests are concentrated around the Latin American futures of Latin American art, or the essentially Latin American issues it raises, we have tended to exclude works which, for example, take the processes of composition and construction as their only subject matter. Since such purely reflexive abstract art deliberately avoids specificity, it cannot be illuminated by being considered within a Latin American context. This is not to say that such art may not embody certain values, but these tend to be the values of the schools of New York or Paris and of international capitalism."[5] But the exclusion from one narrative does not necessarily entail inclusion in another. So Oiticica and Lygia Clark's neo-concrete works of the 1950s, which rupture the hygienic purity of the modernist grid to incorporate the body and the senses, are always rediscovered with a sense of surprise.

Latin American art occupies a peculiar position, being both part of but also distinct from Western artistic traditions and the modernist canon. On the rare occasions when it is included in general histories of art, this is almost always in terms of European norms. So Norbert Lynton, in *The Story of Modern Art*, sequel to E. H. Gombrich's *The Story of Art*, mentions only, of all possible artists from Latin America, the Mexican muralists Diego Rivera, José Clemente Orozco, and David Alfaro Siqueiros, but judges that their propagandist intentions involve repudiating modernism.[6] (However, he has no difficulty in drawing the post-Dadaist propaganda photomontages of John Heartfield into the fold of modern art.) So stereotypes are repeated, and Latin American art is reduced to the Mexican muralists and magical realism.

The notion of a fantastic or marvelous reality that conditions a specifically Latin American experience runs from Alejo Carpentier's *lo real maravilloso* to García Márquez's magical realism; in relation to the visual arts it has tended to favor figurative rather than abstract and, to an extent, both builds upon and resists the Surrealists, who were among the first Europeans to pay serious attention to the complexity of modern Latin American culture and to value the alternatives it seemed to offer.

This "marvelous reality" was the governing conception for the first group exhibition of Latin American art in a major museum for twenty years, *Art of the Fantastic: Latin America from 1920 to 1987*, organized by Holliday T. Day and Hollister Sturges for the Indianapolis Museum of Art in celebration of the Tenth Pan-American Games in 1987.[7] Twenty years earlier (1966) Stanton Catlin and Terence Grieder had mounted the monumental *Art of Latin America since Independence* at the Yale University Art Gallery.[8] This had been "addressed primarily to the North American university community," and had a specifically continental approach, its aim being to compare and contrast Latin American culture and sensibility with those of North America. It is interesting that Frida Kahlo, now the most famous artist from Latin America, was not among the nearly three hundred artists included there.[9]

The Argentine art historian Damian Bayon proposed the theme of the fantastic for the Indianapolis show, and thirty artists over three generations were selected. A determined effort was made to distinguish this exhibition's notion of the "fantastic" from Surrealism. The proposal was that Latin American "reality" contains many distinct cultural elements that give the art produced there a "fantastic effect," whose devices "such as metamorphoses, incongruous hybrids,

dislocations in time and space and shifts in scale and materials create fantastic images which break the rules of the natural world."[10] This falls within an interesting tradition in Latin America that rejects Surrealism, considered as an intellectually programmatic theory derived from Freud, in favor of an idea of a more spontaneous and intrinsically "fantastic" reality. Arguing that the Fantastic is not an "ism" and could in theory be part of any style including geometric art, in practice the organizers did not include any; although six comprehensive themes, shared in some form by the thirty artists ("the Catholic church, colonial past, Pre-Columbian and African influence, political oppression, Latin America's role in Western culture and its isolation") were identified,[11] the exhibition only attempted to address the one aspect, omitting "the rich history of abstract or concrete art, the enormously varied and fascinating folk traditions [and] the mural movement initiated in Mexico." A groundbreaking exhibition nonetheless, it did not attempt visually to contextualize these six "themes," nor to question the conventional division between popular and "high" art.

What follows is a critical analysis of the exhibition I organized with the help of Guy Brett and Stanton Catlin, *Art in Latin America: The Modern Era 1820–1980*, at the Hayward Gallery in London in 1989.[12] It coincided with another exhibition, *Les Magiciens de la terre*, in Paris.[13] Although the approaches were very different, they shared an impulse to break out of the restrictive canon of European and North American art. *Magiciens de la terre*, which, as its title suggests, had a global coverage, took a horizontal slice through contemporary art, juxtaposing artists of international reputation with local and "indigenous" artists who were sometimes also ritual practitioners. If this exhibition was criticized for superficial juxtapositions and lack of context, mine was criticized for too much history and too much context.

Art in Latin America: The Modern Era 1820–1980 had its origins in a unique research and teaching context at the University of Essex. This is the only university in the United Kingdom, so far as I know, to offer specialist courses at both graduate and undergraduate level in Latin American art, and has done so since the early 1970s. The courses began in the context of an Area Studies degree within the radical formation of Essex, a University founded in the 1960s (like Warwick, Sussex, and East Anglia). The Area Studies programs were interdisciplinary, incorporating Literature, Sociology, Government (Politics), and History. The issues that I have been concerned with and which fed into the Hayward exhibition were formulated in this interdisciplinary context: nation, race, indi-

genism, periodization, and cultural syncretism. The Department of Art History was also one of the first to include theory, which has now become a mainstream component of art history courses and encouraged an approach that challenged the classic stylistic histories of art. This expansion of the parameters of the subject led, for instance, to critical reappraisals of modernism, in which the nature of Latin American art in the nineteenth and twentieth centuries could play an interesting role. We also continued to stress the need for direct experience of the painting or sculpture under study, and the lack of actual Latin American works to see was acutely felt. The commercial pressures on museums and galleries to pull in the punters tends to discourage the unfamiliar. The public presentation in an exhibition of new or overlooked bodies of work or the reconceptualization rather than recycling of familiar ones can pose problems of various kinds. Art historians may tend to pursue a scholarly agenda that needs mediation for a public of whom only a small proportion may be the specialists to whom an argument is addressed.

The unusual willingness of London's Hayward Gallery to bring together unfamiliar bodies of work supported by original research provided the conditions for *Art in Latin America*. The exhibition was thought of as a temporary museum of post-independence Latin American art; its structure was partly a consequence of its origins in a teaching program, in which Latin American history was divided into the colonial and post-independence periods. The intention was also to work with the special physical space of an exhibition, its capacity for nonlinear presentation and for unexpected juxtaposition to question straightforward narratives and conventional periodization. Raising questions of artistic identity within a post-colonial perspective, it incorporated pre-Columbian and popular works. So, for example, the same Aztec sculpture was visible in two spaces: at the start of the exhibition in the conventional position of "Pre-Columbian Origins" and also in the Muralist gallery, to signal the revaluation of pre-Spanish culture during and after the Mexican Revolution. More could probably have been done to question the official versions of history: for instance the fact "independence" itself, conventionally used as a watershed in many places, was not recognized as such among indigenous populations as opposed to the urban elites. The inclusion of popular and "ethnographic" material was, however, an attempt to look at the plurality of cultural traditions and the nonsequential timeframe of Latin American modernity.

The introductory space of *Art in Latin America* contained early maps and two works from the colonial period: one of the extraordinary *Angels with Guns* from the Andean school, and the other a "caste" painting with the Virgin of Guadalupe (fig. 1). These signaled cultural miscegenation and the syncretic iconography that have retained considerable currency. The first room, painted red, was devoted to heroes of independence like Simón Bolívar and the Peruvian

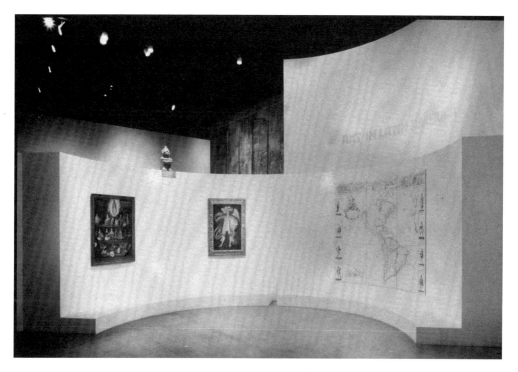

Fig. 1. Introductory room of *Art in Latin America: The Modern Era 1820–1980*, at the Hayward Gallery in London, 1989, with a view of an Aztec sculpture and Mexican Muralists beyond

martyr José Olaya. One of the many discoveries made during the initial research travels for the exhibition was the quantity and quality of these portraits that were barely known outside Latin America; many were housed in government buildings, and it was often a diplomatic issue to acquire them. The only work that I did not have the opportunity to see in the flesh before requesting it was José Gil de Castro's magisterial portrait of the Martyr Olaya, which was housed in the National Museum of History in Lima, regularly closed during my visits.

The second room (painted dark green) looked at Academies: and this was in fact one of several instances in which the actual histories did not coincide

Figs. 2 and 3. Views of room three of *Art in Latin America*, "Nature, Science, and the Picturesque"

with the conventional periods, for the Mexican Academy was founded under the Viceroyalty in 1785, while in other countries a Fine Arts Academy was not founded until the twentieth century. These were followed by a large gallery that made a striking contrast: it included landscape and *costumbrista* paintings by both European travelers and local artists, as well as objects of popular manufacture and ethnographic material (figs. 2 and 3). The purpose was to bring together the wide-eyed gaze of the traveler in search of exotic lands, costumes, and customs and the

Fig. 4. The room titled "Modernism and the Search for Roots" in *Art in Latin America*

native artist for whom these were familiar and homely "realities." Two "offshoot" galleries developed aspects of this material: firstly, the landscape paintings of the Mexican artist José María Velasco, whose epic views of the Valley of Mexico deserve much wider recognition, and secondly, the prints of the Mexican graphic artist José Guadalupe Posada.

A suite of rooms then addressed different aspects of the first decades of the twentieth century: on the one hand responses to modernism ("Modernism and the Search for Roots" [fig. 4] and "Indigenism and Social Realism") and on the other, the Mexican Mural Movement that had such a massive influence within America. The latter, of course, presented one of the most serious museological problems of the show: how to represent the huge and immovable murals. We managed to borrow a very large cartoon for a mural by Juan O'Gorman (fig. 5), which gave a sense of the scale and physical presence of the originals, and also had a continuous display of slide sequences of the major mural cycles. The room also contained the art of the pre-conquest period that was being revalued at the time (fig. 6).

The final four rooms were intended as parallels and contrasts to show the diversity of twentieth-century Latin American art. One section was devoted to the extraordinary Madi movement's abstract, geometrical, and mobile objects. Then were two counterpoised rooms, one painted black, the other white. The first was called "Private Worlds and Public Myths" (fig. 7) and was an attempt to present and critique the Surrealist frame that is often imposed on Latin American art. This room included work by Frida Kahlo and María Izquierdo, but also the kind of chosen objects so valued by the Surrealists such as masks, works by

Haitian artists inspired by voodoo beliefs, and the wooden carvings of artists like the Brazilian GTO, but set within their own contexts. The other room, curated by Guy Brett, and called "A Radical Leap," included work by the Venezuelan abstract artists Alejandro Otero, Carlos Cruz Diez, and Jesús-Rafael Soto, and some of the extraordinary neo-concrete works dating from the '50s and '60s by Hélio Oiticica and

Figs. 5 and 6. Views of a room devoted to "The Mexican Mural Movement" and art of the pre-conquest period in *Art in Latin America*

Lygia Clark, whose *Rubber Grub* can be seen in the foreground of the installation photograph (fig. 8), together with other pieces that are intended to be moved, worked, picked up, worn, and played with. The final section was probably the most problematic, in that its selection of more recent art (although not attempting to come up to date) was determined by the preceding arguments about History and Identity.

The exhibition was criticized both from within and from outside Latin America, though it also had support from some quarters. One view was that its huge temporal and geographical scope meant that it missed out on specific histories and specific contexts. But my starting point was that issues of identity and a *mestizo* culture are common to most Latin American countries, although

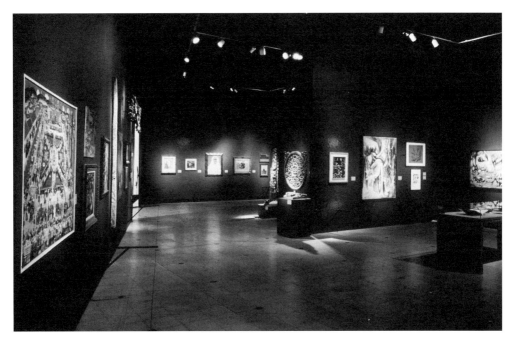

Fig. 7. The room "Private Worlds and Public Myths" in *Art in Latin America*

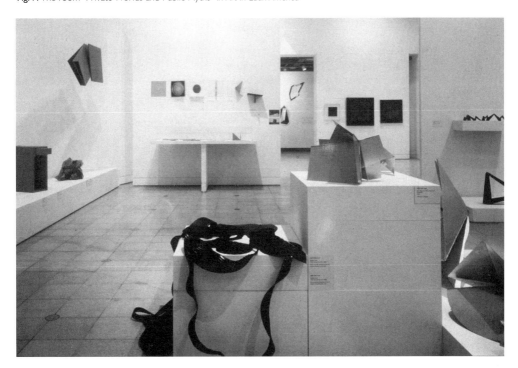

Fig. 8. The room "A Radical Leap" in *Art in Latin America*

differently articulated, and would still dispute the charge that Latin America appeared in this exhibition as "exotic, primitive, quaint, pure . . . expressed by the erasure of all national art histories turning the continent into one place."[14] I also feel that one of the alternatives for those keen to make the art of this continent better known falls into a different type of cultural and political essentialism, and that is nationalism. Working on the Hayward exhibition in the late 1980s, I encountered for the first time the idea that the art of a country should be dealt with only by its nationals, with the corollary that art historians were concerned only with the art of their own country. Admittedly, in the difficult economic conditions in many Latin American countries, it has been often almost impossible to travel abroad, and the assumptions of privileged art historians used to roaming visually, intellectually, and physically in any territory they please can indeed look neo-colonial. Much could be said about the nationalist perspectives that reign both in museological and art historical discourses in Latin America and are reinforced by an institutional permeability: art historians tend to move much more freely between museum and university than in the United Kingdom. While on the one hand nationalism as the expression of an ideal imagined community has been a form of resistance to colonialism, it has also accompanied an independence often won in the name of a few, ignoring indigenous and immigrant peoples whose culture and language are not defined within the new nation states, and has provided a myth of unity when in fact little existed.

Major exhibitions of the art of any given country have often been of a celebratory nature and generated by political and economic interests.[15] Post-independence cultural initiatives in most countries have been insistently concerned with national identity. There have been well-intentioned projects to write the story of Latin American art from within, but these have always fallen back on the basic geopolitical map. Edward Sullivan's *Latin American Art in the Twentieth Century* was explicitly a reaction against the dominance of European and North American critics and historians writing about and exhibiting Latin American art. Divided country by country, each section is written by a native art historian or critic, and by and large follows an uncritical national narrative illustrated by the expected artists. There were, though, encouraging notes of dissent, even within this structure. Alicia Haber, for example, wrote of Uruguayan artists working under the dictatorship of 1973–84, whose works "respond to the disillusionment with the concept of ideal nation, which in the collective imagination constituted the paradise of immigrants, a model of homogeneity, democracy,

tolerance, innovation, culture, economic stability and a high level of education. In the years of dictatorship, the myth of Uruguay as the Switzerland of the Americas was dispelled once and for all."[16]

I would be happy for the monolithic, essentializing constructions of Latin American art to which I have contributed to fade away if it were in favor of the incorporation of Latin American artists into a broader, international arena in the contexts both of historical and contemporary projects (this is already happening among the international curators of contemporary art within which Latin American artists now have a high profile) and also of specific and detailed studies of artists and visual practices above and below the national.

Criticism of the Hayward exhibition of a different kind came from the European press. Aesthetic quality here was the issue: apart from objections to the mixture of "low" and "high" art, there were condescending comments about the paucity of paintings of "European museum quality," or even "acceptable paintings"; while the muralists and Frida Kahlo were "weakened by their early 19th century forebears."[17] Judgments about quality, in fact based upon habits of taste, were left undefined. "Such dubious phrases revealingly echo a language of 'purity' for which cultural miscegenation can only be seen as a failure to meet 'proper' standards. Latin American culture is nothing if not *mestizo*: a condition it turns into its triumph and its challenge to European norms."[18] Art historians both within and without Latin America could well benefit from this challenge in a world whose condition is increasingly and richly *mestizo*.

1. José Oswald de Andrade, "Anthropophagite Manifesto" (1928), trans. in *Art in Latin America: The Modern Era 1820–1980*, exh. cat., ed. Dawn Ades (New Haven: Yale University Press, 1989), 312. The 1998 São Paulo Bienal took "anthropophagy" as a multilayered concept to structure both its historical and contemporary international sections.

2. George Kubler, for instance, was a pioneer in both pre-Columbian and Latin American colonial art.

3. The Tate Gallery, for instance, owns a scattering of works: a couple each by the Mexican muralist Diego Rivera, the Chilean Surrealist Roberto Matta, and the Cuban Wifredo Lam, some examples of the abstract artists Carlos Cruz-Diez and Jesús-Rafael Soto, but these are rarely if ever on display.

4. Iwona Blazwick, ed., *Century City: Art and Culture in the Modern Metropolis*, exh. cat. (London: Tate Gallery Publications, 2001).

5. Oriana Baddeley and Valerie Fraser, *Drawing the Line: Art and Cultural Identity in Contemporary Latin America* (London: Verso, 1989), 3.

6. Norbert Lynton, *The Story of Modern Art*, 2nd ed. (Englewood Cliffs, N.J.: Prentice-Hall), 167–69.

7. Holliday T. Day and Hollister Sturges, eds., *Art of the Fantastic: Latin America from 1920 to 1987*, exh. cat. (Indianapolis: Indianapolis Museum of Art, 1987).

8. Stanton Loomis Catlin, ed., *Art of Latin America since Independence*, exh. cat. (New Haven: Yale University Art Gallery 1966), ix.

9. Kahlo's worldwide posthumous reputation began with a U.S. retrospective in 1978–79 and an important exhibition at the Whitechapel Art Gallery in London in 1982, *Frida Kahlo and Tina Modotti*. Her popularity is because of, rather than in spite of, her obsession with her Mexican/Latin American identity, which sharpens the issue of her gender.

10. Day and Sturges, *Art of the Fantastic*, 38.

11. Ibid., 40.

12. Ades, *Art in Latin America*. The first plan to title the exhibition *Latin American Art since Independence* was abandoned when we discovered that "independence" meant little to an English audience—in evident distinction from an American one.

13. Jean-Hubert Martin, ed., *Magiciens de la terre*, exh. cat. (Paris: Editions du Centre Pompidou, 1989).

14. Juan Davila, letter to Guy Brett, *Transcontinental: Nine Latin American Artists* (London: Verso, 1990), 105.

15. A major 1990 exhibition of Mexican art, *Mexico: Splendors of Thirty Centuries*, at the Metropolitan Museum of Art in New York coincided with negotiations for the GAT trade agreements, while the only major national exhibition of Latin American art recently in the United Kingdom was *Art from Argentina* at the Oxford Museum of Modern Art, marking the resumption of diplomatic relations after the Malvinas War. It should be noted that since 1989 an important exhibition was organized by Waldo Rasmussen, *Latin American Artists of the Twentieth Century*, commissioned for the International Fair at Seville, 1992, it was subsequently exhibited at the Museum of Modern Art, New York, and the Centre Pompidou, Paris. Other notable national or monographic shows have included *Imagen de Mexico* at the Schirn Kunsthalle in Frankfurt, the Messepalast in Vienna, and the Dallas Museum of Art in 1987–88, and *Diego Rivera: A Retrospective* at the Detroit Institute of Arts, 1986.

16. Alicia Haber, "Uruguay," in *Latin American Art in the Twentieth Century*, ed. Edward J. Sullivan (London: Phaidon, 1996), 274.

17. Tim Hilton, "A Feast and Famine," *The Guardian*, 25 May 1989.

18. Peter Hume, letter to *The Guardian*, 27 May 1989.

Art History and Its Audience: A Matter of Gaps and Bridges

Sybille Ebert-Schifferer

That the museum as a public educational institution must be concerned mainly with the size and breadth of its audience cannot be disputed. While I endorse this proposition, I believe also that scholarly research is of equal importance to the museum in the Western world—a point on which there is likely to be dissenting opinion. But I am concerned here not so much with this debate as with the challenge of bridging the gap between what a scholar writes and what the public gains from it. To begin with the gap: I believe that, at least in Germany, it has profoundly to do with the general image the nonacademic world has of art history as a scholarly discipline. I offer two favorite anecdotes as illustrations:

> (1) My husband and I once gave a dinner reception for one of his business partners. After expressing his delight at the table, which I had set elegantly and adorned with flowers, our guest declared: "Well, after all, that's what you've been trained in."
>
> (2) I once had to explain to a woman in a high political position why, for conservation reasons, I felt unable to lend her paintings from the museum to decorate the rooms that a friend used for official entertainment. Her furious response was, "Are you suggesting that she is not a cultured lady?"

In the first case, art history is regarded as a means for the aesthetic refinement of practical, everyday life; in the second, it is thought that a good general education fully qualifies a person to assume responsibility for works of art and their history. Both ideas are based on misunderstandings, the latter being more dangerous than the former. My thesis is that art historians are themselves partly to blame for this distorted image. To understand why, we need to consider the history of the discipline.

The first art historians in the nineteenth century were connoisseurs—*amateurs* who had gained their knowledge as part of a deep general culture and who came from neighboring disciplines; I am thinking of figures like Gustav Friedrich Waagen, the first Director of Berlin's Gemäldegalerie, who studied philosophy; the great Swiss historian Jacob Burckhardt; and even Wilhelm von Bode, the Director General of Berlin's museums during their period of dramatic

growth, who studied law. Their lectures and writings—for instance, Burckhardt's endlessly reprinted *Cicerone*[1]—in turn influenced the aesthetic awareness of the educated bourgeoisie. This lively exchange between scholars and laity declined after World War I, and even more so after World War II, when the social classes who supported this kind of general education disappeared. In time, the approach to art became more or less ossified into a mixture of Burckhardt's historical method with Heinrich Wölfflin's formal analysis. This shift is in part attributable to a changing canon of what is considered essential for basic education; for a while it included knowledge of the newest findings of the natural sciences and required more information about politics and sociology as well as what in Germany is called "social competence." All this is unquestionably important for enlightened participation in a democratic society. The present emphasis means, however, that knowledge about art is acquired not by reading art historical publications by contemporary scholars—as was the case in in Burckhardt's time—but by means of art calendars, coffee-table books, and blockbuster exhibitions. This is how people have come to learn about Wassily Kandinsky, Pablo Picasso, and Andy Warhol. As a result, such formerly admired Old Masters as Correggio, Gerrit Dou, and Guido Reni have been mostly forgotten while only a few of their prominent colleagues, like Botticelli and Rembrandt, have remained in the public consciousness.

Art historians are, however, responsible for scholarly publications as well as for the popularizing texts in coffee-table books, art calendars, and text panels within exhibitions. Their encounters with the public have all too often been characterized by one of two extremes: they may write in either a mostly incomprehensible scholarly jargon or in a simplistic language that scrupulously avoids anything unexpected that might disturb the established cultural canon. The latter attitude assumes that people do not really want to learn anything new but just want confirmation of what they already know. That those exhibitions that are successful in achieving high attendance figures and financial return are devoted to only a narrow range of artists and themes seems to verify this hypothesis.

Compounding this unfortunate state of affairs is the fact that most people come to a museum unprepared—without knowing period dates, biblical and mythological subjects, and so on. To fill in the gaps in their knowledge is a nearly impossible challenge for the museum staff assigned to conduct a guided tour. Required to explain perhaps several dozen pictures within an hour, the art historian has barely enough time to comment in depth on the specifically artistic qualities

of any individual work. In an age marked by a shrinking capacity for concentration, when most visual communication offers itself to be seen at a glance and not to be read carefully, visitors do not typically have the patience to explore a work of art with their eyes. If it is true, as I believe, that you see what you know (and, conversely, see less if you know nothing), it is then essential to guide people in seeing, at least when they face a formally complex work in which they can find no starting point from which to read it. The common practice in museums is that guides try to comply with shortness of time and with the public's expectations by offering a sort of "Big Mac with everything," mingling description, biographical information about the artist (mostly anecdotal highlights), and what passes for interpretation—that is, methodologically speaking, means and results. The most problematic category is interpretation, since it tries to conform to the audience's expectations by rhetorical emphasis. Thus, a line becomes "incomparably masterful" (whatever that means), a blue might be connected innately with the connotation of "divine," and a composition is just "great." An unquestioning audience simply accepts such shallow pronouncements, never learning in a deeply personal way why art matters. At this point of contact with the public, as well as in its popular written forms, art history is presented reductively, as if frozen in a state of "immanent description."

Before continuing to discuss this problematic gap between art history and its audience, I would like to emphasize the negative image that affects the art historical profession as a result of such superficial transmission of information by writers or lecturers who may not even be trained art historians—and the public cannot distinguish between the one and the other. This experience conveys to the uninitiated person the impression that, given the free time to reanimate fragments of earlier education and to learn some artists' biographical data by heart, she or he could easily do the same job. The unfortunate consequence is the belief that art historians and art historical research are altogether superfluous in a museum, which, one might reasonably conclude, could be better run by a well-educated lawyer or a manager with a degree in business administration. Because most museums in Germany are publicly funded, politicians and bureaucrats therefore have a heavy hand in the choice of directors. Sometimes, in fact, the responsibility for museum and exhibition policy in ministries and local parliaments is given to politicians who have earned their merits in the supervision of, for example, the municipal waterworks; at other times, elected mayors supervise their cities' cultural institutions directly, without any professional consultant,

considering themselves educated enough to do so. But who, following such reasoning, would entrust an art historian with flying a jumbo jet only because he asserts that he had always been fond of airplanes?

In this climate, it is no wonder that a serious exhibition program has become increasingly difficult to realize, since to the general public the banal alternative looks exactly the same. Thus is perpetuated the tendency to confirm repeatedly the small canon of general art historical knowledge while automatically promising greater public attention and economic return. It may escape notice that both of these results are achieved often because the funding for the exhibition included support for an aggressive publicity campaign.

Astonishingly, the results of serious art historical scholarship—for example, in a museum's permanent collection, a temporary exhibition, or the historical restoration and reconstructions of castles, churches, and cities—attract every year a mass audience that exceeds the number of Germans who attend soccer games. Indeed, in Germany such art historical work generates a larger share of the gross national product (2.5 percent) than agriculture, yet the discipline of art history has managed to disappear completely behind its products.[2] As I maintain, this invisibility endangers the conservation of cultural heritage as well as the quality of public education—both of which are, in my view, essential for social integration and cultural identity. The ramifications of such social factors for the well-being of a democratic society, far beyond any direct economic return, have been recognized also in the United States in a report by the Department of Education, *A Nation at Risk*. In response, in the 1990 annual report of the J. Paul Getty Trust, Harold J. Williams concurred that democracy depends fundamentally on the awareness of a common cultural identity and its integrative power.[3]

Therefore, in the interest of the greater good—social as well as aesthetic—a bridge between art history and the general public must be built, and the work must proceed from both sides. The art historian's challenge is to enable a larger audience to keep abreast of the state of research by providing ongoing art historical publications. Here it may be instructive to look at the example of Germany, where, by tradition, scholars have considered it professionally unbecoming to write seriously, but intelligibly, for a broader audience, without a profusion of footnotes. Fortunately, a middle course between these two extremes—specialized, sophisticated scholarly essays and "dumbed-down" popular publications—has begun to emerge. In Germany the year 1998 saw the appearance of a new kind of book: general surveys of the whole of art history, or of the history

of German art, written in clear language by university professors (and occasionally by museum curators). These studies reflect the current state of research and modern methodological approaches; easy to read and reasonably priced, they have received favorable notice even in professional journals—"A new trend in German art publishing is the welcome addition of high-quality reference books," reported *The Art Newspaper.*[4] In some cases, superbly produced exhibition catalogues reflect the same level of scholarship without alienating or intimidating the public. Yet such publications can be written only on the basis of specialized research in both universities and museums, research that was conducted without any consideration of the needs or interests of a larger audience

Thus, there are encouraging signs that the bridge is starting to be built from one side, from the art historians' side. But what about the other? That is up to the general public. If it responds to this trend by reading these books and catalogues, informing itself about current art historical knowledge, then the bridge will succeed in spanning the gap. Even more important is establishing a minimum standard for art history education in schools—a tradition that is well established in Italy, for instance, but is virtually absent in German schools (not surprisingly, since the material for the training of teachers is barely adequate!). We would then gain both a better-prepared audience for our museums and better-informed interlocutors in the political and business world. We cannot, of course, force this reform. So the question is: how can we encourage it? The whole process is obviously circular and is therefore difficult to cut through. But we can do several things: improve the quality of our guided tours, in part by not entrusting them to untrained docents; expand labeling in galleries, providing more than the name of the artist and the subject of the work (notwithstanding the extra cost incurred in time and money); and, finally, create stimulating, yet serious exhibitions. People like to be challenged; most of them, if asked what they expect from the museum, make it clear that they seek education, not only entertainment. They are happy if they leave an exhibition having had an engaging experience that has augmented their knowledge.

As art historians, we have to pay equal attention to things that we should *not* do: we must not lend ourselves to exhibitions and publications that have no educational or scholarly purpose, financially tempting though it may be. We should resist lowering our standards, not only for the sake of preserving our professional integrity, but because to trivialize our cultural heritage undermines the goal of conserving it. What is required is a professional ethics based on educa-

tional and scholarly obligations, not on market and entertainment values—Hollywood will always do better at that. Art has other qualities that demand different forms of communication. Equally important, universities must train students to write clearly, in a manner intelligible to an educated lay reader, and should not, as is still often done, encourage the cultivation of cryptic academic jargon. Only thus will the public image of the art historian become more positive and regain a professional stature comparable to that of a physician or an engineer—namely, as the *only* one to whom the administration of a museum or the organization of an exhibition can be entrusted. And, just maybe, also the *only* one who is able to handle, analytically, the masses of images that confront our culture via telecommunications and the media.

We must be able to demonstrate that art history is more than a fashionable society entertainment—that it is, instead, an intellectual adventure that tells us more about ourselves, our roots, our identity, and our way of living and thinking. The most distinctive products of the Western culture in which we are deeply rooted are democracy, human rights, and technological creativity. Its foundation is Greco-Roman antiquity and Christianity; one of its most salient characteristics is a way of thinking that develops the new from an associative process of rethinking the old (as opposed, for instance, to cultures with a different conception of tradition—that is, the tradition of exactly reproducing the old, without altering it). Please understand: I do not allege any superiority for Western culture in stating this, but we are born into it; and, as long as we refrain from imposing our way on those of another persuasion, we should continue to nurture this trait. As a result of the never-ending tension between tradition and innovation, between society and the individual (artist), between the material and the ideal, art and its history provide an inexhaustible model for the investigation of our kind of creativity. We must bring this creative force into the canon of general culture again. Art historians therefore may not consider their discipline as a secret knowledge reserved only to themselves, or misuse it for lulling the public to sleep by repeated confirmation of simplified basics, even if the latter provides easily earned money, massive publicity, and generous sponsors.

1. Jacob Burckhardt's *Der Cicerone: Eine Anleitung zum Genuss der Kunstwerke Italiens* was first published in 1855. The English edition is *The Cicerone: An Art Guide to Painting in Italy for the Use of Travellers and Students*, trans. A. H. Clough (New York: Scribner, 1908).

2. See Hans Haacke and Klaus Staeck, "Düsseldorfer Erklärung," in *Kulturförderung in gemeinsamer Verantwortung. I: Manifeste-Positionen: Weissbuch des Aktionkreises Kultur,* 2nd ed. (Cologne: Kulturkreis der deutschen Wirtschaft im BDI, 1997), 88. The same facts and others of relevance can also be found in Rainer Beck, "Identität vor Rentabilität: Ein Plädoyer für das (statische) Museum," *Pantheon* 58 (2001): 203.

3. National Commission on Excellence in Education, *A Nation at Risk: The Imperative for Educational Reform: A Report to the Nation and the Secretary of Education, United States Department of Education* (Washington, D.C.: United States Department of Education, 1983), quoted in the J. Paul Getty Trust Annual Report, 1990.

4. Hans-Juergen Moesch, "Germany: Show and Tell: The Expressionists Get the Lion's Share of Monographs while von Zabern Continues with Their Exemplary Studies of Antiquity," *Art Newspaper* 10, no. 89 (February 1999): 59. Other recent examples, beyond those mentioned in the article, are: Robert Suckale, *Kunst in Deutschland: Von Karl dem Grossen bis Heute* (Cologne: DuMont, 1998); Werner Hofmann, *Die Moderne im Rückspiegel: Hauptwege der Kunstgeschichte* (Munich: C. H. Beck, 1998); Heinrich Klotz and Martin Warnke, *History of German Art*, 3 vols. (Munich: C. H. Beck, 1998–2000).

www.display: Complicating the Formats of Art History

Barbara Maria Stafford

This paper has a simple thesis: museums need to make a broad public aware—in all their complexity and diversity—of the formats images and objects have assumed historically. Universities ought to drive home the fact that not all genres or styles aim for the same effect or do the work in the same way. Despite the obviousness of these remarks, neither the academic nor the worldly have grappled with our slide into a new visual-communication monoculture in which the future seems not to have a past. While much cultural theorizing today meditates on the globalization of collections, the economies of scale, the end of encyclopedic desires, and the role of the state in maintaining a plurality of artistic offerings, the limited definition of this "new inclusivity"[1] has not been examined.

My larger argument will be that for whatever reason they may be occurring, the simultaneously smoothing and fragmenting capabilities of electronic media oblige the two sides—academic and curatorial—to collaborate. Our concern must be to make audiences aware of pattern complexity and the implications of various forms of display—not just to plan for attracting masses of viewers into more and more opulent "art parks."[2] Indeed to achieve intelligence in the one, we require the other. Web downloading has produced new layers of liquid imagery: the notoriously elusive "initial" artifact, the copy, and its subsequent anthologization within one or more databases. Everything online, then, as the music industry has discovered to its dismay,[3] is *mixed* media. Art historians and museum professionals know that mixtures differ. The problem is that the public does not know—or, perhaps more accurately, does not know it needs to care—about differences existing between new versions of old variants.

Our current exhibition practices are not helping. It is staggering how seldom audiences encounter *types* of art dating from before the late nineteenth century or, if they are exposed to them, how rarely they are asked to think about them as resonating in some way with emergent formats. Consider, for example, the monolithic focus in the United States on Impressionism, which even museums are now coming to realize is a well on the verge of being drained dry. It is not reassuring, however, that as a hedge against potential visitor ennui the *Post-Impressionists* are, predictably enough, being resurrected.

I offer as evidence this front-page story from the *Chicago Tribune*,

announcing the postmillennial blockbuster exhibiting Vincent van Gogh and
Paul Gauguin:

> The Art Institute of Chicago has received the largest corporate grant
> in its history for an exhibition that will examine the most popular
> anecdote in art history. Ameritech Corp on Thursday gave the
> museum $1.5 million to organize "Van Gogh and Gauguin: The Studio
> of the South," the first in-depth examination of the relationship that
> culminated in the most sensational act by a pioneer of modern art:
> Vincent van Gogh cutting off an ear. Although the exhibition—
> scheduled to open in Chicago on September 22, 2001—does not set out
> to clarify reasons behind Van Gogh's pathology, its 120 to 150 paintings
> will reflect the creative stresses that arose between Van Gogh and
> Gauguin as they lived and worked together in the South of France.[4]

The *Tribune* art critic, Alan Artner, noted that both Irving Stone's 1934 novel *Lust
for Life* and Vincent Minnelli's 1956 film adaptation made certain that any show
of these artists' works will be a "preordained success." The implication here is
that the exhibition will be a smash hit because these are the kinds of things the
public wants to see. We also learn from the article that Ameritech, the sponsor-
ing corporation, had in 1995 given the Art Institute $1 million for another "sure
thing," a retrospective of Claude Monet, just as last year, the Boston Museum of
Fine Arts received $1.2 million from the Fleet Financial Group for its *Monet in
the 20th Century*. Back in Chicago, with another grant of $800,000 from
Ameritech, the Art Institute mounted *Renoir Portraits* in 1997 and broke atten-
dance records. Summarizing the rationale for all such enterprises, Diane Wagner,
Ameritech's media-relations manager, declared: "We're a home-town company.
We're here to stay [ironically, the business has now gone global with a new British
CEO living in England!]. We have a long-standing commitment to the commu-
nity. So we capitalize on the brand name of the Art Institute: 'Van Gogh and
Gauguin' increases that."[5]

 To respond by pointing the finger at the opportunistic corporate world
would be too easy. Instead, I want to ask what is wrong with this picture from
the art-world perspective. While art museums over the last twenty-five years
have become adept at reaching out to new and different audiences, as Glenn
Lowry reminds us, is it true to say that these institutions have "widened their

range and interests"?[6] Similarly paradoxical is the intensive focus in art history circles since the 1960s on the details of spectator response;[7] so significant is the phenomenon that it has obliterated the importance of considering the role played by genre in visual rhetoric.

Here we begin to discern a major reason for the absence of a sophisticated awareness in the larger population—the failure to see that not all media are sketchy, impressionistic, and blendable, on the one hand, or that they necessarily produce a rootless divisionism, a free-for-all fracturing, on the other. In the remainder of this essay, I want to approach from an underexplored angle the problem of divergence between the professor and the curator. I have been suggesting that in their wholesale emphasis on the dictates of viewer response, both parties have, ironically, left the education of the public behind. I believe that the general representational poverty of computer graphics and Web design—the new individualized mass media—presents an opportunity to collaborate and reformulate our troubled relationship. To that end, to demonstrate why making distinctions among *types* of formats matters deeply, especially today, I offer a brief reflection on the homogeneous polyglot of the Internet: the pseudo-genre of e-collage (my term for the boiled and blended visual products emerging from increasingly compressive electronic technologies).

The world is divided into two types of people: those who when they hear the word *collage* recall the textured *ars combinatoria* typical of Cubist, Futurist, and Dadaist works, and those who, increasingly, conjure up visions of friction-free e-commerce. Just what distinguishes today's coalescent e-collage from Pablo Picasso's and Georges Braque's overt gluing of shredded newspaper or chair caning onto canvas, Filippo Tommaso Marinetti's associational typography of words-set-free, Hannah Höch's seamed object-pictures, or Kurt Schwitters's sculptural juxtapositions of familiar with unfamiliar elements?

Too often, editing and morphing software transforms an anonymous hodgepodge into a single bland amalgam that looks variegated only to the most cursory glance. Fusive multimedia—that unstable patchwork of video, audio, text, animation, and graphics collected within an electronic interface—tends to mask the identity of the distinctive genres that constitute it. Blur results when velocity, intangibility, and a welter of hyperlinked entities melt down into an indissoluble megamedium.

I am not launching into a Luddite lament for the loss of a prior intersective aesthetics, nor am I reminiscing nostalgically about the tangible union of

bundled substances thriving before the dawn of today's digital chaotics. I do want to suggest, however, that not all bits are created equal. There are real consequences when pervasive computer-based operations go out of sight and out of mind. In the vast and flickering reaches of cyberspace, whose geometric structure is generally not visible to the users trolling through it, the ideal of a suture-free flow of data reigns. The old contiguity of inlaid detritus out of which early-twentieth-century assemblage was built has given way before the new connectivity of objects and people teleported from afar and denuded of their corporeality. As virtual places or electronic addresses without physical location, the evanescent sites composing this "transarchitecture"[8] open recursively onto vistas of links leading playfully to other links in a continual cascade.

One of the obvious effects of information technology has been to make transactions of all kinds appear smoother. The miracle of the Internet—functioning simultaneously as interlace and labyrinth—is its open-endedness, its collaborative invitation to viewers to clip, recirculate, and reedit messages with easy creativity into a potentially infinite number of customized versions.[9] A drawback of this permeability and malleability is the erasure of distance and the capacity to spread virtually anything swiftly by contagion. The absorption of a segmented space into a crystalline cyberspace collapses formal, geographic, and personal boundaries. Given the enormity of the Internet's precincts, retaining some borders might counteract the feeling—quite common among its navigators—of being overwhelmed, disoriented, and distracted. Collage, unlike e-collage, reminds us that important developments often occur at the *material* edge and on the tactile margins, whether we are speaking of nature, culture, bodies, communities, or design practices.

The distributed and mentalized digital environment, which slides strangers instantaneously into proximity but does not situate them face-to-face, "fits" far-flung appearances together in fluctuating and transient ways. In addition to the loss of spatial particularity, there is the shock of *temporal* disjunction as well. Walter Benjamin described this rupture as the sudden intrusion of a forgotten past[10] into the onward march of the present. The Net's etherealization and elision of sensory relationships differs dramatically from the modernist creation of an impermanent "in-between" realm through three-dimensional collage, where the viewer is constantly made aware that a picture or object is a haptic relation of unlike things. In the collage and assemblage, what we see, touch, smell, and even hear subjectively acts as a shareable bridge to a phenomenal

world always in the process of becoming.

A case in point is the encyclopedic chamber shaped by Kurt Schwitters from 1923 onward inside his Hannover house.[11] The remnants of this complex *MERZbau*, partially reconstructed within that city's Sprengel Museum, are unexpectedly dazzling. Dreary black-and-white reproductions in art-history textbooks routinely misrepresent the shining whiteness and dashes of primary color lighting up this concrete ambience, transforming it into murk. Illustrations also tend to straighten the skew of its montaged reliefs and jutting column—elements resembling nothing so much as the slant of Hermann Warm's film sets for *The Cabinet of Dr. Caligari*. The representational features of German Expressionism, however, have been sieved through the purifying grid of Russian Constructivism and the linearism of De Stijl chromatics. Distortions have turned abstract, filtered through El Lissitsky's[12] and Laszlo Moholy-Nagy's dynamic stereometries or Theo van Doesburg's globalizing diagonals.

Not unlike his boxy *MERZ-Bild 31* (1920)—a pinwheel composed of a perforated tin-can lid, paper slivers, tickets, cardboard, tulle, and other fabric scraps—Schwitters's continually augmented architectural project struggled to reembody an artificial space in danger of being vacated. His smaller relief constructions contain bits of industrial waste, used and discarded materials, the ruins of ordinary life, grafted onto the deracinated mentalese of Suprematist painting, where streamlined hardware floats like gravity-defying aliens within a generic void. Similarly, in his large coordinated habitat, the borders subtly dividing niches from compartments, photographs from wood, arrest the observer's attention and invest a steady stream of effects with particularity. This desire to reintroduce palpable presence into a universe shot through with hermetic machinery lies, I believe, behind the artist's statement about Merz made in 1924—namely, that he wanted to incorporate more reality into the image: "Merz means to create connections, preferably between all things in the world."[13]

Automatically smoothed computer graphics, slipping down the road of invisibility, stand at an antipode from Schwitters's thicker, segmented, and detailed cabinet of curiosities.[14] It is not necessarily true that hybrids hide the heterogeneity of their components. But often they do: on a computer monitor, elements from a real-world object can easily be mingled, stretched, twisted, flattened, increased, or diminished without the user knowing how it was done. This is both the beauty and the problem of hyperactive digital media. While classic collage sent complex messages that changed the way viewers thought about the

world, polymorphous electronic mélange—to which no one commits and which no identifiable person generates—seems less art and more game theory. Contrast the seamlessness of online simulation with the marriage of the mechanical and the natural in Fernand Léger's staccato painting *The City* (1919, Philadelphia Museum of Art), which reconfigures urban experience as kinetic jolts of discrete, brightly colored fragments.

The morphing of disparate data is exacerbated by the exponential expansion of electronic markets. Corbis Corporation, the privately held company that Bill Gates founded in 1989 to be a preeminent electronic repository of great images, aims to "capture the entire human experience throughout history"[15] and unfurl it on World Wide Web sites. As his mission to gain supposedly nonexclusive rights to sell digital images extends to greater numbers of museums and private holdings, more and more graphics are being removed from the public domain. Such omnivorous, undiscriminating acquisition—a sort of cartel e-collage —mimics the falsely unifying optical styles it encourages. I am reminded of "splattervision," or taking everything in without focusing; "scanning," or viewing entirely in one sweep, and "zeroing," or the subsequent mass focusing and selling of everything that has been collected.

This relentless hoarding and electronic translation of images of all kinds has many implications, including limitations on "fair-use" rights to employ digital images freely for educational and scholarly purposes. While Microsoft's more-than-casual interest in content is being scrutinized, the perceptual impact of such amassing and "integrating" of disparately instantiated data by a single provider and through a single mode of reproduction is not. Such reductiveness parallels at a corporate level the thinned compositional diet of Impressionism at the museum-blockbuster level. To be sure, the Bettmann Archive—which Gates now owns—formerly reduced etchings, lithographs, oil paintings, and Depression-era photographs to the same medium of black-and-white photography—or, rather, re-photography. But the sheer scope of the appropriation, the simulating power of the operating system, and the control vested in one umbrella organization sets contemporary cybercorporation mergers and their controlling strategies apart from old-fashioned "collaging" picture troves like Bettmann and Alinari. Far from being interested solely in developing platforms and tools, Microsoft seems bent on making it impossible not only to convert to other software (the "lock-in" factor) but even to envision the plural modalities assumed by sensory information prior to encoding.

Like the covert coordination of intangible assets and the manipulation of dematerialized strategies required to play and win in a networked society, reductive aggregates merely simulate the appearance of cooperation between real people and physical events. What is eliminated from both is situated demonstration. How does the individual reconcile the collection and display of constantly evolving information with a personal struggle to make sense of changing patterns? A partial answer is offered by Jeff Wall, who, among contemporary artists, has thought most extensively and deeply about the importance of representative generic constructions, figure typologies, conventional stories, and ritualized gestures: "Depictions are generic because, over time, themes, motifs, and forms bear repetition and reworking, and new aspects of them emerge in that process. Genres are forms of practice moulded slowly over time like the boulders shaped by water, except that these formations are partially deliberate, reflexive, and self-conscious."[16] This observation helps focus the problem concerning current practice—namely, that it has swept together two antithetical concepts of gathering and disseminating multiples. The producers of early-twentieth-century assemblage and montage recognized, like Marcel Duchamp, that creativity operates in a field of givens, of readymades,[17] while latter-day digital *bricoleurs* extol the efficiency of the hypermeld.

The dizzying propagation of visual culture on the Web looks oddly the same. As I stated in my opening comments, curators have to look at the Internet as more than a source of virtual advertisements for marketing their collections or as a "supplementary portal of value"[18] to attract more paying visitors. And professors must reconsider the importance of teaching generic distinctions. Working together inside and outside the museum, then, we have a prime opportunity for a joint educational project based on complicating the available formats not only of an increasingly electronic art history but of a user-response-driven global culture.

1. This was explored briefly in a panel discussion with Neil Harris, Thomas Krens, Alberta Arthurs, and Catherine David: "The Social and Cultural Dimensions of Public Policy on the Arts and Humanities: The Responsibilities of Museums in the Age of Globalization," as part of a conference called "The Arts and Humanities in Public Life," held at the University of Chicago on January 22 and 23, 1999.

2. The term is Ada Louise Huxtable's in "Museums: Making It New," *New York Review of Books*, 22 April 1999, 13.

3. Richard Kurin, "The Distribution of Ethnographic Music on the Web," presented at the panel "Economics of Arts and Humanities Policy: Property Rights in the Information Age," as part of the Chicago "Arts and Humanities in Public Life" conference.

4. Alan G. Artner, "2001: City Cleared for Art Odyssey," *Chicago Tribune*, 12 March 1999, 1.

5. Artner, "2001," 22.

6. Glenn D. Lowry, "The State of the Art Museum, Ever Changing," *New York Times*, 10 January 1999, 40.

7. It was launched by Ernst Gombrich's stress on the beholder's share and refueled during the next decade by the reader-response theories of Wolfgang Iser and Stanley Fish.

8. The term *Internet* was coined by a UCLA professor of architecture, Marcos Novak.

9. Barbara Kirshenblatt-Gimblett, "The Electronic Vernacular," in *Connected*, ed. George E. Marcus (Chicago: University of Chicago Press, 1996), 32.

10. Miriam Bratu Hansen, "Benjamin and Cinema: Not a One-Way Street," *Critical Inquiry* 25 (winter 1999): 311.

11. *Kurt Schwitters: Werke und Themen—Besucher-Information* (Hannover: Sprengel Museum, 1991), 11.

12. See esp. El Lissitzky's *Kabinett der Abstrakten* of 1926–28, at the Sprengel Museum. Drawings for this system of sliding screens and fluid walls can be seen in *The Museum as Muse: Artists Reflect*, exh. cat. (New York: Museum of Modern Art, 1999).

13. *Kurt Schwitters*, 11.

14. In my *Good Looking: Essays on the Virtue of Images* (Cambridge: MIT Press, 1996, 1998), 68–81, I develop the connections between the non-linear systematics of the early-modern cabinet of curiosities, the Macintosh toolbar, and the Internet.

15. Goldie Blumenstyk, "Colleges Wonder If Microsoft Is Their Next Competitor," *Information Technology: Microsoft's Reach*, in *Chronicle of Higher Education*, 24 April 1998, special section.

16. Thierry de Duve, Arielle Pelenc, and Boris Gruys, "Interview," in *Jeff Wall* (London: Phaidon, 1996), 14.

17. Dalia Judovitz, *Unpacking Duchamp: Art in Transit* (Berkeley: University of California Press, 1998), 7.

18. Steven Henry Madoff, "Where the Venues Are Virtually Infinite," *New York Times*, 10 January 1999, 41.

THE EXHIBITION AS
DISCURSIVE MEDIUM

Eloquent Walls and Argumentative Spaces: Displaying Late Works of Degas

Richard Kendall

An exhibition is a visual event, often—but not inevitably—accompanied by words. An art book or catalogue, in contrast, is primarily a verbal event, often—but not inevitably—accompanied by images. Defined in this way, the exhibition and the scholarly publication are seen as antithetical, or perhaps as polarized extremes of a wide spectrum of communication. In practice both kinds of event rely on a complex fusion of the visual and the verbal: as we look silently at paintings in a gallery, we invoke words, phrases, and more or less sophisticated concepts to help us articulate what we see and feel; and as we study a catalogue text, a flood of remembered images invades our experience of reading. Technological wizardry has further narrowed the gap, presenting us with sequences of superb color reproductions—in effect, miniature exhibitions—on the printed page, and integrating audio tours, continuous videos, and elaborately conceived and illustrated storyboards with the exhibition space. But the divide still yawns, and legends persist: catalogues are for specialists, bought by the many, read by the few; a book is the proper place for new ideas to be propounded, for information to be enshrined, and for freshly scrutinized works to be documented; the walls of the art gallery are hung to please the crowds. In the context of the exhibition, this intermediate area between word and image has another, somewhat ill-defined dimension: that of the installation itself, and the possibility that nonverbal factors might embody or project the explicitly academic ambitions that lie behind it. Can the manipulation of light and space, the disposition of objects, and the sequencing and shape of rooms direct us to a curator's thinking? While the choice of works will always dominate the generation of meaning,
to what extent can the juxtaposition or separation of individual pictures and sculptures communicate new notions about them? How can purely visual presentation—working alongside and in tandem with the ubiquitous printed, electronic, and hybrid expedients of our age—create equivalences for intellectual perceptions?

Degas: Beyond Impressionism, which opened at the National Gallery in London and traveled to the Art Institute of Chicago in 1996, was a test case in a number of respects.[1] The first major project to deal exclusively with the art of

Edgar Degas's later decades, it aimed to bring a mostly unfamiliar body of work to the attention of a wide audience and to propose a number of new readings of his achievement. From the beginning, then, revisionism was in the air. Second, both exhibition and catalogue emerged from an unusually sustained period of cooperation between the academy and the museum in which I, as guest curator, was welcomed to almost every stage of the institutional planning process.[2] While conducting research, seeking out pictures and sculptures, and writing the accompanying catalogue, I also took an active part in the design of the London installation and its associated features, contributing to—though not necessarily determining—decisions about gallery layout and picture location, vitrine style and hanging levels, color and typography, audio and video scripts; in the filmed sequence explaining Degas's tracing methods, my hands were even seen holding the charcoal.[3] Finally, the nature of the exhibition space in the Sainsbury Wing at Trafalgar Square offered an immediate challenge to the scholarly program. Divided into six medium-scale, haphazardly shaped rooms with fixed walls, this area defined not just the size of the show (some ninety objects) but important aspects of its identity. So distinct and inflexible are these rooms that they cannot be fought, but must instead be turned to advantage. At an early stage, I proposed that six discrete themes should be chosen from the pictorial and historical materials being gathered, one for every room, each tailored to the size and character of the space in question.[4] Necessitating the omission of other themes and therefore other works, this proposal offered an early—if somewhat rudimentary—example of the interaction between image and idea at a practical level. To assess the relationship between the installation and the academic project in the case of *Degas: Beyond Impressionism*, it is necessary to stand back from the 1996 event and expand a little on its origins.

The proposal to embark on an ambitious show of Degas's late oeuvre was first made around 1989 and was prompted by a number of factors. Work on earlier publications and exhibitions had convinced me that responses to Degas's career had become seriously distorted in favor of his formative years and, in particular, the period of his involvement with Impressionism. In the scholarly literature as well as the popular imagination, Degas was seen almost invariably as a "painter of modern life," identified with subjects from the 1870s and 1880s that had been noted by his contemporaries: "racehorses, ballerinas, and laundresses," according to Jules Castagnary; "café-concert singers, women outside a café, and women at their toilette," following Georges Rivière.[5] Degas's work after about

1890, however, was habitually overlooked, with only isolated late canvases or pastels attracting notice and even fewer efforts made to understand them in their changing times. Despite the fact that Degas lived for another quarter-century, and in contrast to the published outpourings on his middle years, there were no specialist studies, no monographs, and barely a handful of articles devoted to this final phase, which was typically glossed over with references to his declining eyesight, his anti-Semitism, and his supposed retreat from the art world.

The more I worked on Degas's later life and art, the less satisfactory this account seemed to be. The works of the 1890s and early 1900s—with their blazing colors, radical graphism, and emphatic forms—seemed to cry out for attention, just as they resisted any attempt to comprehend them as latter-day "modern-life" subjects. New and not necessarily comfortable meanings seemed implicit in their structures, and a fresh understanding of their fabrication and earlier currency was clearly overdue. Encouragement came from discussions with colleagues who shared some of these views, among them Jean Sutherland Boggs, the initiator and principal curator of the groundbreaking Degas retrospective shown in Paris, Ottawa, and New York in 1988 and 1989.[6] In the last section of this exhibition, Boggs brought together an astonishingly grand and diverse array of late drawings, prints, photographs, pastels, paintings, and sculpture, revealing the exceptional vigor of the artist's final years as well as an unmistakable shift in his procedures. As with many of the best exhibitions, the 1988 show posed as many questions as it provided answers, and the case for further historical and thematic research seemed irresistible. Whereas the retrospective brought coherence to the late phase by locating it in the continuum of Degas's career, the new challenge was to see it in all its separateness.

One of the unifying themes running throughout the six chapters in my exhibition catalogue was the transformation of Degas's art and practice in these last years. In this view, many of the fundamental premises on which his imagery in the Impressionist period had been based and through which it had come to be understood—the representation of authentic, contemporary experience, for example, or the use of unorthodox materials—had been progressively abandoned toward the late 1880s. In their place a different set of priorities had appeared, some evolving gradually from the concerns of his early career but many seeming to contradict the qualities that had become so fixed in the academic and popular mind. After the era of Impressionism, for example, we find the artist narrowing his range of subject matter drastically, effectively turning his back on many of the

themes itemized by Castagnary and Rivière in favor of just two principal motifs: women at their toilette and dancers at rest. Similarly, the practical pyrotechnics of the 1870s were replaced by a dogged return to charcoal, pastel, and oil, now enhanced by an idiosyncratic approach to serial production based on the use of tracing. After the breadth of his middle years, it seems, Degas had turned into a pictorial obsessive, returning endlessly to the same compositions even as he pushed his now more limited means to expressive extremes.

So crucial were these issues that I argued at the planning stage for their incorporation into the exhibition's fundamental design. Not only was each space to be devoted to a clearly defined theme, but in certain rooms Degas's stubborn relationship with his motif would be reflected in a sequence of works on a single subject: for example, in room 3 were images of women dressing their hair, and room 4 contained a suite of female bathers. Care was taken also to represent the characteristic media of these years—notably pastel, and charcoal on tracing paper—even though this might mean the exclusion of a more finished or elegant object in favor of a working drawing. Rather than attempting to repeat the highly successful 1988 show, I wanted emphasis to be placed on related clusters or sequences of images that brought the viewer close to Degas's own technical procedures.[7] Research had shown that the elderly artist produced all his drawings, paintings, and wax sculptures in a single ill-lit, cluttered studio, laboring at ranks of intimately linked pastels and carrying motifs from one medium or dimension into another with a kind of incestuous abandon. Hanging some of these groups in the exhibition galleries close together allowed their interrelatedness to become apparent, and installing bronze casts in close proximity to paintings and works on paper proposed further kinships. Low light levels and dark-hued walls intensified the experience, implicitly stressing the hermetic, self-referential nature of Degas's late creativity.

In common with most exhibitions, however, certain issues explored at length in the text of *Degas: Beyond Impressionism* proved unsuitable for translation into the language of the installation. A discussion in chapter 2 concerning Degas's intricate and little-studied dealings with the art market after 1890, for example, might have been condensed into a storyboard or included in a spoken commentary, but it held out few hopes for immediate visual expression. If the equally underestimated significance of the artist's revived interest in the techniques of the Old Masters was everywhere in evidence on the walls, it too favored verbal rather than graphic exegesis. Even Degas's serial processes and the use of

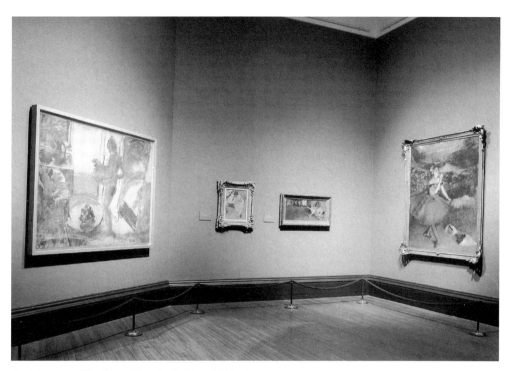

Fig. 1. Room one, "The Years of Transition," of the exhibition *Degas: Beyond Impressionism* at the National Gallery, London

tracing paper—another prominent theme in the catalogue—could hardly be addressed directly, as limited space in the galleries precluded the kind of technical display for which the National Gallery has become so celebrated.

When the exhibition plan was completed, the topic chosen for the introductory room (fig. 1) was both central to the art historical argument and unequivocally visual in character. Titled "The Years of Transition," this space encapsulated the restlessness of Degas's art in the 1880s and early 1890s, setting it apart from most of the paintings and sculpture to be found in subsequent galleries. Appropriately, this quality was reflected in the room's design and appearance, which was more asymmetrical as an arrangement and less penumbrous than spaces devoted to the late work proper. To underline this shift the walls were painted in a cool blue-gray, offering maximum contrast to the darker, warmer colors of the rooms beyond, which were visible from most points in the initial room. The variety of Degas's work of the period was evident in the range of scale and finish in nine pastels and oils; in the diversity of subjects, from portraits to genre scenes, ballet performance to bathrooms; and in the contrast between intimate images and publicly ambitious pictures. This was the Degas known to

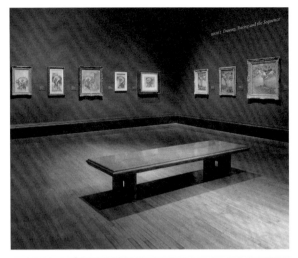

Figs. 2 and 3. Room two, "Drawing, Tracing and the Sequence," of *Degas: Beyond Impressionism*

millions, still recognizably the artist of the Impressionist group shows and the skilled painter and draftsman who took delight in his versatility. Large paintings like the Art Institute's *Millinery Shop* and the National Gallery's *Hélène Rouart in Her Father's Study* showed that oil on canvas remained a central concern at this date, while virtually unknown images—such as the stark lilac, pink, and green *Dancer with Bouquets* from the Chrysler Museum of Art (in Norfolk, Virginia)—hinted at audacities yet to come.

As they stepped into room 2, visitors began their encounter with a different, less glamorous Degas (figs. 2 and 3). Under the title "Drawing, Tracing and the Sequence," more than twenty similar-scale works of art were hung in clearly defined groups, all but two in charcoal and pastel on paper and the majority in related series of bather or dancer motifs. Now the walls were deep reddish brown, approximating the color of Degas's last studio and allowing his pastels to glow with the multihued brilliance that must have accompanied their making. Hung side-by-side, three variants of the same traced composition—*Red Ballet Skirts* (Glasgow Museums, Burrell Collection), *Three Dancers in Yellow Skirts* (Cincinnati Museum of Art), and *Three Dancers* (Ordrupgaard, Copenhagen)—marked the distance of Degas's color from the descriptiveness of Impressionism and spoke eloquently of its late liberation. Nearby, a family of studies for the larger pastel on paper *Dancers* (formerly Reader's Digest

Fig. 4. Room three, "Combing the Hair," of *Degas: Beyond Impressionism*

Association, Pleasantville, New York) revealed the jigsaw-like piecing together of his complex compositions and the monochrome beginnings of these sumptuous images. This passage from line to color was summarized in a progression of six charcoal drawings of nude bathers, forming a Muybridge-like panorama along one wall and establishing a creative principle to be explored in later rooms.

For practical reasons we decided to avoid the use of storyboards and information panels in the galleries, leaving only object labels and room titles on the already richly hung walls.[8] Audio tours were made available and a specially commissioned video was shown regularly in an adjacent viewing theater, while an illustrated leaflet derived from the catalogue text was given to visitors as they entered the exhibition. In an additional sense, therefore, this installation was an extreme case, relying relatively little on a common verbal narrative and a great deal on the imaginative responses of the audience to the display as a whole. Some elements of the exhibition, it might be argued, were self-suficient and self-explanatory in these circumstances: room 3, for instance—dedicated to drawings, pastels, and paintings of women combing their hair—offered direct access to the artist's sensuous handling of his materials and the inventive treatment of a familiar, timeless activity (fig. 4). Encompassing the mundane and the monumental as

well as the transcendent (the last in canvases from the Oslo Nasjonalgalleriet and the National Gallery—both called *Combing the Hair*), this display of just eight pictures revealed the obsessiveness of the late Degas in a vivid and seemingly uncontroversial form.

The largest space in *Degas: Beyond Impressionism* was set aside for pictures and sculptures of women bathing, the single most persistent image in Degas's last decades (fig 5). This gallery, which contained some of the most spectacular loans,

also amplified the issue of the unmediated sensual consumption of the works on display. In the wealth of critical commentary on his middle years, Degas's representation of the female nude has been a recurring and much contested topic, suggesting unregenerate traditionalism to some, abject or sinister voyeurism to others, and a proto-modernist concern for emancipated form to writers of varying persuasions. Here, for the first time, the debate was transposed to the late phase of the artist's career, in a group of some of his largest sculptures, in such haunting canvases of the mid-1890s as

Figs. 5. Room four, "Women Bathing," of *Degas: Beyond Impressionism*

After the Bath, Woman Drying Herself (Philadelphia Museum of Art) and *Woman at Her Bath* (Art Gallery of Ontario), and in large and dramatic charcoals and pastels. If the scholarly controversy could not be addressed explicitly, the almost oppressive, fixated nature of Degas's final engagement with the female body was unavoidable, as was the expressive role played by his studio procedures in this protracted dialogue. A figure that first appeared in a bronze might resurface in a drawing or an oil, as if pursued relentlessly—even frenetically—from medium to medium, while gestural boldness in wax or pastel seemed to become inseparable from largeness of physique.

Several features of the gallery itself contributed to this complex exchange. Resembling the high, capacious structure of an artist's studio—and, coincidentally, approaching the dimensions of the space used by Degas at the time—room 4 came closest of all the rooms to suggesting his intense working environment, where two- and three-dimensional images accumulated in profu-

Fig. 6. Room five, "The Role of Sculpture," of *Degas: Beyond Impressionism*

sion and fed off each other's idiosyncrasies. The somber walls and dense hanging evoked something of this atmosphere, as did efforts to link associated subjects and juxtapose sculptures with pictures of similar motifs. A similar ambition provided the focus for room 5, where the proposal that Degas used his wax statuettes as models for drawings and other works, and not vice versa, was set out in unprecedented detail (fig. 6).[9] Nowhere in the exhibition was precise selection

and installation so critical to the ideas at issue, demanding higher-than-usual vitrine heights, exact alignments of objects and—with certain examples—extreme proximity between pictures and sculptures. Although historical and critical discussion remained confined to the catalogue, audiotape, and leaflet, an alternative mode of argument, conducted in purely visual terms, was in effect offered to visitors.

How do we evaluate the success of such an exhibition, especially in the elusive terms this essay has tried to explore? The task may well be impossible, as each of the straws we grasp at proves less buoyant than the last. Critics of both the London and Chicago shows were generous in acknowledging the novelty as well as the power of the work on view, while a new elucidation of themes, techniques, and preoccupations was detectable in certain of their texts.[10] But critics can be suspected—sometimes unjustly—of spending time on the study of catalogues, leaflets, and press releases, and thus privileging the word over the evidence of their eyes. Attendance figures in both cities far exceeded expectations, but again the testimony of a half million visitors could be ambiguous. Museum audiences often claim to be oblivious or indifferent to precisely those concerns—wall color, lighting, label length, and gallery design—that so preoccupy curators, and even the most subtle questionnaires have yet to distinguish between perceived and received wisdom among exhibition crowds. Ultimately, perhaps, we are thrown back once more on the works of art and the exhibition's capacity to animate them for a new generation. Each of the objects in *Degas: Beyond Impressionism*—as in any other installation—is changed in our perception with the passage of time, sometimes by default, sometimes through the reading of an incisive text, sometimes by the company it keeps. It is a central tenet of both art histories—or if it is not, it should surely become so—that where these encounters are fueled by scholarly energy and visual conviction, preferably working in close conjunction, they are more likely to leave their mark.

1. Richard Kendall, *Degas: Beyond Impressionism,* exh. cat. (New Haven: Yale University Press, 1996).

2. Credit for this cooperation is principally due John Leighton (then curator of nineteenth-century painting at the National Gallery), now director of the Van Gogh Museum in Amsterdam, and Michael Wilson, head of exhibitions at the National Gallery.

3. This was made possible by many members of the National Gallery staff, led by Herb Gilman, exhibition designer, and members of the gallery's video unit.

4. For reasons explained below, the chosen themes did not all correspond directly to the six chapters of the catalogue. The subdivisions in the exhibition did, however, determine the arrangement of plates in the catalogue, where each section was introduced by a short essay on the theme in question.

5. Quoted in Kendall, *Degas*, 125.

6. Jean Sutherland Boggs, *Degas,* exh. cat. (New York: Metropolitan Museum of Art, 1988).

7. For obvious reasons, a number of major works included in the 1988 exhibition appeared also in 1996, alongside many less familiar or previously unexhibited pictures. The linking of modest groups of images had been attempted in certain previous exhibitions, although never on this scale or as part of a separate, extended study of the issue.

8. Limited wall space was a factor, as was the apprehension that storyboards would cause congestion at certain points in the galleries.

9. As with many other issues discussed in this essay, the detailed background and full references can be found in the pages of the exhibition catalogue. Sculpture and two-dimensional works by Degas had been juxtaposed in a number of earlier exhibitions, but the argument had never been addressed as specifically or extensively.

10. The installation at the Art Institute of Chicago, while following the broad pattern of that in London, was the work of a different design team and included a much larger introductory section.

Telling Stories Museum Style

Mark Rosenthal

Who among us has not had the student's experience of writing a paper about a work of art and then suffering a feeling of deflation on reading it before the object itself? The ideas—so fiercely held and agonizingly crafted into language— fail to resonate in the work. In its mute eloquence the image simply cannot be contained by the words conjured by the writer. This same humbling disappointment forever haunts the curator, who has learned to distrust the place and placement of the word vis-à-vis the art object.

At various times in recent history—for instance, at the Robert Ryman retrospective at the Museum of Modern Art in 1993—the artist and the curator, Robert Storr, went so far as to drop labels from the installation altogether, providing information only through the gallery handout. The purpose, it seemed, was to encourage silent communication by the viewer, while discouraging the common search for help with the visual experience through the vehicle of words placed alongside the art. What was to be learned at the exhibition, then, would be communicated only nonverbally. Note the sentiments of the critic Peter Schjeldahl with respect to another exhibition:

> Wall texts are a bane of late-twentieth-century museology, turning art shows into walk-in brochures. We can't help but read them . . . and thus are jerked from silent reverie into nattering pedagogy. Art and education are terrible bedfellows. They don't even like each other. Their congress makes for bad sex in the head. The unwary viewer of a label-larded exhibition . . . incurs the grimmest of mental states: edification.[1]

For the curator, the supremacy and inalienable rights of the work of art become a premise written in concrete. The object's reality and impact, its elevated and judgmental position in relation to the word, are unchallenged. This status does not mean that art history, critical theory, sociological investigation, and even speculation have no place in our engagement with the work of art—only that when these pursuits are placed side-by-side with the work of art, they pale, inevitably failing to "speak" with an eloquence that rivals that of the work. Is this premise sacred? For the time being, few curators question it.

Another old shibboleth that retains authority is the rhetorical query put to the young curator by the wizened museum veteran: "Isn't your idea for an exhibition really better as a book?" In other words, an exhibition is not an essay. Each genre is approached in a different manner, and the exhibition must make its own kind of narrative sense, discursively and intellectually, through the visual experiences to be had in the galleries of the museum. It is for this reason that an exhibition and its accompanying catalogue do not have a steadfast relationship to one another. In some cases, the catalogue may accord precisely with the exhibition, providing explanations of the curator's decisions, offering extended entries about each work shown, and reproducing only those. That is the traditional exhibition catalogue, but this genre has evolved under pressure from commercial publishers who want to veil its appearance for the simple reason that a catalogue, or record, of an exhibition is less sellable than a book. What results is a publication in which the curator puts forth an examination of the subject without being limited by the contents of the exhibition. Still, even for this type of volume, the curator will have seen and compared virtually every relevant work and thus will have his or her thinking shaped before the work of art.

Whereas the art historian is like a novelist, having virtually limitless space that allows for a profusion of digressions, the curator can be compared, in part, to a film director, who must operate within temporal restrictions in conveying stories. For them, contexts may be subordinated in favor of characters and relationships. Juxtaposition and installation become essential tools in the curator's bag of tricks, by which visual dramas are staged and insights generated.

In 1996 I organized an exhibition titled *Abstraction in the Twentieth Century*.[2] It was a theme I had dreamed of exploring for over twenty years, and I had spent five years pondering the manner in which it might be presented. Since no one had ever attempted this enterprise, I saw myself as a mapmaker, charting a terrain for the first time. (Of course, people had written about this history, but shockingly little.) I realized early on that for my purposes and pleasure I had no interest in making an encyclopedia; that was for a bookshelf, not an experience on one's feet. Indeed, I myself would have had no interest in seeing such a thing—three hundred works by three hundred different artists. Such an exposition could hold my interest only if I were checking off entries in a stamp collection, not learning about the phenomenon of abstraction in its broadest visual sense. We hardly read straight through an encyclopedia, but we do, ideally, meander through an exhibition in its entirety.

My purpose in the exhibition was to offer a first overview of this pan-twentieth-century movement, to draw its most prominent contours and crucial juxtapositions, using the installation to allow the works of art to relate a rich and often surprising art historical narrative. The three contemporaneous pioneers—Wassily Kandinsky, Kasimir Malevich, and Piet Mondrian—were arrayed in depth and compared. Jumps through the century proved enlightening, as well—these leaps aided by the special capacity of the Guggenheim Museum's architecture, to allow viewing across great spaces. Scanning the museum's spiraling ramp, one could, from a single standpoint, take in Malevich's paintings and Richard Serra's sculptures, or works by Dan Flavin and Vladimir Tatlin—both pairs of artists were included in a single exhibition for the first time anywhere. Olga Rozanova's green-stripe painting could finally be seen in proximity with Barnett Newman's *Zip*. Typical of the uniqueness of these juxtapositions was a comment made to me by both Ryman and Ellsworth Kelly—namely, that their work had never been shown together in an exhibition. These two contemporary abstractionists—long pigeonholed, respectively, as Minimalist and Color Fielder—had not been seen for their basic shared historical lineage and the ways in which they related to that background. The exhibition is the most effective medium to enable the discovery of such relationships—or differences—and this potential shapes its methodology. Hence, placing a white canvas by Robert Rauschenberg beside one by Barnett Newman offered an extraordinary opportunity to examine how the artists' works and ideas jibed with and contradicted one another. Of course, at a later time, another curator will undoubtedly attempt to shape the story of abstraction differently in an exhibition, emphasizing other artists, bringing out other qualities in the works. My own attempt to extract a reading from these relationships lives on in the catalogue essay, but this is by its very nature an inadequate substitute for the experience of the exhibition itself.

Some purposes are best served through the viewing of a body of work, rather than through the vehicle of the written word. For instance, an exhibition can make a highly effective case for a neglected period of an artist's work, or for an unknown or little-known individual. A splendid example is Gert Schiff's *Picasso: The Last Years, 1963–1973*,[3] an exhibition at the Guggenheim Museum in 1983. Up until then, this period of Picasso's painting had, when it was not being derided, been mostly ignored. Though the exhibition was hardly a raving success at the time, it had the effect of putting a new focus on Picasso's late work; many exhibitions and studies followed, with the result that the art gained new students and admirers.

The curator's principal activities—exhibition and acquisition—are especially influential with regard to contemporary art, allowing the artists to be evaluated on a firsthand basis by large numbers of viewers. The decision by Alfred Barr on behalf of the Museum of Modern Art to purchase four paintings by Jasper Johns from his first exhibition in 1958 did much to trigger quick recognition and evaluation of this seminal artist's work. Harald Szeeman's 1969 exhibition, titled *When Attitudes Become Form*, at the Bern Kunsthalle, helped to crystallize the character and dimensions of Post-Minimalism.[4] The 1979 Joseph Beuys retrospective at the Guggenheim Museum ushered in two decades of intense scrutiny and celebration in America of contemporary German art, following many years of indifference.[5] A comparable impact was produced by Katharina Schmidt's 1996 exhibition *Canto d'Amore*, at the Basel Kunstmuseum, where this century's commingling of artistic and musical aesthetics was revealed in a tangible and memorable way.[6] I hasten to reiterate that such exhibitions most often are born out of the curator's encounters with works of art rather than by his or her reading texts about them.

Exhibitions devoted to an individual contemporary artist are often the result of a greater or lesser degree of collaboration between curator and artist. Once, in a conversation with a colleague whose specialty is eighteenth-century French painting, I mentioned that I had just submitted an essay to an artist for his response to my observations about his work. My friend was horrified, saying he would hardly want to have Fragonard comment on his own essay. But that is a matter of necessity for the curator of contemporary art; recall the notorious 1986 interview between Benjamin Buchloh and Gerhard Richter,[7] in which the critic asserted numerous ideas about the artist's work, and Richter doggedly rejected every one. Should not my colleague want to hear what Fragonard had to say, or to have had the opportunity to ask Michelangelo his response to Leo Steinberg's discussion of the *Last Judgment*? After all, besides interpretation and analysis, there are possibilities for realizing intention and factual information. The curator's opportunity with the artist is so full of potential, it must be exploited even at the risk of ego damage as the soundness of his or her ideas is tested. Who could fail to concede the truth of—and not admit one's own position in relation to—Barnett Newman's famous formulation that "aesthetics is for me like ornithology must be for the birds."[8] While an art historian, the curator must be wary of becoming an ornithologist as well. Hence, the living artist deserves to have a heavy hand in his or her exhibition, both the concept and shape of it

as well as the catalogue. Think of a city planner or social engineer redoing a community without consulting its inhabitants. Their interests are undeniable and inalienable.

Up to now I have focused on the advantage of the exhibition over the written word. But by their nature, exhibitions also have obvious limitations—the perfectly realized set of choices existing only in a tray of slides, where color and scale leave much to be desired, and ideas about issues outside the literal frame of the object can hardly be elaborated sufficiently in wall text. *Qu'est-ce que la sculpture moderne?*, at the Centre Georges Pompidou in Paris in 1986, presented opposing inclinations toward either nature or civilization.[9] A wonderful departure point for a written discussion, the argument was not sustained by the works of art themselves; indeed, the "voices" of the objects could virtually be heard contradicting the accompanying wall labels and didactic installation.

The Pompidou's sculpture show is one of many that effectively drives home the inherent difficulty of a theme exhibition, in which the curator's point of view overrides the testimony of the works. First of all, the viewer is pulled in two (often divergent) directions, now toward the art object, now toward the frame of reference created by the curator. (I have never found any curator's—or scholar's—ideas equal to the compelling force of a great work of art.) Second, discursiveness is the sine qua non of the theme show, working against the aura of reverence and contemplation that is usual in a museum, or in a monographic exhibition in which the story is imparted solely by the objects. This is not to say that a theme exhibition will always diminish the work of art—only that the theme must be worn so loosely by the works that they can continue to express their creators' aspirations. Exhibitions with themes of chronological boundaries, movements, or subject matter are examples of less problematic types. *The Genius of Rome, 1592–1623* (Royal Academy of Art, 2001)[10] and *Art Nouveau 1890–1914* (National Gallery of Art, Washington, D.C., 2000),[11] are two such exhibitions in which the works do not illustrate a debatable curatorial thesis.

By contrast, a well-done monographic exhibition can seem naturally coherent. It offers the viewer an opportunity to review his or her salient thoughts about an artist's work, thanks to the incontrovertible evidence of the actual objects—consider, for example, the impact of the 1998 Jackson Pollock retrospective at the Museum of Modern Art in New York.[12] For the curator, a monographic exhibition demands humility before its subject. This type of exhibition must function as a biography, with all key moments accounted for, whatever the

author's assessment of or interest in them. Thus, I did wonder about the decision to eliminate the figurative paintings of Piet Mondrian in the American venues of the 1994–96 retrospective that started at the Gemeentemuseum in The Hague, which resulted in a distorted representation of his development.[13] At the same time, one must avoid being so inclusive as to risk exhausting the patience of the viewer and diminishing the impact of the artist's best works.

Finally, I must devote a word to the role of the museum as a natural hinge between the public and the art world; each has a different interest in the subject of aesthetics (art history, theory, and so forth). The curator's role is to manage the two, introducing one to the other, much as Robert Rauschenberg described himself as working the gap between art and life.[14] The museum professional keeps this in mind, as well as that public support maintains the very existence of the institution. If a museum were to resemble a scientific laboratory in which an audience was unwelcome or ignored, then there would be no future for the institution. Therefore, in practical terms, as well as from an idealistic point of view, museums seek converts—new art lovers. Of course, for those of us who are specialists in modern art, the missionary role is a familiar one. But the curator has in mind, too, the art-world side of the equation and the possibility of telling a story through the vehicle of an exhibition with such success that it instigates further examination and provokes new insights.

1. Peter Schjeldahl, "Springtime for Kiefer," *New Yorker*, 18 January 1999, 83.

2. Mark Rosenthal, *Abstraction in the Twentieth Century*, exh. cat. (New York: Solomon R. Guggenheim Museum, 1996).

3. Gert Schiff, *Picasso: The Last Years, 1963–1973*, exh. cat. (New York: George Braziller, 1983).

4. Harald Szeemann, *Live in Your Head: When Attitudes Become Form—Works, Concepts, Processes, Situations, Information*, exh. cat. (Bern: Die Kunsthalle, 1969).

5. Caroline Tisdall, *Joseph Beuys*, exh. cat. (New York: Solomon R. Guggenheim Museum, 1979).

6. *Canto d'Amore: Musik und bildende Kunst 1914–1935/Canto d'amore: Classicism in Modern Art and Music 1914–1935*, exh. cat., ed. Gottfried Boehm, Ulrich Mosch, and Katharina Schmidt (Basel: Öffentliche Kunstsammlung Basel, 1996).

7. "Interview with Benjamin H. D. Buchloh 1986," *Gerhard Richter: The Daily Practice of Painting, Writings 1962–1993*, ed. Hans-Ulrich Obrist, trans. David Britt (Cambridge: MIT Press, 1995), 132–66.

8. "Interview with Emile de Antonio," *Barnett Newman: Selected Writings and Interviews*, ed. John P. O'Neill (Berkeley: University of California Press, 1992), 304.

9. Margit Rowell, *Qu'est-ce que la sculpture moderne?*, exh. cat. (Paris: Centre Georges Pompidou, Musée National d'Art Moderne, 1986).

10. Beverly Louis Brown, ed., *The Genius of Rome, 1592–1623*, exh. cat. (New York, Harry N. Abrams, 2001).

11. Paul Greenhalgh, ed., *Art Nouveau: 1890–1914*, exh. cat. (New York: Harry N. Abrams, 2000).

12. Kirk Varnedoe, *Jackson Pollock*, exh. cat. (New York: Museum of Modern Art, 1998).

13. Yves-Alain Bois et al., *Piet Mondrian, 1872–1944*, exh. cat. (Boston: Little, Brown, and Co., 1995).

14. "Painting relates to both art and life. Neither can be made. I try to act in that gap between the two." Robert Rauschenberg, quoted in *Sixteen Americans*, exh. cat., ed. Dorothy C. Miller (New York: Museum of Modern Art, 1959), 58.

Repetition and Novelty: Exhibitions Tell Tales

Patricia Mainardi

I would like to expand the bipolar nature of this examination of the university and the museum by including a third element—namely, audience—for, like the moon that pulls the tides, audience exerts a profound influence on the kind of art history we produce. Only by introducing this element into our discussion can we adequately understand the relationship between the museum and the university.

The audience for the university is, alas, the university; we write for each other, we review each other's books, and our teaching is based on our own and each other's work. While we hope that our ideas will reach the general public, we rarely bring them there directly. That same public, however, is the direct audience for the museum. No matter how much museum professionals would prefer to address themselves primarily to other museum professionals or to university art historians, the nature of the medium within which museums work is public—and expensive—and so they must consider the attitudes and preferences of their audience when planning exhibitions.

Museums, at least in the United States, are obliged to attract the largest possible audiences, not only to swell the Ticketron receipts but also to patronize their gift shops and restaurants, whose sales help to underwrite the ever-increasing cost of mounting exhibitions. No matter how art historically significant a show may be, if it appeals only to scholars, it will not draw crowds; thus, the estimated body count of visitors is extremely important to museums when requesting funding, either from government or from private sources. And so museums try to serve both God and Caesar by alternating a few specialist exhibitions with crowd-pleasers, their efforts resulting in what seems to be an endless number of mediocre Impressionist shows. No matter how much we speak of the diversity of audiences as the paramount objective, every American museum director knows that Impressionism sells.

As an example, my neighborhood Brooklyn Museum was one of the organizers of the superb *In the Light of Italy*, an excellent example of an art historical inquiry that could be done only by a museum.[1] The show illuminated the practice of pre-Impressionist plein air painting in early-nineteenth-century Italy, where artists from all nations converged. Bringing together over a hundred, mostly unfamiliar, paintings, the exhibition was revelatory and received high

praise, especially from university art historians. Despite this, it drew a small percentage of the crowds that came for that same museum's *Monet and the Mediterranean*, a relatively mediocre exhibition that seemed to have dredged up anything and everything of Claude Monet's that could be shoehorned into the theme.[2] No matter; tour buses of visitors filled the museum until the wee hours and stayed to patronize the extensive Monet gift shops that had sprung up like mushrooms in former exhibition spaces. Despite the critical acclaim for *In the Light of Italy* and the raspberries that greeted *Monet and the Mediterranean*, the financially strapped Brooklyn Museum, which has seen its municipal budget slashed year after year, followed up with a repeat performance of the latter: *Impressionists in Winter* opened in May 1999, replete with acres of gift-shop merchandise. That is the economic basis of American museum art history.

As a historian of nineteenth-century art, I feel this inequity perhaps more keenly than many of my colleagues because the exhibitions that pay the bills—the cash cows of the museum world and the "repetition" part of my topic—are invariably Impressionist, much to the detriment of the rest of the century's thematic possibilities. Several years ago, for example, five midwestern museums joined together to mount an exhibition of their Impressionist holdings.[3] I was invited to lecture at several of the venues, and each time, impressed with the museum's holdings of Barbizon landscapes, I suggested that these same museums could organize a superb Barbizon exhibition collectively. I was told each time that this would be impractical; such a show would be too expensive because it could not command the audiences of Impressionism.

Museum audiences, it would seem, prefer Impressionist shows to everything else, but I have come to think that the attraction is as much to the story the exhibition tells as to the paintings that compose it.[4] The unprecedented success of the Museum of Modern Art's recent Jackson Pollock show suggests to me that Abstract Expressionism shares some of the same myths and legends constituting the morality tale repeated by most Impressionist exhibitions. These repetitions are the residue of modernist art histories, the truths of previous generations that have finally reached the larger audience in an aesthetic "trickle-down" theory. The expected response of a poststructuralist university art historian, whose career is typically novelty driven, is to debunk such myths and legends while at the same time proposing new ones. Museums do this at their own peril, however, for these oft-told tales are what bring people into museums.

One of the basic tales of modernism is that of the bohemian artist who,

scorned by philistines, was obliged to live in poverty, enduring the slings and arrows of outrageous critics, but who worked hard and persevered, true to his (rarely to her) unique vision. After his death this impoverished artist was recognized as a transcendent genius, his once-scorned works now commanding fabulous prices. John Rewald probably did more than anyone to perpetrate this legend with his magisterial *History of Impressionism*,[5] published in 1946. So well did he succeed that, despite several decades of revisionist scholarship, some version of this Horatio Alger tale is still being told by most Impressionist exhibitions in America. University scholars can natter on that the Impressionists' careers were similar to those of their contemporaries, that several of them (Monet, for example) were quite successful during their own lifetime, that some (such as Edgar Degas and Berthe Morisot) were regularly accepted into the annual Salons.[6] Revisionists can demonstrate that critics of various traditional stripes were often prescient, while modernist critics sometimes said very stupid things—Charles Baudelaire did, after all, hail Constantin Guys and not Edouard Manet as the painter of modern life.[7] No matter. The old myths continuously reassert themselves, often in the exhibition catalogue, almost invariably in the wall labels and Acoustiguides that teach art history to the general public, or through popularizers like Sister Wendy, whose television program commands a larger audience than does any university art historian. In wondering why this is so, why university art history has had so little effect on the accounts given in exhibitions, I notice that the oft-told tale is the typical American success story wherein perseverance and hard work are rewarded with eventual vindication and financial success. No wonder it reverberates with American audiences and has less resonance in Europe, where exhibitions are constructed to tell different tales. In France, for example, the tale often celebrates the pleasures of a life of creative achievement, with the elision of unpleasantness. Now that American Abstract Expressionism has been reformulated as a morality tale along the lines of the American success story, we are witnessing its newfound success with the general public, in the past always notoriously hostile to abstract art.

To illustrate the different art histories, imagine the critical response within the art-history community to a university-press study of Impressionism that repeated these same fables. It is unimaginable that such a text would ever be published—but it would pass unnoticed in one of those magnificent coffee-table albums of luscious reproductions of Impressionism, and it has even surfaced in exhibition catalogues. As the art publisher Harry Abrams once said to me years

ago about such publications, nobody reads the text anyway; it's all about the color reproductions, reproductions that Rewald used to complain were hyped up into 110 percent living color.

But if it's all about the pictures, then what university art historians are saying is just a gloss and of no lasting import—at best a footnote to the main experience of the exhibition, which is looking at pictures. This is what the public usually thinks—that an exhibition is merely a collection of pictures assembled for admiration and delectation and that scholars who criticize the tales exhibitions tell are just nit-picking. Yet the experience of looking at pictures, whether acknowledged or not, is understanding them as part of a tale—a narrative constructed from the juxtaposition of pictures, the inclusions and the exclusions. The reason this narrative is invisible is that, like what we call common sense, we have so absorbed its values that we can no longer recognize the tale in the telling of it. Let me give an example by comparing two equally important articles and their influence (or lack thereof) on Impressionist exhibitions. In 1980 Kirk Varnedoe published "The Artifice of Candor: Impressionism and Photography Reconsidered," pointing out that the Impressionists were not influenced by photography because the medium was not technologically advanced enough to capture the "snapshot" quality of subjects from modern life.[8] Although Varnedoe was not the first to offer this insight, his article was published in a widely circulated journal, *Art in America*, with many illustrations, and he was speaking about the general public's favorite art movement, Impressionism. As a result, the point he made was absorbed immediately into the canonical understanding of Impressionism, and since then virtually every exhibition, wall label, catalogue, and Acoustiguide has reminded museum visitors that the Impressionists were not influenced by photography but that, if anything, the reverse was true.

Two years later Joel Isaacson contributed an equally groundbreaking article, "Impressionism and Journalistic Illustration," to *Arts Magazine*.[9] With numerous reproductions, Isaacson pointed out that the Impressionists swam in a sea of lithographic images of modern life; omnipresent in late-nineteenth-century Paris, these images appeared both in the illustrated press and as cheap prints. Isaacson disclaimed any attempt to show specific iconological borrowing, wanting instead to demonstrate something more important: that the Impressionists, far from single-handedly creating the fashion for such subjects, were part of a much larger cultural movement focusing on modern life. Like Varnedoe's insights, Isaacson's were duly incorporated into university art history. But

Isaacson's perceptions never made their way into the public consciousness, and I have yet to see a museum show that would "demote" Impressionist artists by acknowledging the similarities between high art and popular imagery that he published in *Arts* eighteen years ago. That the relationship between high and popular art is an accepted part of twentieth-century art historiography only serves to underscore the ideological underpinnings of Impressionism.[10] I suggest that the reason for the different reception of these two scholars' ideas into museum art history is that Varnedoe aggrandized the originality of Impressionist paintings by rejecting the common assumption that they were influenced by photography, while Isaacson subtracted from them some of that originality by demonstrating that they often rode the coattails of a widespread lithographic fashion for images of modern life. In our everyday world of simulacra, both the collectors who lend the paintings and the public that visits museums for an increasingly rare firsthand experience of originality and authenticity are likely to find Isaacson's insights appalling rather than appealing—and so they have been mostly ignored.

There are many other ways in which exhibitions tell tales: selective negative comments by conservative contemporaneous critics, often affixed to wall labels, reinforce both the image of persecuted genius and the prescience of modernists. It would be a vastly amusing project to collect all the negative comments made about such paintings by modernist critics, and to exhibit *them* alongside the pictures—but that would complicate the simple morality tale of good and evil that exhibitions often convey. Although, for conservation reasons, museums do not usually mix paintings and works on paper, hostile caricatures of modernist pictures often find their way into exhibitions, even if relegated to marginal areas. The oft-told tale is, again, one of ignorant persecution of genius, while the fact that such caricatures were a standard part of nineteenth-century exhibition criticism, satirizing academicians and modernists alike, is usually left unsaid. The appearance of a negative caricature in the recent Pollock show leads me to predict that Abstract Expressionism is about to incorporate the oft-told tale and become transformed into a popular museum draw.

When the modernist viewpoint was dominant in art historiography, it was shared by both museum and university art historians alike. It was only when the latter became intent on deconstructing, rather than perpetuating the heroic mode endemic in modernism, that the schism between museum and university art history began to develop. Although this conference is taking a step toward

repairing that schism, we can do so fully only by engaging the attention of our respective audiences.

1. Philip Conisbee et al., exh. cat., *In the Light of Italy: Corot and Early Open-Air Painting* (New Haven: Yale University Press, 1996). The other sponsors of the exhibition were the National Gallery of Art in Washington, D.C., and the Saint Louis Art Museum.

2. Joachim Pissarro, exh. cat., *Monet and the Mediterranean* (Fort Worth: Kimbell Art Museum, 1997).

3. See Marc S. Gerstein, *Impressionism: Selections from Five American Museums* (New York: Hudson Hills Press, 1989). The five museums were: the Carnegie Museum of Art, the Minneapolis Institute of Arts, the Nelson-Atkins Museum of Art, the Saint Louis Art Museum, and the Toledo Museum of Art.

4. Kirk Varnedoe and Pepe Karmel, *Jackson Pollock,* exh. cat. (New York: Museum of Modern Art, 1998).

5. John Rewald, *History of Impressionism* (New York: Museum of Modern Art, 1946); there have been numerous revised editions.

6. The first major study to challenge the modernist reading was published in 1965; see Harrison C. and Cynthia A. White, *Canvases and Careers: Institutional Change in the French Painting World* (Chicago: University of Chicago Press, 1993).

7. His "Peintre de la vie moderne" was written in 1860 and first published in *Le Figaro* on 26 and 29 November and 3 December 1863; see Charles Baudelaire, *Ecrits sur l'art* (Paris: Gallimard et Librairie générale française, 1971), 2:133–93.

8. Kirk Varnedoe, "The Artifice of Candor: Impressionism and Photography Reconsidered," *Art in America* 68, no. 1 (January 1980): 66–78.

9. Joel Isaacson, "Impressionism and Journalistic Illustration," *Arts Magazine* 56, no. 10 (June 1982): 95–115.

10. For examples, see the catalogue of the 1990–91 Museum of Modern Art exhibition, *High and Low: Modern Art and Popular Culture*, ed. Kirk Varnedoe and Adam Gopnik (New York: Harry N. Abrams, 1990). The exhibition traveled to the Art Institute of Chicago and the Museum of Contemporary Art in Los Angeles.

German Art—National Expression or World Language?
Two Visual Essays

Eckhart Gillen

In a lecture marking the closing of Berlin's Alte Nationalgalerie (Old National Gallery) for renovation in 1998, Hans Belting looked back at the quasi-religious national idea that had inspired it. Dedicated in 1876, five years after German unification, this was not a museum intended to house the art collection of the nation, like the National Gallery in London, but a temple dedicated to national art, to contemporary *German* art. Today, Belting observed, such an idea has become anachronistic, "The national idea is almost categorically excluded by the unstoppable globalization of contemporary art."[1]

Belting's idea is hardly a new one—in 1906 the same thesis, then more controversial, was proposed in the context of the debate occasioned by the *Deutsche Jahrhundertausstellung* (Exhibition of a Century of German Art), held in this same Nationalgalerie. The notion of a common "world language [of art] . . . beyond natural differences in place and race" was articulated by Julius Meier-Graefe in the catalogue for the exhibition, which he organized in 1906 with Alfred Lichtwark and Hugo von Tschudi.[2] Although it offered a vast overview of work by German artists from 1775 to 1875, the exhibition was intended to challenge the very idea of a distinctly *national* art that expressed "the nature and culture of a people"—a then widely held position defended by, among others, the Heidelberg professor Henry Thode, who also happened to be the son-in-law of Richard Wagner.[3] The *Jahrhundertausstellung*, instead of attempting an "objective" art historical retrospective of a century of German art, was conceived as a visual essay—a reassessment of the past from a particular and by no means uncontested contemporary artistic viewpoint. As the Berlin critic Karl Scheffler observed, the exhibition, although devoted to nineteenth-century art, "was intended not to provide historical insights but to promote an idea of the present."[4] His comments acknowledge the purposive inclusion of a key period—between the end of the Rococo in 1775 and the beginning of an Impressionist view of art in 1875—which the exhibition organizers considered the provisional culmination of a continuous "developmental history." This term had been used by Meier-Graefe in 1904 in his pioneering *Entwicklungsgeschichte der modernen Kunst*, in which, in accordance with Darwin's teachings, he described modern art as an evolutionary

development.[5] Rather than stressing the break with tradition, Meier-Graefe put forth the idea that a viewer could understand the Old Masters better because of the modern artist's work and vice versa: "El Greco helps Cézanne, and he is helped by Cézanne."[6]

In an article on the *Jahrhundertausstellung*, Lichtwark (then director of the Hamburg Kunsthalle) noted that in its selection of artists and their works "this exhibition deals a powerful blow to academic teaching."[7] He and his two colleagues saw themselves as operating independently from the "narrow specialization of the [scholarly] caste"[8]; they had an eye for the innovative spirit of artists who "convey insight into long-concealed possibilities of development."[9] Past art, then, was treated as a signpost for future art. The appreciation for both past and contemporary art—the standards for art historians and the art market alike—should be credited, they insisted, to artists: "It is not art historians who need art . . . Only artists deal with the proper essence of art. It is indispensable to them, for it gives them language and content. They develop themselves even as they develop art . . . they are the guardians and the destroyers, the true—good and poor—curators of art."[10] Accordingly, in evaluating, selecting, and installing works in the *Jahrhundertausstellung*, the three organizers sought to see the past with the eyes of contemporary artists, employing a formalist, aesthetic approach that still has resonance today. Lichtwark described the essayistic method that he preferred as "serious in intent but quite loose in form . . . not scholarly according to German academic standards, but merely stimulating, letting ideas be guessed at rather than expressing them directly."[11] Texts and exhibitions, he maintained, ought to be personal and lively; the Germans, however, regrettably take seriously only what is "ponderous, dull, and difficult to understand."[12]

The romantic landscapist Caspar David Friedrich (1774–1840) was the major discovery of the *Deutsche Jahrhundertausstellung*, and his reception on that occasion presents an interesting case. Though dead for sixty-six years, Friedrich (only recently rediscovered by the Norwegian Andreas Aubert) was embraced by both factions as a precursor of their respective aesthetic agendas. For both the nationalistic journal *Kunstwart* as well as the internationalists espousing Impressionism, Friedrich was an artistic revolutionary, but while the former stressed the religious, mystical dimensions of his art, the latter saw in him a fore-runner of modern landscape painting. Tschudi openly conceded that this latter response was anachronistic: "To be sure, what speaks to us is not what his contemporaries heard: it is not the Ossianic atmosphere of that lonely figure standing

on the bright sandy dunes, dreaming across the deep, black eternity of the sea, whose roar is conveyed by the white spray of the waves. All this romanticism, which was perhaps the essential thing for the artist himself, recedes for us before the new vision of the beauty of landscape that his art has revealed to us . . . a beauty in which we recognize the beginnings of a development that has continued into our own time."[13] Thus, through the lens of Impressionism, Friedrich could be hailed as a pioneer of open-air painting,[14] his work identified as the beginning of a formalist-aesthetic line of development. The content of his painting, its "Ossianic atmosphere" and political allegory—for example, its references to the Wars of Liberation and the Restoration—were forgotten or consciously ignored.

The three organizers of the *Deutsche Jahrhundertausstellung* were supported by idealistic groups within the bourgeoisie who were involved in the process of their own emancipation. They hoped that with the landscape painting of Friedrich as inspiration and model there would emerge a true German art, one close to nature, in opposition to the "false pathos" of the *Gründerzeit* (the period following German unification), serving as "a declaration of the reawakening of a German desire for culture and the awareness of culture."[15]

Following World War II, in the wake of the later catastrophic consequences of the insidious belief in a German *Sonderweg*, of a distinctly German destiny, the art historian Werner Haftmann revived Meier-Graefe's idea of viewing German art not as a national or racial phenomenon but as part of a world language of art, and this attitude has persisted to the present.[16] "When we go to an exhibition of contemporary art," writes Hans Belting, "we prefer to look into the great wide world rather into a mirror of Germany, and the great world was synonymous with the U.S.A., in which for decades we [Germans] sought an *ersatz* identity."[17] Following the Second World War, no one wanted to speak of German art, inasmuch as the theme had been misused for so long, "and it was hardly possible even to use the word 'German,' except in political speeches. Since the Fall of the Wall we may do so again, but we have to practice it afresh."[18]

The Berlin exhibition *Deutschlandbilder* (Images of Germany) of 1997–98 presented just such a field for practice and for overcoming the prohibition.[19] Like the *Jahrhundertausstellung* of 1906, it offered a retrospective of German art, and it, too, took the form of a visual essay, one "composed of flesh and intellect . . . a formulation of theses . . . left to the works themselves."[20] But whereas the earlier exhibition had a purely aesthetic agenda and sought to transcend a national perspective, *Deutschlandbilder*, without positing a distinctly

national art, was concerned with the encounter between German art and the peculiarities of German history since 1933. By choosing this date it thus established the beginning of the period not by the conventional benchmark of the *Stunde Null,* or "zero hour" of 1945 but rather by the National Socialist seizure of power, and thereby affirmed a historical continuity between the prewar and postwar periods. In this exhibition German art was presented for the first time as a confrontation with the breakdown of civilization symbolized by Auschwitz; more than ninety artists explored the significance of the Holocaust for our contemporary consciousness.

It was no accident that *Deutschlandbilder* was shown in Berlin, the capital of the Third Reich and, from 1945 to 1989, the contested arena of the Cold War. In this city, where signs of the cold-war division of the country are still evident today, the scars of a fractured history cannot be ignored. Only in Berlin and in the former GDR can one experience the physical traces of events that have been repressed in the West out of guilt, shame, and fear. This is true even of the site of the exhibition itself, the Martin-Gropius-Bau. Built between 1877 and 1881 as the Kunstgewerbemuseum (Arts and Crafts Museum), it is located in the administrative center of Nazi terror. There, the Reich Schutzstaffel (SS) security center in the former Prince Albrecht Palace has been open to visitors since July 1987 as a memorial titled "Topographie des Terrors" (Topography of Terror). During the course of rebuilding and redevelopment, which diminished the evidence of the area's history (following the dictum "out of sight, out of mind"), the politically incriminating buildings—but not the Wall—were torn down (fig. 1). The building of the former Kunstgewerbemuseum itself, which had been given up by the State Museums of the Prussian Cultural Foundation, nearly fell victim to the goal of creating a "car-friendly" city—a plan that would have made room for a city expressway along the Wall. Hans Haacke's installation for *Deutschlandbilder,*

Fig. 1. Martin-Gropius-Bau, northeast corner, site of the *Deutschlandbilder* exhibition, 1997

Concrete (fig. 2), which filled the floor of the Martin-Gropius-Bau's central atrium with freshly cast cement, was an ironic statement on this urge to pave over the city's catastrophic past, making it disappear into the circulating currents of traffic and capital. Two works by Anselm Kiefer, *Germany's Spiritual Heroes* and *Your Golden Hair, Margarete, Your Ashen Hair, Shulamite,* the latter inspired by a refrain from Paul Celan's classic Holocaust poem, "Todefuge" (Fugue of death), were installed so as to articulate this connection between the art inside and the historical legacy outside: they were hung in the building's east-wing gallery, which offers an unobstructed view onto the grounds of the former Gestapo headquarters.

Fig. 2. Hans Haacke (German, b. 1936), *Concrete,* 1997, in the atrium of the Martin-Gropius-Bau. Cement, 83 feet 4 inches × 49 feet 6 inches (2600 × 1510 cm)

Deutschlandbilder showed how, well into the 1950s, German art, by practicing the current "world language of abstraction" of *art informel,* was characterized by a denial of the Nazi past. At most, a darkly atmospheric palette and some evocative picture titles, as in *Sodom, Nero,* and *Green Gate* (fig. 3) by Emil Schumacher and *Aggressive, Blood and Decay,* and *Nuked* by Bernard Schultze, convey a vague idea of the horrors experienced, of the physical devastation and the emotional desolation of the War. It was not until fresh impulses from abroad

Fig. 3. Emil Schumacher (German, b. 1912), *Green Gate*, 1958. Oil on canvas, 67 × 52 inches (170 × 132 cm). Von der Heydt-Museum, Wuppertal

entered the German art scene in the early 1960s, in the form of American Pop Art and New Realism from France, that there was a movement away from the two dominant tendencies of postwar West German art—the neo-romantic abstract idealism of *art informel*, in which "German inwardness" had survived war and postwar capitulation as if in a cocoon, and epigonal variations of the Expressionism of Emil Nolde and *Die Brücke*.

The art of Gerhard Richter presented one of the most interesting cases of this shift in German art after 1960. Richter, born in Dresden in 1932, had left the GDR in March 1961 (five months before the Wall was erected), moving from Dresden to Düsseldorf "to get away from the criminal 'idealism' of the Socialists."[21] Prescribing for himself an artistic cure, he resolved from then on to think and act "without the help of an ideology. I have . . . no idea that I can serve . . . no belief that shows me the way, no image of the future, no construction that

I can place on things in order to be given an overriding meaning."[22] Richter went to the West just after the time when Germany's paralyzing collective amnesia had been interrupted permanently by the landmark Ulm trials in 1958. Ten years after the Nuremberg War Crimes Tribunal, this second series of legal proceedings, the so-called National Socialist and concentration-camp trials, had been launched by a minor bureacratic incident. The former SS-Oberführer Bernhard Fischer-Schweder, who had been responsible for mass executions in Lithuania, was living under an assumed name in Ulm when he petitioned for his reinstatement as a civil servant and his true identity was discovered. Richter began in 1964 to introduce such subjects into the series of photo paintings he had commenced in 1962, inspired by his response to the work of Andy Warhol and Robert Rauschenberg. A typical example is *Herr Heyde*, painted in 1965 (fig. 4). After copying a photographic motif from a newspaper onto canvas, Richter smudged the oil paint while it was still moist. Inscribed at the bottom is the caption taken from the source: "Werner Heyde in November 1959, as he gave himself up to the authorities." In the process of adapting a small newspaper photograph to the medium of easel painting, its proportions were enlarged, giving it qualities of permanence, aura, and dignity that belie the circum-

Fig. 4. Gerhard Richter (German, b. 1932), *Herr Heyde*, 1965. Oil on canvas, 21 ⅝ × 25 ⅝ inches (55 × 65 cm). Private collection

stances of of the actual event.[23] Professor Werner Heyde, a member of the Nazi Party since 1933 and of the SS since 1936, was a director of the mental hospital at Würzburg and one of the National Socialist regime's leading euthanasia doctors (more than 100,000 adults were killed). After 1949, under the name Dr. Fritz Sawade, he worked as a neurologist and court adviser in Flensburg, his second career facilitated by a network of influential civil servants, medical colleagues, and university professors. When Heyde's true identity was revealed, he gave himself up to the police in Frankfurt and spent four years in prison awaiting trial. As a consequence of his abandonment by former supporters, he hanged himself

in his cell on February 13, 1964, leaving a farewell note defending the termination of "life not worth living." Thus, the long-forgotten case of Heyde became a telling example of the historical continuity between the Third Reich and the postwar period in West Germany. It was the journalistic coverage of this story that inspired Richter's painting.

In the unrepentant climate of the Adenauer Republic, Richter thus took up the taboo theme "the murderers are among us,"[24] in an apparently nonconfrontational, unthreatening, but no less insistent way. It was his distaste for a facile moralizing condemnation—and his sensitivity to the problems involved in portraying a perpetrator of evil crimes in the mask of the petty bourgeois—that induced him to employ found photographs as motifs. Richter's painting language betrays no emotion and no critique. As he put it, "Suddenly, I saw [photography] in a new way, as a picture . . . free of all the conventional criteria I had always associated with art. It had no style, no composition, no judgment. It freed me from personal experience."[25]

Fig. 5. Willi Sitte (German, b. 1921), *Stalingrad* diptych, 1961. Wings, 60 ³/₈ × 47 ¹/₄ inches (153.5 × 120 cm) each; predella, 48 ³/₈ × 94 ¹/₂ inches (123 × 240 cm). Gemäldegalerie Neue Meister, Dresden

Richter's seeming indifference, his ostensible rejection of message, lack of opinion, and flight from any established artistic viewpoint were his protection against the temptation to reideologize or renationalize art. Unlike the GDR artist Willi Sitte, who made use of the pathos formula of the altarpiece and the hackneyed character masks of "Critical Realism" in his Stalingrad diptych of 1961 (fig. 5), Richter did not paint from the self-assured position of an antifascist who parades the correct historical perspective. His criterion for choosing photographs was "content, definitely—though I may have denied this at one time."[26] By presenting without judgment the Heyde newspaper photograph, Richter was attempting to objectify his special relation-

Fig. 6. Gerhard Richter, *Family*, 1964. Oil on canvas, 59 × 70 ⅞ inches (150 × 180 cm). The Olbricht Collection, Essen

ship to the motif depicted—a relationship that is obvious also in his use, in other works, of family snapshots from an album that he brought with him from the GDR. According to one commentator, "[t]his album marks a continuity between Richter's 29th year in the GDR and the following years in West Germany. It points to memories of the family that remained behind, of friends and acquaintances."[27]

Family (fig. 6) shows Richter himself at the age of eight with his dachshund Struppi, his sister, his mother, and his grandmother in Waltersdorf, where he grew up. *Aunt Marianne* (fig. 7) shows the artist as a six-month-old baby on the lap of his aunt, a woman who was placed in a mental institution before World War II and who, apparently, died as a euthanasia victim. "The report of her death at the time, according to Richter, prompted no one in the family to look into its cause."[28] In dealing with such difficult content, Richter insists on recognizing "only what is"; "any description and pictorialization of what we do not know is meaningless."[29] Thus in his practice as an artist Richter adopted an artistic credo that was close to Ludwig Wittgenstein's epistemological maxim, "What we cannot speak about we must pass over in silence."[30]

Fig. 7. Gerhard Richter, *Aunt Marianne*, 1965. Oil on canvas, 47 ¼ × 51 ¼ inches (120 × 130 cm). Private collection

Fig. 8. Gerhard Richter, *Funeral,* from the series *October 18, 1977,* 1988. Oil on canvas, 78 ¾ × 126 inches (200 × 320 cm). The Museum of Modern Art, New York

As a result of his experiences with socialist idealism in the GDR, Richter adhered to a rather pessimistic anthropology, his skeptical, distanced understanding of art equivocating between inventing nothing, "no idea, no composition, no object, no form—and to receive everything: composition, object, form, idea, picture."[31] After 1966 he painted large series of works, often in drastically different styles: the non-representational "gray paintings," the lattice and window pictures, and—from 1976 onward—abstract works. Then in 1988, to the surprise of all, he produced a cycle of fifteen photo paintings, *October 18, 1977,* a dark and disturbingly ambivalent epitaph to the first, "idealistic" generation of the terrorist Red Army Faction (fig. 8), a series based on photographs of events that culminated in the suicides of the terrorists Andreas Baader, Gudrun Ensslin, and Jan-Carl Raspe on that day in Stammheim Prison. It is a painted requiem to the perpetrators, who murdered many times and at the same time were, in their own eyes and those of many sympathizers, themselves victims of their mothers' and fathers' repressed fascism, "which haunted the children who had to destroy themselves in order to escape it."[32] In his appeal during the RAF's department-store arson trial in 1968, the defense attorney for Baader, Horst Mahler, justified the motive for the crime as rebellion against a generation of parents who tolerated

millions of atrocities during the National Socialist time and had thereby implicated themselves.[33] Peter-Jürgen Boock, who played a crucial part in the kidnapping of Hanns Martin Schleyer, president of the Deutscher Arbeitgeberverband (German Association of Employers), recently offered a similar motive: "From my standpoint, the entire conflict that began in 1968 was reflected in Schleyer's person. He was an SS man who after 1945 reentered the German economy in a leading position. With our actions, we wanted to begin at the point where we saw historical processes that would have ended with—again—a fascist state. . . . It is frightening how close we came, with our shot-in-the-head actions, to what we professed to have struggled for."[34] In a purported "people's trial," held in their "people's prison," the RAF wanted to prosecute Schleyer as the symbolic figure of the "evil Nazi father."[35] Here, unwittingly, the radical left offered a macabre analogy to the Nazi "people's court of law," resurrecting a mythic folk notion of nineteenth-century romanticism.[36]

Richter's cycle is not to be misunderstood as political support of either the terrorists and their aims or of their victims. These are pictures of failure and of sympathy for humanity, for the individual who is in danger of disappearing behind the abstraction of a collective image of the enemy. The *October 18, 1977,* cycle strove to realize what Theodor Adorno had expected from painting almost forty years earlier: a capacity to "stand up to suffering by helping to give it symbolic form,"[37] eschewing attempts to make sense of tragedy. The artist himself stated: "Art has always been basically about agony, desperation, and helplessness (I am thinking of Crucifixion narratives, from the Middle Ages to Grünewald; but also of Renaissance portraits, Mondrian and Rembrandt, Donatello and Pollock). We often neglect this side of things by concentrating on the formal, aesthetic side in isolation. Then we no longer see content in form, but form as embracing content, adding to it. . . . The fact is that content does not have a form: it *is* form."[38]

Here the conflict that marked the debates surrounding the *Jahrhundertausstellung* at the beginning of the century—the conflict between art as an international, universal language of form and art as an expression of identity, history, and individual and collective memory—seems finally resolved in the painting of Gerhard Richter. Richter succeeded, in the internationally disseminated and universally understood language of photo painting adapted from Warhol and Rauschenberg, in addressing the trauma of German post-fascist society without falling back on the clichés of national identity.

At the beginning of the last century two museum art historians and an art critic emancipated art from its subordination to the quest for national self-discovery by rejecting all traditional taxonomies and hierarchies of genre and creating a new type of exhibition that disposed the public to view works of art as autonomous configurations, to grasp the exhibition as an aesthetic discourse. To be sure, after the book burnings of May 1933, the campaign against "degenerate art," and above all the genocide against European Jews, this emancipated art had lost its standards and its innocence. All attempts in the postwar era to forge a link to the heroic age of "classic" modernism seemed, especially in Germany, forced and epigonal, as was evident from the all too frequent and demonstrative use of the prefix "neo": Neo-Dada, Neo-Expressionism, Neo-Realism, the New Figuration.

For this reason *Deutschlandbilder* presented German art since 1933 not as a triumphal procession of a rehabilitated modernism victorious over bad politics, ultimately achieving international recognition and moral *Wiedergutmachung* (reparation). Rather German art was seen as an often torturous engagement with political and cultural dysfunction, with the experience of irretrievable loss, as a contribution to the dialogue of the living with the dead. This exhibition-as-essay focused, without claims of comprehensiveness or correct periodization, on the "sharp turns"[39] of German art, the beginnings, the ruptures of generations, and the changes of perspective between remembering and forgetting. *Deutschlandbilder* wanted to sharpen one's view of the solitary figures in the two countries divided by the Cold War of the arts. The abstract "black pictures" of a generation of West German artists disillusioned by the "economic miracle" (e.g., Raimuns Girke and Emil Schuhmacher) came up against the "realistic" pictures of the "black period" in East Berlin (e.g., Harald Metzkes) as a protest against the official suppression of melancholy. Throughout the exhibition the dialogues between East and West artists structured the reading of the installation—for example: Hans Hartung, who had lived since 1932 in French exile, with the Dresden Constructivist Hermann Glöckner; the Düsseldorf nail artist Guenther Uecker with the Thuringian draughtsman, Gerhart Altenbourg, with his nail-pierced dying warrior; the Saxons Georg Baselitz with Hartwig Ebersbach; Jörg Immendorff with A. R. Penck; Hanne Darboven with Carlfriedrich Claus; Sigmar Polke with Via Lewandowsky. . . . Nightmares, obsessions, and compulsive repetitions became visible, but new constellations were also formed that enabled the viewer to overcome old patterns of seeing and ideological blinders so as to discover common attitudes in a divided country.

1. Hans Belting, "Moderne und deutsche Identität im Widerstreit: Ein Rückblick in der deutschen Nationalgalerie, *Identität im Zweifel: Ansichten der Deutschen Kunst* (Cologne: DuMont, 1999), 122, 131.

2. Hugo von Tschudi, et al., *Ausstellung deutscher Kunst aus der Zeit von 1775–1875 in der Königlichen Nationalgalerie: Berlin 1906*, 2 vols., exh. cat. (Munich: Bruckmann, 1906). The exhibition comprised 2,022 paintings and 3,331 works on paper.

3. The quotation is from Hans Belting in the epilogue to Julius Meier-Graefe, *Entwicklungsgeschichte der modernen Kunst* (Munich: 1987), 2:741. The Nazis regarded Henry Thode as a pioneer of their campaign against "degenerate" art. See Bettina Feistel-Rohmeder, "Was zu Heidelberg begann," *Das Bild: Monatsschrift für das deutsche Kunstschaffen in Vergangenheit und Gegenwart* 4, no. 1 (1934): 396.

4. Karl Scheffler, "Die Jahrhundert-Ausstellung," in *Die Zukunft*, no. 25 (1906): 88–95. Quoted in Angelika Wesenberg, "Impressionismus und 'Deutsche Jahrhundert-Ausstellung Berlin 1906,'" in *Manet bis van Gogh: Hugo von Tschudi und der Kampf um die Moderne*, exh. cat., ed. Johann Georg Prinz von Hohenzollern and Peter-Klaus Schuster (Berlin: Staatliche Museen and National Galerie; Munich: Bayerische Staatsgemäldesammlungen and Neue Pinakothek, 1996), 364.

5. Julius Meier-Graefe, *Entwicklungsgeschichte der modernen Kunst* (Stuttgart: J. Hoffmann, 1904), 3 vols.; the English edition is *Modern Art: Being a Contribution to a New System of Aesthetics*, trans. Florence Simmonds and George W. Chrystal, 2 vols. (New York: G. P. Putnam, 1908).

6. Meier-Graefe, *Entwicklungsgeschichte* (1987 ed.), 720.

7. Quoted in Helmut R. Leppien, ed., *Kunst ins Leben: Alfred Lichtwarks wirken für die Kunsthalle und Hamburg von 1886 bis 1914*, exh. cat. (Hamburg, 1986), 133. The article was published on 21 August 1900.

8. Meier-Graefe (1913), quoted in Catherine Krahmer, "Tschudi und Meier-Graefe: Der Museumsmann und der Kunstschriftsteller," in Hohenzollern and Schuster, *Manet bis van Gogh*, 374.

9. Tschudi (1912), quoted in Krahmer, "Tschudi und Meier-Graefe," 374.

10. Julius Meier-Graefe, quoted in Krahmer, "Tschudi und Meier-Graefe," 374.

11. Letter to Andreas Aubert, 14 February 1893, quoted in Hans Präffcke, *Der Kunstbegriff Alfred Lichtwarks* (Hildesheim: G. Olms, 1986), 140.

12. Letter to Leopold von Kalckreuth, presumably 5 February 1901, quoted in Präffcke, *Der Kunstbegriff Alfred Lichtwarks*, 144.

13. Quoted in Wesenberg, "Impressionismus," 367.

14. In fact Friedrich was working behind closed windows in his studio. A much-quoted statement he made—"The painter should not simply paint what he sees before him, but also what he sees within himself"—became an absolute in the book *Deutsche Innerlichkeit* (German inwardness) by Ulrich Christoffel (Munich: R. Piper, 1940): "Eternity is within us. The outside world only throws its shadows into this kingdom of light" (p. 109).

15. Georg Fuchs, *Deutsche Form: Betrachtungen zur deutschen Jahrhundert-Ausstellung* (1907), 68, as quoted in Klaus Wolbert, "Deutsche Innerlichkeit: Die Wiederentdeckung im deutschen Imperialismus," in *C.D. Friedrich und die deutsche Nachwelt*, ed. Werner Hofmann (Frankfurt: Suhrkamp, 1974), 36.

16. Werner Haftmann, *Malerei im 20. Jahrhundert*, 2 vols. (Munich: Prestel, 1954–55). The English edition is *Painting in the 20th Century*, trans. Ralph Manheim, 2 vols. (London: Lund Humphries, 1960).

17. Hans Belting, "Moderne und deutsche Identität im Widerstreit," 125.

18. Ibid., 138.

19. *Deutschlandbilder: Kunst aus einem geteilten Land—Katalog zur zentralen Ausstellung der 47. Berliner Festwochen im Martin-Gropius-Bau*, exh. cat., ed. Eckhart Gillen (Cologne: DuMont, 1997). The English edition is *German Art from Beckmann to Richter: Images of a Divided Country*, ed. Eckhart Gillen, trans. Susan Bernofsky et al. (Cologne: DuMont, 1997).

20. Klaus Hartung, "Essay aus Kopf und Fleisch: 'Deutschlandbilder'—die Ausstellung der Berliner Festwochen und der deutsch-deutsche Geschichtsdiskurs," *Die Zeit*, 5 September 1997.

21. Gerhard Richter, *The Daily Practice of Painting: Writings 1962–1993*, ed. Hans-Ulrich Obrist, trans. David Britt (Cambridge: MIT Press, 1995), 13.

22. Richter diary entry, 23 April 1984, *The Daily Practice of Painting*, 108.

23. Richter discussed his intentions with Wolfgang Pehnt in 1984. See ibid., 117.

24. *Die Mörder sind unter uns* is the title of a film directed by Wolfgang Staudte in 1946.

25. Richter, *The Daily Practice of Painting*, 72–73.

26. Ibid., 143.

27. Susanne Küpper, "Gerhard Richter: Capitalist Realism and His Painting from Photographs, 1962–1966," in Gillen, *German Art from Beckmann to Richter*, 233–34.

28. Küpper, "Gerhard Richter," 233.

29. Richter diary entry, 23 April 1984, *The Daily Practice of Painting*, 108.

30. Ludwig Wittgenstein, *Tractatus Logico-Philosophicus*, 2nd ed., trans. D. F. Pears and B. F. McGuiness (London: Routledge and Kegan Paul, 1971), 151.

31. Richter diary entry, 12 October 1986, *The Daily Practice of Painting*, 129.

32. Bernd Nitschke, "Eine Generation der Ausgeschlossenen, von Anfang an," in *Konkursbuch* 2 (1978): 16.

33. See Stefan Aust, *Der Baader-Meinhof-Komplex* (Munich: DTV, 1989), 71.

34. "Mitleid wurde verdrängt," *Die Zeit*, no. 32, 1 August 1997, 10.

35. Heinrich Breloer, *Todesspiel: Von der Schleyer-Entführung bis Mogadischu* (Cologne: Kiepenheuer, 1997), 129.

36. It is worth noting here that, a little over two decades later, RAF defense attorney Horst Mahler has become a figurehead of the neo-fascist NPD!

37. Theodor W. Adorno, statement given at *Erstes Darmstädter Gespräch: Das Menschbild in unserer Zeit,* ed. Hans Gerhard Evers (Darmstadt: Neue Darmstädter Verlaganstalt GmbH, 1951), 215–16.

38. Richter diary entry, 27 January 1983, *The Daily Practice of Painting,* 102.

39. This was the title (originally *Harte Wendungen*) of a painting by Paul Klee from 1937, the year of the "Degenerate Art" exhibition, reproduced in Gillen, *Deutschlandbilder,* 74, fig. 16.

A Case for Active Viewing

William H. Truettner

Since the mid-1980s, critics and scholars in the field of American art have noted a widening gap between the academic and curatorial worlds. On the one hand, *Time* magazine critic Robert Hughes places blame on new approaches to scholarship. Academic art historians, writes Hughes, pursue long-winded analyses of works of art so that they can dodge issues of quality. Their main preoccupation is to expand the range of thesis subjects, thus bringing "relief to the worn-out pastures of American academe."[1] Stanford University professor Wanda Corn, on the other hand, attributes the gap to a broad-based political and cultural shift to the right. That shift undermined "public museums' ability to sustain independent scholarly inquiry," she maintains, turning them away from the academy and from "new kinds of exhibition thematics and installations."[2]

Those voicing reservations about the direction of museum scholarship—trustees, corporate sponsors, conservative critics, and journalists—are perhaps responding to the shift that Corn describes. But are museum professionals also advocating a retreat to safer ground? I suspect they are, but quietly, behind the scenes, so that their influence has gone relatively unnoticed. Directors and curators, many trained in departments that stressed issues of style and connoisseurship, have been uneasy all along about the kind of scholarship that by the mid-1980s was playing a major role in academic institutions. In many ways, they believe, the academy's approach threatens the fundamentally aesthetic mission of most United States art museums, a mission curators accept and carry forward. In a word, the museum officials seem to regard academic art history as neglecting the pleasures of seeing for a more restricted look at the historical side of works of art. The difference between the two, I would suggest, depends on whether we believe that viewers engage works of art through passive or active means.

To be sure, even a passive engagement registers on viewers as thoughts, feelings, associations, and—to some degree—a factual account of whatever the subject of the work might be. But such an engagement usually features observation over investigation, on the assumption that assessing artistic merit is the key to understanding the human impulse that refines and upgrades artistic production. Merit, in other words, cannot be seen as an issue of time and place; it is firmly entrenched in every great work.[3] This kind of thinking is likely to stabi-

lize meanings over time, to make a lasting virtue of high aesthetic purpose. Works of art, in turn, may be used to project that "purpose" over broad historical epochs—not just decades but sometimes entire civilizations—which are inevitably transformed into ideal (or imaginary, if not so ideal) pasts.

An active engagement between viewer and work of art presumes that the viewer brings to the work a more specific time-and-place perspective. Artistic merit will still be an issue, but it is only one of several that viewers apply to investigating how aesthetics and history interact. Implicit in the process is the assumption that different viewers will see this interaction differently and that consensus will be reached only after considerable debate. Or perhaps not at all. Or for only a relatively short time. Thus, works of art viewed in this way sacrifice an enduring status; their meanings are open to continual revision, to the unpredictable. And that, in turn, causes some degree of alarm among institutions founded to preserve and protect them—indeed, whose very existence is predicated on the assumption that they are treasure houses, stocked with collections that have a timeless value.

For museums and curatorial staffs, exhibitions focus the difficulties of stressing an active role for works of art. The first of many problems is gallery texts. If a curator believes that a group of works on exhibition is part of a historical dialogue, he or she must explain in what form the dialogue emerges and how it relates to the theme of the exhibition. This brings forth objections from critics like Peter Schjeldahl. In a recent *New Yorker*, Schjeldahl began a review of an Anselm Kiefer watercolor show at the Metropolitan Museum of Art in New York with the following: "Wall texts are a bane of late-twentieth-century museology, turning art shows into walk-in brochures. We can't help but read them . . . and thus are jerked from silent reverie into nattering pedagogy. Art and education," he continues, " . . . make for bad sex in the head"; they lead the viewer into the limbo of "neither quite looking nor quite thinking."[4] Good sex, we surmise from these comments, is akin to the pleasure of looking, the feeling to be experienced from a sensual play of line, texture, and color. But wall texts also diminish, according to the critic, subsequent mental activity—the thoughts and feelings that follow a moment of viewing pleasure. The texts, therefore, subvert a one-to-one relationship between a viewer and a work of art—a primary experience that a museum attempts to foster.

In fairness to Schjeldahl, he does say that the texts in the Kiefer show are an exception. They are "fat" paragraphs that work well to open up "lean" pic-

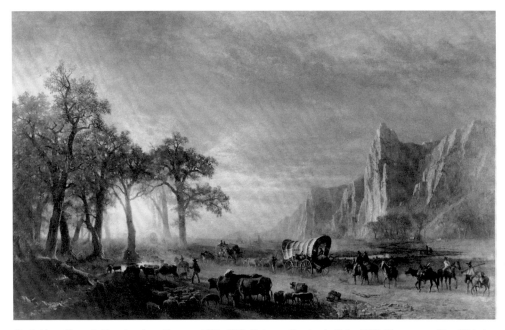

Fig. 1. Albert Bierstadt (American, born Germany, 1830–1902), *Emigrants Crossing the Plains,* 1867. Oil on canvas, 67 × 102 inches (170.2 × 259.1 cm). National Cowboy & Western Heritage Museum, Oklahoma City, 72.19

tures. Kiefer's work, he claims, "pants" for exegesis.[5] But while he acknowledges that the watercolors don't entirely explain themselves, he blithely ignores what many academics believe: that few works of art do. One way to reduce tension over this issue is to explain in an unobtrusive way, in a way that subtly encourages engagement *and* understanding. For curators, however, that is less a solution than an introduction to more problems. In addressing works of art, for example, how much should we allow issues of quality and connoisseurship—which to some extent can be seen as excluding history—to determine what we do? Or, conversely, how much should we limit works to a time-bound, artifactual status, so that we can investigate how they combine aesthetic strategies and historical beliefs. With Kiefer, it is possible to proceed both ways. Many of the watercolors in the Metropolitan show are disarmingly attractive, while commenting obliquely and ironically on the Third Reich—and on such platitudes as "coming to terms with the past." So when critics and the public came to see Kiefer's work, they were prepared to acknowledge that beneath an appealing exterior was a disturbing historical message.

But take another set of critics and a different audience—one devoted to nineteenth-century paintings of the American West. Many from this group are

convinced that paintings such as Albert Bierstadt's *Emigrants Crossing the Plains* (fig. 1) and Frederic Remington's *Fight for the Water Hole* (fig. 2) are what they appear to be—heroic but relatively honest and straightforward accounts of this country's westward migration. Challenge this assumption, as we did in *The West as America*, an exhibition held at the National Museum of American Art in 1991,[6] and your life will never be the same again. The exhibition argued that the paintings represented not an objective account of westward expansion but highly charged rhetoric that glossed over some of the darker moments in United States history. The reaction (focusing on several overly insistent gallery texts) was swift and unfavorable. Audiences resented being told that there might be another, less high-minded way to view the paintings. Indeed, one woman wrote, in a comment book that was placed at the end of the exhibition: "I always thought painting was supposed to be about hopes, dreams, the imagination. Instead you seem to say it's a political statement at every brushstroke. Your tendentious opinions betray a . . . blindness to the paintings themselves [and to what they say] about the appeal of the West . . . art is bigger than everyday logic."

Fig. 2. Frederic Remington (American, 1861–1909), *Fight for the Water Hole*, 1903. Oil on canvas, 27 ⅛ × 40 ⅛ inches (68.9 × 101.9 cm). The Museum of Fine Arts, Houston. The Hogg Brothers Collection, gift of Miss Ima Hogg

The belief that works of art are demeaned when their ideological goals are not taken at face value—that is, when the sanctity of "hopes, dreams, and the imagination" is breached to admit "everyday logic"—is a fairly consistent response among those willing to equate a *truthful* past with the ideal past projected by works of art. This brings us to another dilemma. If an ideal past can be read as a kind of artistic subterfuge, what happens to the values presumably embodied in that past? In effect, it is harder to pin them down, to quantify them as moral and social assets. This is indeed unsettling to those who believe that order and progress proceed from a stable past, that from such a past we draw

Fig. 3. Norman Rockwell (American, 1894–1978), *Freedom From Want*, 1943. Oil on canvas, 45 ¾ × 35 ½ inches (116.2 × 90.2 cm). Norman Rockwell Family Trust and the Norman Rockwell Museum at Stockbridge, Massachusetts

values that have guided one culture after another since the beginning of time.

　　With all this at risk, why would a curator attempt shows that have the potential of unsettling widespread notions about art and history? To some degree, I suspect, because of the Siren song of academics, because their art history seems to offer a range of ideas about works of art that museums, despite the consequences, could put to good use. What these ideas promise is a way of supplementing aesthetic analysis with historical context, enabling a curator to explain in less mystifying terms how art does its cultural work. Presenting art this way, more and more curators are discovering, is a long, uphill battle. Some wonder if it is worth it; does the public finally receive a more fulfilling museum experience? I would argue that exhibitions linking art and history have the potential of reaching a broader, if not necessarily larger, audience than those in which aesthetic goals predominate.

Fig. 4. Luigi Lucioni (American, b. 1900), *Village of Stowe, Vermont,* 1931. Oil on canvas, 25 ³/₈ × 33 ¹/₂ inches (64.5 × 85.1 cm). The Minneapolis Institute of Arts. Gift of the Estate of Mrs. George P. Douglas

And, further, that viewers' encounters with such exhibitions prompt them to make more judgments than they might ordinarily make about the importance of works of art, what they seem to say, and how they say it. In other words, museums *can* promote a richer, more challenging aesthetic experience for their audiences with exhibitions that show a close interaction between art and history.

　　Consider, for example, exploring New England art of the 1930s and 1940s through a pair of complementary pictures: *Freedom from Want* (fig. 3) by Norman Rockwell and *Village of Stowe, Vermont* (fig. 4) by Luigi Lucioni—artists who had considerable reputations during those two decades but whose work, until recently, has not often been seen on the museum circuit. If examined in a historical context, both paintings turn out to be quite remarkable artistic and cultural barometers—*Freedom from Want*, in particular. The genesis of Rockwell's

painting was President Franklin Roosevelt's "Four Freedoms" speech, delivered to Congress on 6 January 1941. But the artist, sensing that Roosevelt's rhetoric was too "noble" and "high-blown" for popular consumption, transformed one of the "Freedoms" into a Thanksgiving celebration, staged at his home in Arlington, Vermont.[7] Surrounding the table, on which "Freedom from Want" does indeed prevail, are members of his family —including the housekeeper, who delivers to them a plump, perfectly roasted turkey.

Fig. 5. Marion Post Wolcott (American, b. 1910), *Corner of Main Street, Center of Town, after Blizzard, Brattleboro, Vermont*, 1940. Library of Congress, Prints & Photographs Division, FSA-OWI Collection, LC-USF34-053018-D

On one level, the painting depicts the good fortune of the Rockwells, extended to represent a typical American family. Warmth and good cheer are matched by the generous supply of food (too generous for the times, Rockwell later thought). The old gentleman presiding over the table has the demeanor of a good-natured patriarch. Grace has already been said (or was, perhaps, dispensed with); otherwise he continues the role that heads of families and church elders had assumed in earlier Thanksgiving paintings. From the window behind him, a cleansing white light falls across the table, transforming the food and the serving pieces into ceremonial items. The objects rest on a simple white cloth, softly worked to provide a tranquil surface across which the family carries on a lively exchange. That exchange ripples down both sides of the table, and finally out to the viewer, who is engaged by the glance of the middle-aged man at the lower right.

Sharing is the more subtle message of the picture. The bowl of fruit in the center foreground is an invitation to join the family gathering, to experience

the blessings of middle-class life. At the same time, to move from the viewer's end of the table to the opposite end involves working through the family hierarchy—the more serious side of the sharing message. The prestige bestowed on the old gentleman carving the turkey must be earned. Thus the painting alludes to the social dynamics of the nuclear family—how they define values and maintain order and stability in an America still recovering from the depression.

The Lucioni painting, I would argue, turns *Freedom from Want* inside out—that is, it provides the exterior setting for the kind of highly ritualized family gathering that Rockwell has set in his own Vermont dining room. The self-sufficient village of Stowe, folded neatly into the mountains above, can be seen as an image equally important in establishing domestic standards for the region and the nation. So, in different ways, do two additional New England images, both made in the 1930s and 1940s. The first is a view of the main street of Brattleboro, Vermont (fig. 5), by the Farm Security Administration photographer Marion Post Wolcott; the second is *In the Green Mountains* (fig. 6) by Grandma Moses. Wolcott comfortably juxtaposed new and old Brattleboro; Grandma Moses, instead, retreated from the present into an innocent past. In the end, however, both pictures construct an ideal domestic world—small-town, intimate,

Fig. 6. Grandma Moses (American, 1860–1961), *In the Green Mountains,* 1946. Oil on pressed wood, 17 ½ x 21 ½ inches (44.5 x 54.6 cm). Grandma Moses Properties Co., New York

and, for the most part, untroubled by the social and economic conditions of that era.

To make these arguments in an exhibition, would surely require several extended text panels. But visual complements, such as the ones illustrated above, provide the most helpful context for *Freedom from Want.* They explain, using related subjects, how the picture defined values for middle- and working-class Americans, reminding them, at a critical time during World War II, that fighting for freedom was a way to secure "a healthy peacetime life."[8]

Providing such a context runs counter to what most American art museums

have been doing for the past century. Between about 1910 and 1920, they turned from programs that stressed the social and moral benefits of art appreciation to ones that stressed the pleasure of viewing. Alan Wallach and Carol Duncan have thoughtfully described the effects of this change on museum culture in the twentieth century.[9] Briefly stated, it has encouraged museums to feature art as unique and sacred—as objects on a pedestal, to be worshiped passively by adoring viewers. Matthew Prichard, an official of the Boston Museum of Fine Arts at the turn of the nineteenth century, maintained that the mission of an art museum was not "[to] educate [visitors], but to make its treasures their friends for life and their standards of beauty." Joy, not knowledge, Prichard claimed, was "the [sole] aim of contemplating" works of art.[10] Housing the great collections of this era are numerous classical buildings, each drawing on the past to give authority to newer aesthetic ideals. These ideals encouraged artists at the turn of the century to privilege the act of art making, thus calling attention to their personal touch. The work of Tonalists and Impressionists, such as George Inness (fig. 7) and John Twachtman, represent the quieter, carefully measured aspect of this trend; cosmopolitan artists such as James Abbott McNeill Whistler and John Singer Sargent (fig. 8) were more assertive in claiming artistic distinction.

Fig. 7. George Inness (American, 1825–1894), *Niagara*, 1889. Oil on canvas, 30 × 45 inches (76.2 × 114.3 cm). Smithsonian American Art Museum, Washington, D.C. Gift of William T. Evans

In the late twentieth century, museums adopted corporate strategies to carry on their mission. Depending on the appeal of masterpieces, and of artist/geniuses (such as Sargent and Vincent van Gogh), who have an established record for attracting large audiences, museums have marketed their authority as tastemakers with great success. Not surprisingly, some of their best customers have been corporations, who have generously underwritten major art exhibitions across the country. The motives of these sponsors are various, from dedicated public service to putting a more acceptable gloss on their image and products.[11]

Once outside this circular relationship, and the benefits that accrue to each party, it is harder for curators to present art in a context that invites active viewer participation. Remove art from its exalted station, show it responding to issues of time and place, and both museums and corporations become uneasy. That version of art is too close to home. What museums and corporations can sell more easily is art on a pedestal. Needless to say, this has a chilling effect on the kinds of shows museums are willing to undertake. Ideas debated within the academy can be met with a sobering lack of support once they cross to the public realm, especially to museum sponsors and supporters accustomed to regarding art as a medium free of the tension and discord of everyday life.

Fig. 8. John Singer Sargent (American, 1856–1925), *Betty Wertheimer,* 1908. Oil on canvas, 50 ¾ × 39 ⅜ inches (128.9 × 100 cm). Smithsonian American Art Museum, Washington, D.C. Gift of John Gellatly

I wish to thank Alan Wallach and Roger Stein for suggestions that greatly improved this article.

1. Robert Hughes, "How the West Was Spun," *Time,* 13 May 1991, 80.

2. Wanda Corn, "Coming of Age: Historical Scholarship in American Art" (see the afterword), in *Critical Issues in American Art: A Book of Readings,* ed. Mary Ann Calo (Boulder, Co.: Westview Press, 1998), 26.

3. For example, in taking issue with the way a painting was interpreted in a recent National Museum of American Art catalogue, the director of a small museum in New England claimed that artists are "almost exclusively concerned with . . . aesthetic fundamentals," and that the content of a work is self-evident ("a painting . . . is what it is: nothing more, nothing less"). See letters of 11 August and 3 September, 1999, in *Picturing Old New England: Image and Memory* exhibition files.

4. Peter Schjeldahl, "Springtime for Kiefer," *New Yorker,* 18 January 1999, 83.

5. Schjeldahl, "Springtime for Kiefer."

6. William H. Truettner, ed., *The West as America: Reinterpreting Images of the Frontier, 1820–1920,* exh. cat. (Washington, D.C.: The Smithsonian Institution Press, 1991).

7. Norman Rockwell, *My Adventures as an Illustrator* (New York: Doubleday, 1960), 342–43.

8. The quotation is from the "Four Freedoms" speech. See James MacGregor Burns, *Roosevelt: The Soldier of Freedom* (New York: Harcourt Brace Jovanovich, 1970), 34.

9. Alan Wallach, *Exhibiting Contradiction* (Amherst: University of Massachusetts Press, 1998), esp. chaps. 3, 8, and 9. See also Carol Duncan, "The Art Museum as Ritual," in Donald Preziosi, ed., *The Art of Art History: A Critical Anthology* (Oxford: Oxford University Press, 1998), 473–85.

10. Quoted in Wallach, *Exhibiting Contradiction,* 52.

11. The Van Gogh exhibition, held at the National Gallery of Art in Washington, D.C., in late 1998, is a case in point. When James Murphy, director of marketing and communications for Anderson Consulting, was asked why his company chose to sponsor the show, Murphy replied that he thought Van Gogh's work would attract top corporate executives from across the nation. Murphy proved to be right. "We got nothing but raves," he said, which had the desired effect of bringing numerous clients to the previews and dinners Anderson hosted during the show. See Kenneth Bredemeier, "Exhibiting the Fine Art of Corporate Image-Building," *Washington Post,* 23 January 1999, E9.

IMPRESSIONISM
The Blockbuster and Revisionist Scholarship

Murder, Autopsy, or Dissection? Art History Divides Artists into Parts: The Cases of Edgar Degas and Claude Monet

Richard R. Brettell

My title is a little too provocative. In fact, if I were giving you the first version, it would be filled with blood and organs and veins and all sorts of disgusting things, because that is what one does when one talks about murder, autopsy, or dissection. And in fact it is backing away from that wonderful title that has produced a rather dull talk.

Artists are never really whole, not even in their lifetimes. Their works, especially with the capitalist art market, were created to be dispersed, and in fact it is only in the artificial and generally posthumous constructions, called monographs or *catalogues raisonnés*, that they are made whole. Yet the monograph and its exhibition equivalent have proven to be so dominant as modes of artistic exploitation that we have come to think of them as virtually transparent.

Every generation, it seems, must once again reassemble the most significant part of the oeuvre of canonical artists, so as to reassess the relevance and power of this material to contemporary audiences, or to test current hypotheses or modes of interpretation. Hence the Gauguin of 1906, when the first retrospective was shown at the 1906 Paris Salon d'Automne, is perforce a different Gauguin than the one reassembled in London in 1955 or Chicago and Washington in 1988.[1]

I introduce Gauguin for two reasons. First, he continues to be the subject of fierce and fascinating debate among scholars and museum professionals today, and second, because I myself played a role in his 1988 reassembly. Indeed, it was precisely because I feared his dissection or murder that I strove with all the gusto of youth to create the conditions for the most recent big retrospective.

Let me explain. When I arrived as a completely unseasoned, inexperienced curator of European painting at the Art Institute of Chicago in 1980, and after I had been there just a few months and involved in a 1980 exhumation of Pissarro, which many of you saw in Boston and London and Paris, I learned about three exhibitions involving Gauguin, all of which were in the planning and early fund-raising stages. One of them, to have been curated by the legendary Kirk Varnedoe for the National Gallery, Washington, and the Guggenheim Museum, was to be called *Gauguin in Tahiti*. The second, planned by Michel

Laclotte and his colleagues for the opening of the Musée d'Orsay, was to be devoted to *Gauguin et l'Ecole de Pont Aven*. The third was being planned by Harold Joachim, then curator of prints and drawings at the Art Institute, and was to celebrate and publish Gauguin's fascinating graphic works, a major collection of which is in the Art Institute of Chicago.

In beginning to correspond with Varnedoe and Laclotte about possible Art Institute loans to two of these three exhibitions, I decided to do something I had actually never done. Using the Ryerson Library at the Art Institute, I reviewed all the previous exhibitions devoted to Gauguin since his death in 1903. This enabled me to measure the intellectual importance of these new projects within a firmly defined context. The result surprised me. I found that as an artist, Gauguin had been more often dissected than presented whole. Publications and exhibitions had treated his work in various physical mediums separately, had divided his oeuvre into areas that were geographically, rather than aesthetically, motivated, and had routinely seen him as a member of groups: the Impressionists, the School of Pont Aven, synthetists, Nabis, Symbolists, Post-Impressionists, etc. Thus, the whole Gauguin—the businessman, the writer, the performer, the painter, the sculptor, the ceramicist, the printmaker, the promoter, the journalist—had not been reassessed in exhibition form since the posthumous 1906 exhibition in Paris.

As a result of this survey, I decided, without consulting the director or my museum colleagues, to write a long and passionate personal letter to Michel Laclotte, the only person powerful enough actually to affect this political/aesthetic complex of exhibitions and publications. My letter analyzed the state of Gauguin scholarship as well as the history of exhibitions of his oeuvre. It argued that the present program of three as yet unrealized exhibitions had slight chance of altering or expanding knowledge about his oeuvre, and that it was time to reappraise his work as a whole. It was, in reflection, the most important text I have ever written about Gauguin, because Laclotte made several telephone calls and had a couple of meetings, and the three exhibitions were cancelled, and the art of Paul Gauguin was born. And I was asked to work with Françoise Cachin and Kirk Varnedoe (and later Charles Stuckey) to make it happen.

I tell the story because embedded in it is a sort of intellectual tragedy. This is, that institutions plan exhibitions and their resulting publications often without serious and thoughtful attempts to measure the effects of their actions on human knowledge as a whole. As long as two conditions have been met—

(1) that no similar exhibition has been mounted in the last ten to fifteen years, and (2) that no one else more powerful is already doing the same subject—an exhibition is most often a go. And this is virtually assured when we're dealing with artists with the marquee power, and hence fundability, of a Gauguin, a Monet, or a Degas.

So on to my colleagues, particularly to Paul Tucker and Richard Kendall, both scholars and independent curators, both unassociated with a powerful museum, and both physicians who have performed an autopsy on, dissected, or murdered their artists, Degas and Monet respectively.

I must confess to having myself done this with my artist, Camille Pissarro, both in publishing a book on a geographically and temporally bound segment of his oeuvre,[2] and by doing an exhibition with his great-grandson devoted to the late urban pictures,[3] and another tiny one to his early work in St. Thomas.[4] But my action came after having worked on the last retrospective, in which his entire oeuvre was reassessed in three major cities. Not so theirs.

Let us take Degas first. Here I must hasten to admit that Richard Kendall, although a dominating person in the world of recent Degas exhibitions, is by no means alone. First of all, Degas's oeuvre was recently rehearsed in toto in an immense exhibition with an equally immense catalogue by four major Degas scholars.

The artist's life has been the subject of an imposing biography, written by the French museum scholar Henri Loyrette,[5] and soon we will have a publication of his letters, overseen by Theodore Reff. In this case, the whole has been subject to the generational scrutiny that we have come to expect for all canonical artists. But in addition to this, we have been treated to separate exhibitions devoted to the various subjects in Degas's oeuvre—the races, the ballet, portraits, and the landscape—and to periods in his career: the years in Italy, the New Orleans interlude (a fascinating exhibition that opened in summer 1999 in that city), and the last three decades.[6] We have been treated to major reappraisals of his prints and most recently to his photography, as well as specialized exhibitions intended to provide a new interpretive context for several key works of art, *The Bellelli Family*, *Hélène Rouart in Her Father's Study*, and *The Little Dancer of Fourteen Years*.[7]

We have also seen Degas's private collection, assembled partially at the National Gallery, London, and more fully at the Metropolitan Museum of Art, as it never could have been in his lifetime,[8] and in addition, we have been

treated to an in-depth look at what Richard Thompson called his "private" working methods.[9]

All in all, the last decade has seen more than a dozen Degas exhibitions, with scholarly catalogues, major international loans, and resulting public reviews. Richard Kendall and Jill De Vonyar are actually attempting the seemingly impossible task of looking yet again at Degas's representations of the ballet. I assure you, we're going to learn a lot from their looking yet again. The brand name "Degas" is alive and well. This constellation of exhibitions is probably unique in the history of museum presentations of the work of a single artist, unique in its variety, range, and concentration. I know of no artists who have been so thoroughly and variously dissected in such a comparatively short period of time. Matisse and Picasso might come close, but I doubt that any recent decade in their exhibition history can surpass that of Degas in the period 1985 to 1999.

Interestingly, the Degas bibliography is almost completely dominated by the books and/or catalogues produced in connection with these exhibitions. They overwhelm the books, dissertations, and scholarly articles produced by the academy in the United States, England, Germany, and France. Here, museum scholarship triumphs numerically, and in many ways methodologically, over academic art history. Perhaps only in the realm of feminist scholarship has the academy made advances that are essentially unrecognized by museum publications. Carol Armstrong, Hollis Clayson, and Eunice Lipton have never done Degas exhibitions, and no one has ever asked Griselda Pollock to do anything so seemingly polite as to curate a Degas exhibition.

What, one might ask, is the shape of this museum Degas? He is an artist obsessed by two major subjects, the dance and the horse race. He worked experimentally in many mediums. He made major contributions to two of the lowest in the hierarchy of pictorial genres: portrait and landscape. He worked and reworked certain major masterpieces, allowing us to create production and conception narratives that are so complex that we art historians wring our hands with pleasure as we tell them. And he lived a long and productive life, making experimental work long into the twentieth century.

Certain of these projects, generally those by Richard Kendall, *are* revisionist. Who before him would have mounted an entire exhibition on Degas's landscapes? Who would bring nearly 100 works of art to bear on producing complex new meanings for a familiar work like the *Little Dancer of Fourteen*

Years? Who besides Kendall would have thought that the late Degas, the Degas beyond Impressionism, was as inventive as he actually was?

Yet one must ask questions as well about the efficacy of *all* these projects. Let us take the late Degas as an example. The beautiful exhibition called *Degas: Beyond Impressionism* opened at the National Gallery in London in the spring of 1996, a little more than seven years after the close of the great Degas exhibition in Paris, Ottawa, and New York.[10] *Beyond Impressionism* contained 102 works, and was accompanied by a beautiful and stimulating catalogue with more than 300 pages, and lots of color plates. Yet its claims that the last decades of Degas's career were what Kendall himself called "little-explored territory" are difficult to swallow when we examine the catalogue of the 1988–89 retrospective.

With 392 total works, it devoted 220 dense pages ans included 98 works (only 4 fewer than Kendall's later exhibition) from the period 1890 to 1912 in Degas's career. And almost half the works, the late works, in the retrospective made a reappearance in the National Gallery less than a decade later. How little explored was this territory, actually. It is true that Kendall's catalogue is both more synoptic and more wide-ranging than that of Jean Sutherland Boggs, who was limited by the format and the collaborative nature of a monographic exhibition and its catalogue.[11] Yet when I walked through *Degas* at the Met, I was even more astounded than I was in London and Chicago seven years later, by the sheer experimental power of these works and by the chromatic extravagance of Degas after 1890.

It was precisely because the hot orange excesses of the Philadelphia and London canvases could be seen just fifteen or twenty minutes after the value-rather than color-dominated paintings of the late 1870s and 1880s that I had such a powerful sense of their originality. This exercise, comparing the representation of works in monographic exhibitions and its catalogue with those in a specialized exhibition and its catalogue might force one to question, oftentimes, the wisdom of smaller exhibitions. One might even create a professional formula: if the idea is new, if the scholarly publication will be a real contribution to the discourse, and if more than two-thirds of the works in the exhibition have not been included in another exhibition with a similar subject within a generation, then the exhibition is a go.

What of Monet? We have had *Monet in the Nineties* for the 1990s, *Monet in the 20th Century* for the 21st century.[12] We've had *Monet in London, Monet in Rouen, Monet at Vétheuil,* and *Monet in the Mediterranean,* and these have been

done around Charles Stuckey's big Monet retrospective in Chicago.[13] All these exhibitions broke, or almost broke, attendance records. All had lines and inexpensive catalogs produced in volume, thereby bringing scholarship or, for our purposes, museum scholarship, to the masses. Six were done to fill in the gaps of the historical Monet, and the other, to define that historical Monet for this generation. Among them there was a tremendous overlap of works of art. In certain cases, works of art had been loaned more than they ought to have been, generally to bring credibility to the exhibition, and, if the truth be told, to repay museum-to-museum debts in the floating craps game called exhibitions. Private collectors, except those interested principally in either fame or the market, are becoming increasingly wary of the circus, and this wariness will result in exhibitions with a decreasing number of new or virtually unpublished works of art.

In the case of Monet, I would argue against the big exhibition. I would argue that the big exhibition actually taught us less than the specialized exhibition, and should I have been able to write a letter to an imaginary Michel Laclotte, I would actually have argued against the Chicago Monet retrospective and for the several smaller, concentrated examinations of parts of his immense oeuvre.

Indeed, if one were to apply the Degas model to Monet's oeuvre, we would be able to mount important exhibitions devoted to his pastels and drawings, his portraits, his extraordinary still lifes, his Salon paintings, his signed oil sketches, his interaction with Renoir or Sargent, his effect on American art, et cetera. We simply know the whole Monet better than we do or did the whole Degas. To release him from the monograph would be a service both to his oeuvre and to our understanding of modern painting.

In this short paper, I have argued that there are values to concentration for certain artists and for survey treatment for others. Yet we must remember several things: one, the public has no scholarly memory; two, a tiny minority of people actually travel more than regionally to see exhibitions, and are, hence, unfamiliar with the exhibition history of an artist; and three, in creating exhibitions, we are putting works of art at risk by removing them from physically stable contexts and subjecting them to many forms of stress.

This brings me to what is evident as a motivating factor in all these exhibitions: the desire for publicity and audience and the concomitant desire to maximize the exposure of canonical artists for the purposes of attendance and income. The brand-name appeal of certain artists ensures that their works will produce a large audience. It is the task of the museum and the academy to

ensure that the continued exposure of these artists' oeuvre to public audiences is actually imaginative.

Little progress has been made in advanced scholarship in altering the canon of modern French painting. T. J. Clark and his students, as well as the post-structuralist critics in today's universities, write about the very same works of art as did the German critic Julius Meier-Graefe at the beginning of the twentieth century and John Rewald in mid-century.

We must also remember that the bodies of work left by canonical artists are not actual bodies. An artist's oeuvre cannot be murdered, autopsied, or dissected. It can only be reconstituted in various combinations, in various institutions, for various audiences. I myself am becoming increasingly aware of the global hunger for Impressionist exhibitions, not just in Japan, which I have stupidly omitted from this Euro-American survey, but in Southeast Asia, Australia, Latin America, Central Europe, Russia, and even parts of the Middle East.

I myself feel that when these works are reconstituted outside of what might be called the "canonical context," Euro-American cosmopolitan urban museums, we will learn even more about ourselves and about the particular forms of capitalist modernism that Impressionism has come to exemplify. Let us remember that new audiences reinvigorate old objects and old ideas.

1. Douglas Cooper, ed., *Gauguin: An Exhibition of Paintings, Engravings, and Sculpture*, exh. cat. (London: Tate Gallery, 1955); Richard Brettell, ed., *The Art of Paul Gauguin*, exh. cat. (Washington, D.C.: National Gallery of Art, 1988).

2. Richard R. Brettell with Joachim Pissarro, *Pissarro and Pontoise: The Painter in a Landscape* (New Haven: Yale University Press, 1977).

3. Richard R. Brettell and Joachim Pissarro, *The Impressionist and the City: Pissarro's Series Paintings*, exh. cat. (New Haven: Yale University Press, 1992).

4. Richard R. Brettell and Karen Zukowski, *Camille Pissarro in the Caribbean, 1850–1855: Drawings from the Collection at Olana*, exh. cat. (New York: New York State Office of Parks, Recreation, and Historic Preservation, 1996).

5. Henri Loyrette, *Degas* (Paris: Fayard, 1991).

6. Jean Sutherland Boggs, *Degas at the Races*, exh. cat. (Washington, D.C.: National Gallery of Art, 1998); George T. M. Shackelford, *Degas: The Dancers* (Washington, D.C.: National Gallery of Art, 1984); Felix Baumann and Marianne Karabelnik, eds., *Degas Portraits*, exh. cat. (London: Merrell

Holberton, 1994); Richard Kendall, *Degas Landscapes*, exh. cat. (New Haven: Yale University Press, 1993); Accademia di Francia, *Degas e l'Italia* (Rome: Fratelli Palombi, 1984); Jean Sutherland Boggs, *Degas and New Orleans: A French Impressionist in America*, exh. cat. (New Orleans: New Orleans Museum of Art; Copenhagen: Ordrupgaard: 1999); Richard Kendall, *Degas: Beyond Impressionism*, exh. cat. (London: National Gallery Publications, 1996).

7. Sue Walsh and Barbara Stern Shapiro, *Edgar Degas: The Painter as Printmaker* (Boston: Museum of Fine Arts, 1984); Malcolm Daniel, *Edgar Degas: Photographer* (New York: Metropolitan Museum of Art, 1998); Hanne Finsen, *Degas and the Bellelli Family*, exh. cat. (Copenhagen: Ordrupgaard, 1983); Dillian Gordon, *Edgar Degas: Hélène Rouart in Her Father's Study*, Acquisitions in Focus, no. 4 (London: National Gallery, 1984); Richard Kendall, ed., *Degas and the Little Dancer*, exh. cat. (New Haven: Yale University Press; Omaha, Nebr.: Joslyn Art Museum, 1998).

8. Ann Dumas et al., *The Private Collection of Edgar Degas*, exh. cat. (New York: Metropolitan Museum of Art, 1997).

9. Richard Thompson, *The Private Degas* (London: Herbert Press, 1987).

10. Kendall, *Beyond Impressionism*.

11. Jean Sutherland Boggs, *Degas,* exh. cat. (Chicago: Art Institute of Chicago, 1996).

12. Paul Hayes Tucker, ed., *Monet in the '90s: The Series Paintings*, exh. cat. (Boston: Museum of Fine Arts, 1989); Paul Hayes Tucker with George T. M. Shackelford and Mary Anne Stevens, *Monet in the 20th Century*, exh. cat. (Boston: Museum of Fine Arts, 1998).

13. Grace Seiberling, ed., *Monet in London*, exh. cat. (Atlanta: High Museum of Art, 1988); Musée des Beaux-Arts, Rouen, *Les Cathédrales de Monet: Rouen* (Paris: Reunion des Musées Nationaux, 1994); Annette Dixon, Carole McNamara, and Charles Stuckey, eds., *Monet at Vétheuil: The Turning Point*, exh. cat. (Ann Arbor: University of Michigan, 1998); Joachim Pissarro, *Monet and the Mediterranean*, exh. cat. (Fort Worth: Kimbell Art Museum, 1997).

A History of Absence Belatedly Addressed: Impressionism with and without Mary Cassatt

Griselda Pollock

Against Exhibitions

In 1915 the art collector and feminist activist Louisine Havemeyer (figs. 1 and 2) organized an exhibition as a benefit for women's suffrage at the New York galleries of M. Knoedler. Displaying both old and modern masterpieces, the show represented latter-day art by just two painters, Edgar Degas and Mary Cassatt. These forty-six examples belonged to major American collectors of the time —from families named Whittemore, Sears, Havemeyer, and Frick—whose bequests would form the foundational holdings of modern French art in museums in Boston and New York.[1]

Fig. 1. Louisine Havemeyer with the Torch of Liberty, 1915. Published in *Scribner's Magazine* 71 (May 1922)

With the works of Degas and Cassatt hung on the walls of one room (figs. 3 and 4), fronted by Old Masters, the exhibition juxtaposed what was modern in art with what was new for women of diverse classes within modernity. Through the two radically different aesthetic practices and ideological perspectives represented, it confirmed modernism's necessary dialogue with the museum effect: the creation of art's histories. At that historic confluence of aesthetic modernism and feminism, Degas and Cassatt could coexist in ways that, so soon thereafter, would become unthinkable to the art historical establishment of both museum and university. We need an act of historical imagination to grasp what advanced women such as Havemeyer and Cassatt *saw* when they assembled this show: old and modern painters, Degas and Cassatt facing each other. To comprehend how this conjunction was both possible and necessary a radical reorientation of current curatorial and art historical conventions is in order.

Fig. 2. Mary Cassatt (American, 1844–1926), *Louisine Havemeyer and Her Daughter Electra,* 1896. Pastel on wove paper, 24 × 29½ inches (61 × 75 cm). Shelburne Museum, Shelburne, Vermont

By 1954, when the curator of the Art Institute of Chicago, Frederick Sweet, mounted an exhibition of three nineteenth-century American expatriate artists involved in European modernism— *Sargent, Whistler, and Mary Cassatt*— the art historian Edgar Richardson offered condescending boredom as his only response to the work of Cassatt: "As a recorder of the female side of that little circle of wealth and privilege, she will always have a place. But tea, clothes and nursery; nursery, clothes and tea."[2] Richardson simply could not see what the French symbolist author Achille Segard had hailed in 1913:

> Such is her place along the Impressionists. She agrees with all the others when it comes to the use of lively and brilliant tones; new and unpredictable harmonies of color; certain peculiarities of composition, or rather *mise en toile*; the need to allow neither anecdote nor any conventional subject; the belief that realism is indispensable; a scrupulous conception of artistic conscience, which demands that one transcribe only emotions that one has experienced sincerely; the obligation to work directly from nature. But Mary Cassatt is set apart from the others by the *intellectual* quality of her feelings, and by a sort of emotional lyricism that is revealed in her work through faces, gestures, and movements alone.[3]

During a lecture with abundant slides, or in an exhibition catalogue, it is possible, and economically feasible, to examine this claim by the display of faces, gestures, and movements in the art of Cassatt. I have repeatedly found such a sequence of details necessary when presenting the work of this artist. Cassatt's reputation has been distorted both by the disdain of the Edgar Richardsons of the world, who see only the limited domesticity of the subject matter—tea, clothes, and nursery—and by the enthusiasm of feminists. Many of the latter justifiably seek to recontextualize such *intimisme* within the cultural revolution

of Impressionism as a whole and the social relations of gender so central to bourgeois modernity. To a lesser extent some of us have addressed the formal, compositional, and painterly qualities that secured for Cassatt a reputation among her contemporaries as an intellectual—an artist whose formal rigor and thoroughly art historically grounded fascination with composition and the rhetorics of the body, gesture, and the face provide a necessary modernist armature for the exploration of what I have called psychological interiority.[4] This term updates what appealed to the symbolist Segard as a level of meaning, embedded within its material infrastructure of form, that touched on human presence and inner reflection. In this context, the extended visual tracking through the oeuvre is not possible, leaving us once again to confront an important distinction between the museum display and the art historical text.

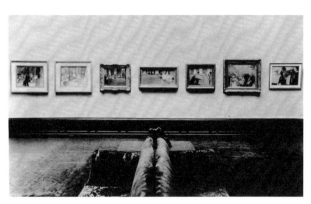

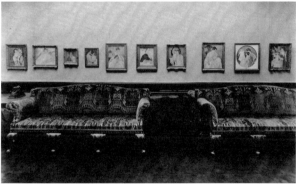

Figs. 3 and 4. Installation of *Loan Exhibition of Masterpieces by Old and Modern Masters,* M. Knoedler and Co. Gallery, New York, 1915, showing the Degas wall (above) and the Cassatt wall (below)

It was not until the 1970s that a defiant challenge was posed to the rampant sexism of the twentieth-century art world. The feminist critique of art history has never, however, been concerned merely with minor revisions, such as adding a woman as the odd footnote to an unchanged, canonical "story of art." Indicting the discipline for its structural phallocentrism and narcissistic sexism (which, ironically, has led to an intellectual blindness, or worse, an active misrepresentation of history), feminist scholars have argued that a historic reconfiguration of the terms *intellectuality, sexuality,* and *creativity* was a fundamental element of modernism between the Second Empire in France and the outbreak of the Second World War. Far from being raised anachronistically late in the twentieth

century and misapplied to the preceding one, gender issues were already central to the culture and society from which modernism emerged as its distinctive cultural articulation. Questions of sexual difference are part of the historical archive and of modernist representation. The writers of twentieth-century art history, however, quarantined discussion of sexuality and the artistically inscribed struggle over its symbolic significance for modernity, modern culture, and modern, gendered subjectivities.[5] We are now, therefore, being obliged to recognize belatedly the extent to which these debates were integral to the aesthetic as well as social and cultural manifestations of the modern in the nineteenth century.

Despite the accommodations made by both university and museum art history to the challenges of the 1970s, the reigning powers have ruthlessly excluded and pointedly ignored what I named in 1988 "feminist interventions into art's histories."[6] So radical a questioning of how we think and write about and display art is dismissed as aberrant. It demands genuine reformulations of the discipline: something other than art history must now take up the study of the histories of art.[7] The feminist provocation to art history demands an understanding that the last great modernization—that of sexual difference—is still the unfinished business of the modernist project. Furthermore, it has become a central problematic of its postmodernist supersession in a new alliance with the extended discussions of difference, alterity, and the signifying process. The questioning of sexual difference, aligned with the theoretical revolutions that led to the other major modernizations of the early twentieth century—of knowledge of the physical universe (Albert Einstein), of theories of language (Ferdinand de Saussure), and of understanding of the unconscious and the psyche (Sigmund Freud)—also took place in and through the visual and the literary within the field of culture. At that historical moment, however, it was widely accepted that these cultural fields seriously articulated issues of subjectivity, sexuality, ontology, and epistemology. They were expected to deal with difficult questions of being, appearance, difference, and meaning; and thus it was not inappropriate, or political, to address art through philosophy, politics, or psychology.

Nothing proves this negative case against Art History more efficiently than the spate of recent blockbusters dedicated to scholarly revisioning of what John Rewald's twin volumes for the Museum of Modern Art gave us as Impressionism and Post-Impressionism. From almost every exhibition text that claims to offer traditional, revisionist, or merely spectacular encounters with the art of the second half of the nineteenth century, any serious engagement with

feminist interventions is totally absent. Through the last three decades, the museum establishment has remade our historical knowledge of early modernism with major centennial exhibitions of Manet, Degas, Seurat, Pissarro, Renoir, Toulouse-Lautrec, and Cézanne, whose early and late careers have also had specialist shows; with revisions of the eight Impressionist exhibitions; and with reassessments of the origins of Impressionism. Between 1980 and 1990 Vincent van Gogh was the object of at least seven major exhibitions devoted to almost every phase and several aspects of his work. Yet it was not until 1998–99 that an exhibition of the work of Cassatt was conceived and circulated.[8] Even with this belated and limited show, Cassatt has been reinstated as an American artist only at the price of her no longer being visible as a participant in French Impressionism and its complex aftermath. Originally planned for New York's Metropolitan Museum of Art, the Cassatt exhibition was dismissed by that institution's chief policy makers because the artist was too boring and overexposed! Following an American trajectory from Chicago to Boston and to Washington, D.C., the show was taken neither by the Tate Gallery in London (which held a John Singer Sargent exhibition in 1998) nor by the Royal Academy (which entertained phenomenal crowds, during the same months the Cassatt show toured the United States, with an exhibition—*Monet in the 20th Century*—that preceded *Mary Cassatt* at Boston's Museum of Fine Arts), Paris would not consider the Cassatt exhibition at all ("Marie qui?").

Cassatt, like Berthe Morisot before her,[9] has been ignored by the key Paris/London/New York exhibition axis. Paradoxically, for the international museum audiences, actively and constantly educated by the blockbuster event, the one American artist to be integrated as a full artistic and intellectual partner in the adventure of Parisian modernism simply does not exist as a figure in that avant-garde circle. Thus, the example of Cassatt shows how an entire generation, from the 1970s to the later 1990s, has been systematically disinformed about what happened in art in nineteenth-century Paris. She is consigned, like several other major modern artists whose art historical fate was sealed by being women (Georgia O'Keeffe and Frida Kahlo, for instance), to the fatefully swift passage from neglected obscurity to overmerchandised popularity without even a momentary halt at the site of intellectual and scholarly reevaluation.

A museum's permanent collection creates for its regular publics an initial and authorized familiarity with the canon that is then extended and fed by the special exhibition, with its apparatus of scholarly catalogue lodged both on

coffee-table and in university art library. The intersection of the museum and the university takes place through a kind of "show and tell."[10] Inexplicably, the truncated tour of *Mary Cassatt: Modern Woman* has shown her work, but there has been no telling—no moment that assembled the usual suspects for serious debate about how this body of work looks to the eyes of art historians retrained after so much new work on the Impressionist moment, or to the intellectual aerials of scholars retuned by twenty-five years of the cultural revolution of feminist theory. None of the American museums that hosted the Cassatt exhibition organized a major conference or symposium to stimulate scholarship on this artist or to create —especially for those who had not encountered her work since 1970—the possibility for imagining how her full incorporation into an expanded history of art might change how we think about Manet, Degas, Pissarro, Monet, or Morisot. The Chicago Art Institute managed a half-day event but nervously combined it only with a debate about the other woman artist whose works they were showing at the time, the Victorian British photographer Julia Margaret Cameron (a timid but effective reghettoization within an all-women event). The Museum of Fine Arts in Boston put on a half-day of talks by distinguished local academics—an event that at least included a lecture by Linda Nochlin, the preeminent scholar of nineteenth-century French art and of feminist art history (who was not, significantly, invited to the symposium in Chicago). Washington's National Gallery planned nothing. Despite its extensive holdings of her work in the Chester Dale collection and the donations and loans from the Mellon family, the museum failed, it seems, to get funding for any art historical event relating to their high-summer showing of the Cassatt exhibition.

These limited events suggest not only a radical loss of nerve but the legacy of the museum's total blockage of feminism's critical interventions in art's histories. Museum art historians are frankly embarrassed by a subject about which they remain recalcitrantly ignorant. Few read the expanding literature outside of art history that is the hallmark of feminism's interdisciplinary and multidisciplinary renovation in every field of contemporary academic endeavor. It would appear that the museum scholar thinks of the feminist manifesto as implying something silly about equality for what he or she presumes are really second-rate artists. The natural equation of the feminine and the inferior, rooted in linguistic and historical hierarchies, is unquestioned because the curators seldom read any structuralism or ideology critique that might render them self-reflective about the ideological frameworks they inhabit as common sense. This failure reveals

not so much the crude split between university and museum; it compounds the absolute incompatibility between feminism as part of a wider radicalization of intellectual practice and the traditional disciplinary formations of art history, still rooted in the narcissistic fantasy of the artist-as-hero lodged within nationalistic legends.

At Boston's Museum of Fine Arts, the Acoustiguide revealed how slightly the so-called revisionism of the social history of art had been absorbed by a generation of curators unsure of how to sell a woman artist whose canonical place they doubt. Cassatt's work was legitimated to its viewing public in terms of histories of taste—for Spain, for fashion, for the theater, for Japanese prints, or for social ideas such as the cult of motherhood. But as I toured the exhibition listening to the pale reflection of arguments I once proposed in a more rigorous vocabulary at the very beginning of a twenty-year study of this artist,[11] I found myself perversely longing for any statement about Cassatt's extraordinary brilliance as a painter, etcher, and pastelist. Where was the discourse on this artist's radical uses of space, on color and surface, on facture, on framing, on flatness and illusion, on reflection and vision? Why could these curators not be better modernists and allow an artist who was a woman to be what the museum always sells us: the great *painter*? Where was any reference to the careful tracking of the relations between bourgeois domesticity, psychological interiority, and the emergence of a symbolist aesthetic through which to read the work after 1891? It is these facets—registering so profoundly the discontinuities between the short-lived moment of Impressionism and the creative reexamination of the relations between modernity and tradition—that yielded the confused but fascinating kaleidoscope of competing modernisms as the century turned. Some further discussion of such matters is to be found in the catalogue essays, where art historical contextualization provides a range of comparative illustrations. Yet these observations in print contrast radically with the vividness of the exhibition as the site of our direct encounter with the painter's mark and the materialized traces of an artistic intellect.

An older colleague once remarked laconically to me in the early days of my academic career as a social historian of art: "Of course, when aesthetics fail, sociology is the only recourse." Something of this taint—social rather than purely aesthetic merit—lingers over the Boston audio guide. Simplified social iconography is, however, a radical misrepresentation of the social history of art and its critical engagement with the selective legacies of modernist discourses. As T. J. Clark

spelled it out in 1984: "I wish to show that the circumstances of modernism were not modern, and only became so by being given the *forms* called 'spectacle.'"[12] For this reason it was Manet's mission (a labor long and fundamentally incomplete) to find a series of signs that showed—not by illustration but by signifying obliquely in a new set of formal dispositions—the inherent ambiguities of meaning and identity in modernity. According to Clark's study of what he calls "painting in Paris" (Impressionism), we must unlearn our present ease with that school, so fostered by the blockbuster exhibition. We must undo any sense that its dealings with the world were somehow visually direct. It is such oversimplification that makes this difficult art so vulnerable to commodification as the most comforting and affirming art on offer. Hence the counterfocus of Clark's other hero: the endlessly difficult and often unattractive anarchist Camille Pissarro.[13] We must reassess the meaning of these painters' persistence at the fault line between perception and representation mediated so self-consciously by materiality and praxis: painting.

> So [Clark concludes a passage on Pissarro] painting put equivalence at a distance. No doubt Pissarro and his friends believed that the look of the world would be found eventually, but only in a dance of likenesses guessed at or half-glimpsed, and always on the point of disappearing into mere matter. For it was matter—paint itself —which was the key to any authentic likeness being rediscovered.[14]

For Exhibitions

The paradox is this: I find myself drawn more and more to the model of the exhibition as a means to elaborate the latest stage of my feminist interventions in art's histories—a stage that I have defined as "Differencing the Canon."[15] By staging encounters between viewers and the works as well as between artworks, the exhibition so conceived opposes the authorized narrative of the didactic museum hanging reflected in chronological-survey art history. Artworks can once again coexist and thus coemerge in the spatialized exchange that takes place within the viewer's mind as she or he moves back and forth and through the actual installation. The Acoustiguide, by contrast, choreographs the visitor's traversing of the exhibition to conform rigidly to the deep narrative drive of teleological art history. My concept of exhibition as encounter in space attempts to allow for the

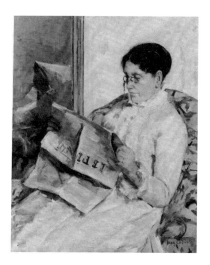

Fig. 5. Mary Cassatt, *The Artist's Mother Reading "Le Figaro,"* 1878. Oil on canvas, 39³/₄ × 32 inches (101 × 81.2 cm). Private collection

Fig. 6. Pablo Picasso (1881–1973), *Portrait of Gertrude Stein*, 1906. Oil on canvas, 39³/₈ × 32 inches (100.7 × 82.6 cm). The Metropolitan Museum of Art, New York. Bequest of Gertrude Stein, 1946 (47.106)

more chaotic and dialogic interaction between works that resembles the way artists think about art and the ways even nonartists absorb and remember their experiences with art.

Taking my cue from Freud, the theorist of psychological modernism, with his emphasis on a mise-en-scène of fantasy and desire as a perpetual play, I suggest that space invents the escape from the tyranny of chronology that functions traditionally as the monitoring art historical superego; space liberates us from the false narratives that the bourgeoisie passes off as history.[16] So let me, in conclusion, invite you to a virtual feminist space where, in utter disrespect for the rules that govern the exhibition practices of most actual museums and the thought processes of actually existing art historians, I assemble an exhibition titled: *Intellectuality and Femininity in the Visual Poetics of Modernist Painting, 1878–1906.*

The first room is introductory. It frames the exhibition with two paintings: Cassatt's *The Artist's Mother Reading "Le Figaro"* of 1878 (fig. 5) facing Pablo Picasso's *Portrait of Gertrude Stein* of 1906 (fig. 6). In the center are two photographs of Cassatt, one taken by the architect Theodate Pope about 1905 (fig. 7) and the other taken in 1925 at the Château Beaufresne in Mesnil-Théribus. The theme of the room is intellectuality, the feminine, and modernist poetics. Cassatt was represented in the Armory Show in 1913 as a hinge figure between the early moments of modernism, whose importance she had done so much to secure through her advocacy with American collectors. Their own array of excellent representative works by Manet, Degas, Monet, and others created the seedbed on which a new generation of modernisms would blossom artistically and culturally, even though the elderly Cassatt herself could not make that transition.[17]

Fig. 7. Theodate Pope (American, 1868–1946), Mary Cassatt, Paris, c. 1905. Hill-Stead Museum, Farmington, Connecticut

The daring suggestion that the monumental paintings of the female figure by Cassatt, found by American critics in the 1890s to be "hard, brutal, inharmonious, and shocking to the eye,"[18] could have had meaning for Picasso in 1906 does not rely on the conventionally understood chains of influence. It is conceived through a Freudian trope of *Nachträglichkeit*: a retrospective "retranscription," to use Freud's own words, from a cultural moment in 1906 that shows where modernist culture dared to go—both in the poetics of the sitter, Stein, and in the aesthetics of the painter, Picasso. This painterly event causes us to revision

an antecedent moment from 1878, when that outcome—the bold portrait of a woman intellectual in modernist style—was still but an imaginative potential in a work that itself lay on the cusp between what had been (eighteenth-century images of the feminine novel-reader contrasting strongly with images of the masculine intellectual) and what could come through its own momentary hybridity. Cassatt's painting of her middle-aged intellectual mother reading a newspaper displaced both the monumental fertility of the maternal body typical of conservative cultural discourse (whose chief exponent among the new painters was Renoir) and the prostitutional body of the masculine avant-garde that runs from Manet's *Olympia* to Picasso's *Les Demoiselles d'Avignon*. Her work defies the logic of the feminine-as-masquerade to conceive, beyond a procreative female destiny, a representation of a thinking feminine-embodied subject whose interiority is psychological and who is intellectually autonomous. The painting insists on what Catherine R. Stimpson—describing representations of Stein's monumental Jewish feminine, lesbian persona—named the "somagrams" of the modernist woman: the writing of the body, the conjugation of the mind and its gendered form.[19]

In my second room there is one shocking and marvelous centerpiece: a nude with exposed breasts rising out of the sea, painted by Gustave Courbet in 1868 and bought by Harry and Louisine Havemeyer in 1893 (Metropolitan Museum of Art, New York). They were encouraged in their collection of Courbet's work by Cassatt who, in 1881, had taken Louisine to the Courbet retrospective at the Théâtre de la Gaîté in Paris. Louisine wrote in her memoirs:

> I owe it to Miss Cassatt that I was able to see the Courbets. She took me there, explained Courbet to me, spoke of the painter in her flowing, generous way, called my attention to his marvelous execution, to his color, to his realism, to that poignant and palpitating medium of truth through which he sought expression. She drew me to a lovely female nude. "Did you ever see such flesh painting? Look at that bosom, it lives, it is almost too real." The Parisians do not care for him. "You must have one of his nude half-lengths some day."[20]

Whereas the patrician Cassatt could not paint her own or another woman's naked breasts, the modernist artist Cassatt *could*, however, recognize the importance of painting the body. This contradiction is no slight aspect of nine-

teenth-century social restraint on women artists. The prohibition on a woman's acknowledging her own sexual body forms was, as Virginia Woolf would later attest, one of the greatest blockages inflicted on women as artists. For if access to the body is denied, the compelling engagement with human desire in art is barely possible.[21] All the great modernist women of the next generation made central the struggle to have access to their own sexuality and its role in the imaginative resourcing of their representation. So how did a determined observer of the fleshiness of sex as part of what made art modern (Cassatt) negotiate a means to find oblique access to that dimension of desire in her own painting?

I believe she scanned paintings by artists like Courbet and Manet, who had laid down the major intellectual and artistic challenge during the 1860s, when she was still grappling with learning her profession under the tutelage of Jean-Léon Gérôme, Thomas Couture, and Charles Chaplin. In their works she found moments of traumatizing alterity and uncanny devices. As a student, not yet able to incorporate what she would have seen in 1867 at Courbet's and Manet's private exhibitions, Cassatt, nonetheless, garnered from her viewings and the press debates around these outsiders' shows, the burden of their reconfiguring of painting both by a pathway through the museum and by submission to painting's utter materialism. Paint oscillates perpetually between what it makes us see or imagine and the substance it recalcitrantly remains.[22] Thus my exhibition would mount a suggestive sequence that would commence with a detail of the back view of the energetic woman in *profile perdue* from Courbet's *Grain Sifters* of 1855 (Nantes, Musée des Beaux Arts). The second detail would be the maid and her bouquet from Manet's *Olympia* of 1863–65—a painting to whose Louvre purchase subscription Cassatt refused to commit because she wanted it to be bought for an American collection. The third detail—the radical image of the back view of a child gazing through railings toward a steam-filled shunting yard below her—is from Manet's *Gare St. Lazare* (National Gallery of Art, Washington, D.C.) shown at the Salon of 1874; Cassatt saw it on her return to Paris after strategically planned study years in Italy, Spain, and the Low Countries. By 1874 she was ready to deal with Manet and Courbet for herself, having tracked them back to their own resources in the art of seventeenth-century Holland and Spain. Two paintings by Manet of 1874, however—*Gare St. Lazare* and *Boating*, which was also bought through her agency by the Havemeyers (National Gallery, Washington, D.C.)—show that between *The Balcony* of 1869 (his homage to both Goya and Velázquez, and a painting Cassatt worked through

repeatedly in the early 1870s) and the *Gare* of 1874, Manet had himself been shifted by a new trend in painting emerging in Paris. This avant-garde tendency altered the sites of representation and the artist's palette to offer the radical possibility of something other than a kind of artistic transvestism imposed on the expatriate, a fledgling woman painter ambitious to be part of the best and most advanced of modern art. It was only the visibility of the "new painting," as Impressionism

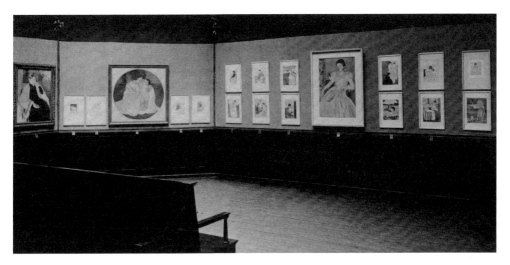

Fig. 8. Mary Cassatt room in the *Exhibition of Paintings and Drawings by Representative Modern Masters*, 1920. Archives of the Pennsylvania Academy of the Fine Arts, Philadelphia

would first be known, as color and space in Manet's startling 1874 works that would have sent Cassatt to search out innovative painters. She would ally her critical practice finally and decisively, finding in that collectivity a home for her own astutely conceived program, based like theirs on the lessons of the 1860s. This section of the exhibition would conclude, therefore, not with paintings but with a series of Cassatt's color prints from 1891 (see fig. 8). Her famous suite of etchings forms a retrospective synthesis of twenty-five years of her work. With its subject matter transfigured by the demanding rigor of color drypoint, the series suggests how a woman would resolve the double bind, imposed by gender and class, on her participation in an artistic conversation in which she was not allowed to speak "out loud" of its central topic: the female body. In *In the Omnibus,* I see a witty recasting of the displaced center of Manet's *Olympia,* with the baby taking the place of the bouquet as the mediating sign between two women separated here by class, in Manet by culture and ethnicity. In *The Fitting,*

the *profile perdue* secures the privacy of the working woman, while the image of the fashionable lady is doubled through reflection. *Woman Bathing* finally tackles the de-eroticized factuality of the moment of a working woman's toilette. The aim here would have been to focus on female embodiment as a challenge to the classic rules of painting the human body—both a body socially encoded by class and the site of desire and subjectivity. This room could be subtitled: "Refused/exposed; promised/revealed."

The third room addresses that moment of modernity and spectacle between 1878 and 1881, when the terms of modernism were formulated: when modernity as spectacle found a language of painting that flirted with and undid the analogy between what was painted and how it was painted. I would start with Renoir's two loge paintings—*La Loge* (1874, Courtauld Institute, London) and *The First Sortie* (1876, National Gallery, London)—and would conclude with a segment of Manet's statement about *la vie moderne: Bar at the Folies-Bergère* (1881–82; Courtauld Institute, London). Beneath the last would be a study section tracking its slow evolution through repeated experiments with the painting of the café and Manet's long reflection (forgive the pun) on the possibilities of the mirror in pictures. Between Renoir and Manet there would an intersecting series by Jean Béraud, showing obviously venal transactions between men and women in loges at the theater—the social historian's real but unacceptable face of depictions of the modern scene—and theater settings by Cassatt. Her visual plotting of women at the matinée theater and the evening opera through her alternating views from inside the loge looking out, and views from outside looking in, would slowly take their place as intelligent elements in a conversation held with her peers. Their dialogue is acknowledged by Manet's "quoting" of a figure from a Cassatt painting in the work that concludes this phase of modernist engagement with the urban spectacle: *Bar at the Folies-Bergère*.[23] This reference alone should ensure that Cassatt's investigation of the mirror and the game of seeing and being seen is acknowledged as part of the archive for Manet's final statement.

The final room would be called "Art's in the Mind's Eye, or Put the Blame on Mame," because if any one individual is responsible for the American love of Impressionism, it has to be Mame Cassatt. None of her paintings would be placed in this final room. The space would, however, contain all the works she caused others to collect and buy. Through this thorough review of the now-major elements of America's prime museum holdings in Impressionism and early modernist French painting, we would reconstruct Cassatt's artistic journey through

emergent modernism. Thus could we reread her own paintings as profoundly dialogical and creatively modernist with respect to sexual difference precisely because of an intellectual and artistic—but gender-inflected—exchange between artists creating a shared project.

My selections for the entire imaginary exhibition aim to present paintings as traces and events in histories that are social, aesthetic, and psychic. They would suggest that artistic transformations have to be considered as simultaneously social, semiotic, and psycho-symbolic. They would raise questions about each artist's singular contributions to a public and multiply authored text: modern art. The very best lessons of formalist analysis and social historical attentiveness to cultural production would be incorporated so deeply as to be invisible. Yet such approaches would also be transformed provocatively by another, a feminist and psychoanalytical vocabulary of encounter, dialogue, and difference, that would make what the viewer was invited to see become strange, recalcitrant, difficult, and refreshingly perplexing. The genuine creativity and complexity of this artistic moment would thus be restored by allowing difference to play in, on, and with the canon.

———

I conclude, reluctantly, that in the current cultural climate my Cassatt experiment could not exist outside the virtual realm. Who would sponsor it? How would marketing promote it? What school program could be built on this? What concept could inform the major publicity handouts or appear on the poster? What branded identity could be merchandised?

A visit to Boston to view the installation of *Mary Cassatt: Modern Woman* in March 1999 yielded its own exemplars of pervasive merchandising. Leaving the exhibition, I was disgorged directly into the specially conceived exhibition shop. There, in individuated sections that echoed the major themes of the show, I could purchase items for my tea table, for my bath time, and for my desk. In addition, I could choose between the large volume, hardback or paper, of the exhibition's mighty multi-authored catalogue at $30; and I could buy a copy of my own Thames and Hudson World of Art monograph at $10.99. The copresence of these books with bath salts and bed linen, writing paper and packets of tea is an unsettling sign that all of us are involved in the commodification of culture. No art history is immune from these processes, though the forms of our complicity

or reconciliation are variously disguised and veiled from us. Given this penetration of all spheres of intellectual practice in both museum and university by the commodity, I am forced to ask: Are there any fractional spaces, any margins to inhabit, any terms of dissidence that could still make any actual university or museum yield the study of art to a radically different configuration? Or will masculinist art-history advocates in both museum and university continue to censor our knowledge of history, denying culture a historical complexity of which women were always an equally significant part?

1. Rebecca Rabinow, "The Suffrage Exhibition of 1915," in *Splendid Legacy: The Havemeyer Collection*, exh. cat., ed. Alice Cooney Freylinghuysen et al. (New York: Metropolitan Museum of Art, 1993), 88–95. A longer analysis of the show, titled *Loan Exhibition of Old and Modern Masters* and held between April 6 and 24, 1915, can be found in Griselda Pollock, *Differencing the Canon: Feminist Desire and the Writing of Art Histories* (London: Routledge, 1999). I am working on a reconstruction of the exhibition, which included twenty-seven works by Degas and nineteen by Cassatt, accompanied by a watercolor of Degas by Constantin Guys and a photograph of Cassatt.

2. Edgar Richardson, "Sophisticates and Innocents Abroad," *Art News* 53, no. 2 (1954): 62.

3. Nancy Mowll Mathews, *Cassatt: A Retrospective* (New York: Hugh Lauter Levin Associates, 1966), 129; translated from Achille Segard, *Un Peintre des Enfants et des Mères: Mary Cassatt* (Paris: Librairie Paul Ollendorff, 1913). Scholars working in the field of Cassatt studies can only be deeply indebted to Nancy Mowll Mathews, whose untiring efforts and rigorous research have produced a major biography of the artist (1994), an edition of the correspondence (1987), an analytical study of the color prints, (1989), a monograph (1987), and a collection of documents, reviews, and commentaries (1996) that have made widely available many of the essential resources on this artist.

4. For a fuller discussion of this point, see Griselda Pollock, *Mary Cassatt* (New York: Thames and Hudson, 1998). I am preparing a longer study of Cassatt in which the illustrations necessary for this analysis will be available.

5. The argument that it is only twentieth-century, professionalizing art history—in both museum and university locations—that began to erase women systematically from the historical record, rendering questions of gender invisible, was first advanced by Rozsika Parker and myself in *Old Mistresses: Women, Art, and Ideology,* rev. ed. (London: Oram Rivers Press, 1994).

6. Griselda Pollock, "Feminist Interventions in Art's Histories: An Introduction," in *Vision and Difference: Feminism, Femininity, and the Histories of Art* (London: Routledge, 1988), 1–17.

7. In this claim I am not rushing headlong into the embrace of novel formulations such as visual

culture, nor am I suggesting that a developing area such as Cultural Studies might better do the job. There are elements, histories, and debates within our tradition that remain viable and valuable. There are great intellectuals and profound scholarship within the field of the study of the histories of art. What has been normalized as art history—regimented and disciplined through survey courses, canons of display and publication, the monitoring of doctoral theses and the reviewing of books—teeters on too narrow a theoretical and political base to serve the complexity of the histories of the visual arts. The legacies of the Cold War have reduced the dominant paradigms, disallowing and excluding too much, even without the tradition, not to mention recent developments from the dynamic interaction with new theoretical paradigms in the humanities and social sciences. Thus I maintain a distinction between art history—the discipline as I encountered it in 1970 and continue to find it in the year 2000—and the field of the histories of art, still awaiting an expanded if always contested array of investigations and interpretations.

8. Judith H. Barter, *Mary Cassatt: Modern Woman,* exh. cat. (New York: Harry N. Abrams in association with Art Institute of Chicago, 1998). The exhibition was shown also at the Museum of Fine Arts, Boston, and the National Gallery of Art in Washington, D.C., in 1998 and 1999. My focus on this exhibition should not imply disregard for other important earlier examinations of the work of Mary Cassatt that have taken place in the United States: Suzanne Lindsay, *Mary Cassatt and Philadelphia,* exh. cat. (Philadelphia: Philadelphia Museum of Art, 1985); and Nancy Mowll Mathews and Barbara Stern Shapiro, *Mary Cassatt: The Color Prints,* exh. cat. (New York: Harry N. Abrams in association with Williams College Museum of Art, 1989). Significant as these excellent exhibitions were to the developing scholarship around the artist, however, their focus and distribution cannot be compared to the effect of the blockbuster, retrospective, and monographic exhibition that the present book addresses.

9. Charles E. Stuckey and William P. Scott with Suzanne Lindsay, *Berthe Morisot: Impressionist,* exh. cat. (New York: Hudson Hills Press, 1987). This, the only recent exhibition of Morisot's work, was confined to the United States: the National Gallery of Art, Washington, D.C.; the Kimbell Art Museum, Fort Worth, Texas; and Mount Holyoke College Art Museum, South Hadley, Massachusetts.

10. Mieke Bal, "Telling, Showing, Showing Off," in *Double Exposures: The Subject of Cultural Analysis* (London: Routledge, 1996), 13–56.

11. Griselda Pollock, *Mary Cassatt* (London: Jupiter Books, 1978). It is as if the museum is now willing to admit the models that academic art history proposed tentatively in the late 1970s. In my 1978 text, I introduced some psychoanalytical perspectives that I have since developed in two further studies of Cassatt: "The Gaze and the Look: Women with Binoculars," in *Dealing with Degas: Representations of Women and the Politics of Vision,* ed. Richard Kendall and Griselda Pollock (New York: Universe, 1992), 106–32; and "Critical Critics and Historical Critiques: Mary Cassatt's

Reading Le Figaro, 1878," *University of Leeds Review* 36 (1993–94): 211–46, to be reprinted in Griselda Pollock with Penny Florence, *Looking Back to the Future: Essays from the 1990s* (Newark: G&B Arts, 1999). These were not listed in the catalogue's bibliography nor was any mention of such a reading made in the literature.

12. T. J. Clark, *The Painting of Modern Life: Paris in the Art of Manet and His Followers* (New York: Harry N. Abrams; London: Thames and Hudson, 1984), 15.

13. Pissarro figures in a chapter in T. J. Clark's most recent book: "We Field-Women," in *Farewell to an Idea: Episodes from a History of Modernism* (New Haven: Yale University Press, 1999), 55–138.

14. Clark, *The Painting of Modern Life*, 21.

15. Pollock, *Differencing the Canon*. This refers to a project to write expanded histories in which the interrelations between sexual difference and representation are analysed historically across the full field of artistic practices by men and women of all nations and cultures.

16. The critique of bourgeois ideology as myth, in which the historical is evacuated and naturalized, is made powerfully by Roland Barthes in his ever-important essay "Myth Today," in *Mythologies* (Paris: Editions du Seuil, 1957), trans. Annette Lavers (London: Jonathan Cape, 1972).

17. In the "International Exhibition of Modern Art," of 1913 held at the 69th Street Armory in New York, Cassatt exhibited *Mère et Enfant*, lent by Durand-Ruel and Sons *(Reine Lefebvre and Margot before a Window*, 1902, no. 408 in Adelyn Breeskin *Mary Cassatt: A Catalogue Raisonné of Oils, Pastels, Watercolors, and Drawings* [Washington, D.C.: Smithsonian Institution Press, 1970]; now in a private collection); and *Mère et Enfant*, lent by John Quinn (*Baby in a Dark Blue Suit*, no. 2, 1890, Breeskin no. 623; unlocated).

18. "Pictures by Mary Cassatt," *New York Times*, 18 April 1895; reprinted in Mathews, *Cassatt*, 215.

19. The lengthy case for this reading is made in my article "Critical Critics and Historical Critiques: Mary Cassatt's *Reading Le Figaro* and in Catherine R. Stimpson's "Somagrams of Gertrude Stein," both in *The Female Body in Western Culture: Contemporary Perspectives*, ed. Susan R. Suleiman (Cambridge: Harvard University Press, 1986), 30–43.

20. Louisine W. Havemeyer, *From Sixteen to Sixty: Memoirs of a Collector*, ed. Susan Alyson Stein (New York: Ursus Press, 1993), 190.

21. See Tamar Garb, *Bodies of Modernity: Figure and Flesh in Fin de Siècle France* (New York: Thames and Hudson, 1998).

22. I am indebted to Alison Rowley for this formulation of the fascination and trauma of painting.

23. It has long been accepted that, in the background array of spectators visible to the left of the barmaid's staring face, Manet made an ironic reference to Cassatt's painting of a woman in black at a matinee—a work now retitled by Judith Barter as *At the Français: A Sketch*, 1877–78

(Museum of Fine Arts, Boston). See Novelene Ross, *Manet's Bar at the Folies-Bergère and the Myths of Popular Illustration* (Ann Arbor: Michigan University Press, 1982), 6–7. See also Griselda Pollock, "View from Elsewhere: Extracts from a Semi-public Correspondence about the Visibility of Desire," in *Twelve Views of Manet's Bar*, ed. Bradford R. Collins (Princeton: Princeton University Press, 1996), 278–314.

The Blockbuster, Art History, and the Public:
The Case of *Origins of Impressionism*

Gary Tinterow

The subject under review here is whether museums and, in particular, block-buster exhibitions can or should reflect the new art history. To begin, one might try to characterize the new art history and ask whether it is, indeed, new—apart from annoying neologisms like "narratology" and "referenticity"? More than a century ago Jacob Burckhardt argued, in *Civilization of the Renaissance,* that art must be seen as the product of its time, and must be studied in a cultural context.[1] Equally innovative were the writings of Arnold Hauser, whose masterful political and social history of art was published in 1951,[2] and Meyer Schapiro, who considered many possible meanings, including psychological and sexual connotations, of Paul Cézanne's apples in 1959.[3] There have been ideologically driven studies in art history throughout the entire last century, including many in shades of Marxism—studies that have launched hundreds of similar investigations of hidden meanings encoded in otherwise familiar works of art. As for theory, writers such as Heinrich Wölfflin and Erwin Panofsky were fundamentally concerned with underlying principles of interpretation, but then they were treating elitist works of art. Perhaps the most important novelty of contemporary art history is the stridency of its assertion of novelty. A typical example can be found in the introduction to Albert Boime's *Social History of Art,* in which he argues that his approach to art as the manifestation of social and political history is new.[4]

In addition to questioning novelty, we might challenge the assertion, sometimes stated but often implicit, of the superior ability of these "new" approaches to interpret works of art. Most of us would reject Pliny's notion of progress and decline in the arts; we cannot consider Impressionism an improvement of Realism, or Cubism an improvement of Impressionism, nor can we say that all the arts are in perpetual decline. Thus we should also be skeptical of any claim of progress in interpretative method. Can anyone today legitimately claim to interpret a Poussin more convincingly than Panofsky, or a Delacroix more astutely than Baudelaire? Of course, I recognize that there are some distinctive characteristics of the new art history: it is essentially Marxist, but its theorists depart from the humanist Marxism of Hauser or Schapiro. They do not draw a

sharp line between art and other visual culture, and in their use of a political and sociological sieve to "interrogate" their material, they often employ the screen of sexual politics. There have always been and there will always be different approaches to the interpretation of art and the construction of art history, and, to my mind, the question of quality is just as important in the evaluation of art history as it is in works of art, and I have gleaned many insights from practitioners of the new art history. But when these art historians refuse to acknowledge distinctions of quality, when they deny the masterpiece and the great artist and state that all previous art history and much art was a tool of oppression, then there is little they can offer me. If an imperialist used art—say a marble by Michelangelo—to club someone and steal his property, that act does not strip the Michelangelo of its qualities as a great work of art. Further, art history is an inadequate—and I maintain, inappropriate—platform from which to promote change in society.[5]

In an essay in the *New York Review of Books* Ian Buruma has complained:

> Historiography is less and less a matter of finding out how things really were, or trying to explain how things happened. For not only is historical truth irrelevant, but it has become a common assumption that there is no such thing. Everything is subjective, or a sociopolitical construct. Finally, and I think that this goes to the heart of the matter, we should recognize that truth is not just a point of view. There are facts which are not made up but real. And to pretend that there is no difference between fact and fiction, or that all writing is fiction, is to paralyze our capacity to distinguish truth from falsehood.[6]

Happily, most museum curators have not experienced the existential doubt that has hobbled some of the most extreme practitioners of art history today. Museums are offspring of the Enlightenment, and most curators are practitioners of that Enlightenment faith, empiricism. For us, who serve "the fetishistic, objectifying regime of consumerist capitalism,"[7] the author never died and the subject still matters. Surrounded by tangible objects, the material evidence, we have never lost sight of the fact that works of art—at least in the case of European art of the modern era—were made by individuals, and we know that we can often recover information that tells us more about who made them, when, and why. Needless to say, these individuals did not work in a vacuum; their work

reflects myriad encounters and exchanges of which they were no doubt only partially aware. We acknowledge also that the artist and the viewer do not occupy symmetrical positions vis-à-vis the work of art, and that an artist's intentions may not always be visible. René Descartes's statement of faith that "there is nothing so remote that we cannot reach it, nor so recondite that we cannot discover it" today seems overly optimistic, but we curators do know that accumulated information, always incomplete and imperfect, can in aggregate help us to understand some of the meanings, still incomplete and imperfect, that the work had in its original context. This information can lead us to appreciate differences in appearance and style as well as to explain, in part, why we value that object today. As Panofsky said, there is no substitute for information.[8]

I am nevertheless aware of the "slippage" between historical fact and our perception of that fact. On the same page as Buruma's essay, blurbs for Janet Malcolm's *Crime of Sheila McGough* exemplified the problem: "She has again and again returned to one theme, the vexed relationship between the objective truth and the narrative truth we impose on it. Stories . . . are always a violation of objective truth, even if they contain no overt lies."[9] The writer might well believe, as Buruma fears, that it is impossible to uncover objective truth. But I believe that it remains fruitful to continue to try—and that the observations borne of these investigations should be at the heart of any speculative or interpretative study. The perpetual skepticism and the self-regarding spiral proposed by current semiotic theory is at essence almost completely incompatible with the study of historic objects, and that is why most curators find this mode of analysis effectively useless.[10]

The exhibition *Origins of Impressionism*, held at the Metropolitan Museum of Art in New York in 1994,[11] is a case in point—an example that demonstrates why it is so difficult to incorporate within a museum exhibition much of what is currently being done in the academy. This project was essentially an experiment in which Henri Loyrette and I imposed a narrative on a set of facts—the nearly two hundred paintings we exhibited in Paris and New York—in order to arrive at some sense of the truth, to see, above all, what happened, even if we could not fully explain why it happened or what it means. The topic at hand is blockbusters, and this was one by all accounts: at the Metropolitan we had just under 800,000 visitors, more than for any previous exhibition of paintings. *Blockbuster*, as we all know, is a loaded term. Museum administrators and most of the public consider it complimentary, while critics consider it pejorative.

Mark Stevens wrote in *New York Magazine*: "As a rule, shows of Impressionist painting deserve suspicion. Only gold, I would venture, does better at the box office, which means that museums often crank out shows of Impressionism as a form of fancy art sausage for the masses."[12] Although the claim may seem disingenuous, this exhibition was not conceived as a blockbuster. The administrators of the museum knew that it would be popular, that we would find a corporate sponsor, and that we would sell many posters and postcards, but the project was fundamentally a curatorial exercise. Loyrette and I wanted to document the

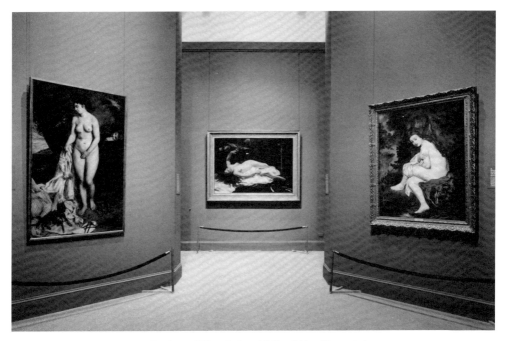

Fig. 1. Installation of nudes by Renoir, Courbet, and Manet in the exhibition *Origins of Impressionism*

occurrence of a new style, over the course of a decade, by a group of painters who worked in contact with one another in and around Paris in the 1860s (figs. 1–3). A typical empirical exercise, it was an experiment whose outcome was by no means certain; that is, we did not know in advance what the exhibition would look like, or whether the pictures would set up meaningful comparisons. We thought it useful to provide some sense of the world in which these artists worked, so we began the exhibition with a gallery devoted to paintings that had been included in the Salon of 1859, a salon that was especially important to Édouard Manet, Edgar Degas, Claude Monet, and Camille Pissarro. This

attempt to provide a visual context was much criticized by journalists. On the one hand, in Adam Gopnik's words: "All the miscellaneous gunk of art in France in the eighteen-sixties, from Salon nudes to newspaper sketches—a lot of it pretty inorganic, not to say stone-cold dead has been meticulously assembled by a team of curators into a single broth."[13] He resented the inclusion of work that did not conform to his standard of quality. Michael Kimmelman thought, on the other hand, that the exhibition "simplifies a complex story in return for a cleaner, more glamorous presentation."[14] He did not believe that the curatorial purposes of the project were primary: "Whatever its intellectual aspirations," he wrote, "it is above all a canny crowd pleaser."[15] John House lamented the absence of context after the first gallery, yet he could see that "laid out before us is a fundamental renewal of the art of painting that took place during the ten years that the show covers: we see a comprehensive rethinking of the formal language, the technique and the subject matter of painting —or, in a nutshell, the beginning

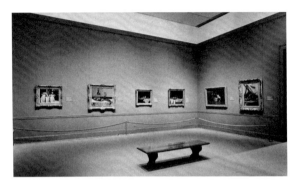

Fig. 2. Installation of still lifes by Cézanne, Pissarro, Bonvin, Manet, and Monet in the *Origins of Impressionism* exhibition

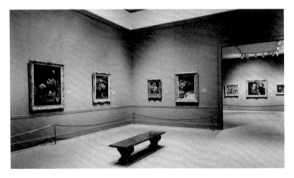

Fig. 3. Installation of still lifes by Bazille, Renoir, and Monet, with works by Degas, Courbet, and Bazille visible through the doorway, in the *Origins of Impressionism* exhibition

of what has come to be called modern art."[16] That is precisely what we wanted to set forth. Although many of these paintings were familiar to well-traveled museum-goers and were often reproduced in books, few of them had been seen together since the 1860s. In fact, never before had there been an exhibition that explored, painting by painting, the chronology of interaction on which almost all interpretative histories of Impressionism are based.

Our show was conventional in that it had a beginning, a middle, and an end. It began with the Salon of 1859 and ended with the canvases painted by Monet and Pierre Auguste Renoir at La Grenouillère in the summer of 1870. I

am reminded of the old joke that "every work should have a beginning, middle, and end, but not necessarily in that order." Yet, quite deliberately, *Origins of Impressionism* had no single conclusion, or indeed any single narrative. As House noted, "The organization of the show and the catalogue group the paintings in a distinctive way, which throws fresh light on visual links and contrasts: the sections are primarily divided according to genres of subject matter, rather than chronologically by artists."[17] We sought to highlight the "call and response" in which the painters engaged—Gustave Courbet's *Woman with a Parrot* in response to Manet's *Olympia*, Manet's *Woman with a Parrot* in response to Courbet's, etc. Also, we thought that hanging works by subject matter would highlight the breakdown in the categorization of genre that was such an important component of the "new painting."

In fact, the exhibition was filled with false starts and dead ends, as we endeavored to convey the fitful and disjunctive nature of history. Gopnik observed: "The trouble is that [the curators] forgot to add the electricity. What was once electric, and ought to seem so now—chiefly, the painting of Manet—has been so diffused into corridors of minor masters, nonmasters, sidelights, and side issues that it can only glimmer instead of seeming really charged. The show is all soup and no lightning."[18] But he went on to say that that was not all bad; and maybe it was good, considering the myriad factors that contributed to the formation of a new school of painting. Kimmelman, however, regretted not finding new ideas about the history of Impressionism: "Expect the works to be presented in a wholly fresh light, and you'll be disappointed. Approach the show for the pleasure of seeing sublime paintings, and you can't be."[19] Here Kimmelman is addressing the central dichotomy in museum experience—between resonance and wonder—described by Stephen Greenblatt: "By resonance I mean the power of the displayed object to reach out beyond its formal boundaries to a larger world, to evoke in the viewer the complex, dynamic cultural forces from which it has emerged and for which it may be taken by a viewer to stand. By wonder I mean the power of the displayed object to stop the viewer in his or her tracks, to convey an arresting sense of uniqueness, to evoke an exalted attention."[20] Gopnik, Kimmelman, and indeed most of the art critics for the popular press, seem to prefer wonder.[21] Mark Stevens wrote: "Hardly a modest theme, the Origins of Impressionism. To take its full measure would require not only a great art historian but also a profound philosopher of modern culture. Otherwise you get a college course. Which is what [the exhibition] often

resembles. The presentation, the wall panels, and the catalogue are certainly worth reading, but what really matters is something else: the opportunity for shameless visual pleasure and for a wandering reverie about the mystery of ends and beginnings. The pleasure . . . could hardly be greater."[22] Obviously, we wanted both in our exhibition: we wanted to arrest visitors with the beauty and power of the paintings, we wanted them to experience wonder, and then we wanted them to consider some of the forces that had shaped the works—that is, we wanted them to be aware of resonance.

Although the catalogue and wall labels contain the "familiar biographico-aestheticist rhetoric," as the tone of another retrospective exhibition has been described,[23] we did venture into the currently popular domains of ideology, cultural context, and politics, if not race and gender. In searching for empirical data to inform these works, we cast a wide net, trying to catch all manner of factors (especially economic), but the issues were by no means examined exhaustively; many would undoubtedly consider the analysis insufficient or, at worst, token. Nevertheless, we curators, like all thinking beings, are subject to the intellectual fashions of the times, and we looked at our topics from today's eclectic variety of perspectives. Yet I should stress that our goal was to document the creation of a new style, to track its development—to assemble the retrievable facts—rather than to explain its occurrence. Some will say that it is impossible to make such a distinction, that we cannot document without imposing a prejudicial narrative (Buruma and I do not agree). We did not attempt to show why the paintings met with institutional resistance initially (although we charted this resistance in the accompanying texts), nor did we attempt to illustrate the constantly shifting background of the Paris art world (which, for that matter, is amply documented in the permanent collection of the Musée d'Orsay). In fact, it is difficult to exhibit resonance on an equal footing with wonder. For our subject, we could have included political cartoons to reflect the politicization of art in the Second Empire, or, perhaps, popular imagery to demonstrate the visual environment in which the Impressionist painters worked. But to do so would have necessarily reduced the emphasis on the formal factors—the creation of a new pictorial language—that constituted our primary interest. (We knew as well that John House was preparing an exhibition, *Landscapes of France*, to be held the following year in London and Boston—a show that would contrast Impressionist landscape painting with contemporary Salon painting.)[24]

In New York the presentation of resonance was restricted to the

Acoustiguide and wall texts and labels, which were quite copious. Since the new style in painting was expressed through a shift in subject matter, an informal painting technique, and a heightened, blonder palette, we thought the most fruitful method of examination would be the side-by-side comparison of paintings. This is the traditional art historical method that most of us were schooled in. But because we refused to adopt a single methodology (say, Wölfflinian) or overarching theory (say, Hegelian), and because we sought to show the complexity of the question in its unruly, contradictory state, it seems to me that our exhibition reflected a postmodern approach to the subject. We wanted to disabuse visitors of the notion that Impressionism was a direct and simple reaction to the academy, having come to believe that the "new painting" evolved more out of emulation of certain independent artists—such as Courbet (in the case of Manet and Renoir); or Jean Baptiste Camille Corot, Eugène Boudin, and Johan-Barthold Jongkind (in the case of Monet and Frédéric Bazille); or Charles-François Daubigny (in the case of Pissarro)—than in opposition to the entrenched power. The dominant forces—no longer monolithic in the 1860s—were in fact highly factionalized: Napoleon III's director general of museums, Conte de Nieuwerkerke, despised the academies; the emperor distrusted the count, and so on. (There are notable exceptions, such as Cézanne, whose art was deliberately confrontational, as was the highly political art of Courbet.) Above all, we did not, as many reviewers reflexively assumed, attempt to trace the origins of modernism, or to validate a particular reading of modernism in the paintings of a previous century, or to advance a totalizing theory about transformation of style. The 1860s are sufficiently interesting in themselves that to seek a reflection of present-day concerns in a culture fundamentally different from ours seemed to us excessively, and unproductively, narcissistic.

Although we conceived *Origins of Impressionism* as an intellectual exercise, it was presented to the public for their edification and enjoyment. Did they enjoy it, and what did they learn? I can begin to answer that question, because a study was conducted at the Metropolitan Museum by Jeff Smith of our Office of Research and Evaluation. More than three hundred visitors were asked whether they would participate in a study, and those who said yes, 81 percent, were asked to answer a set of questions before and after viewing the exhibition. A total of 71 percent completed both questionnaires. The demographic questions informed us that 62 percent of the visitors were female and 38 percent male; that the median age was fifty; that 20 percent came from New York City, one third from the New

York region, one third from elsewhere in the United States, and that 20 percent came from another country. About 20 percent were visiting the museum for the first time. An astonishing 44 percent held advanced degrees, with nearly 60 percent engaged in professional occupations. The median reported income was $53,000. The average museum visitor rates his or her own knowledge of art at 6 on a scale of 1 to 10; in *Origins of Impressionism*, the visitors rated their knowledge at an average of 4.6; they rated their knowledge of the exhibition, prior to seeing it, at 2.9.

Why did they come to the exhibition—for which no advance ticketing or supplemental charge was required? The greatest number—89 percent—came to enjoy beautiful paintings; 54 percent to learn about changes in style; 52 percent to learn about the artists who made the paintings; 41 percent to learn about current thinking on Impressionism; 33 percent to see a show "not to be missed." Seven percent had no expectations or goals.

Visitors spent on average one and one-half hours in the exhibition. Of the total, 81 percent tried to look at every work of art; 84 percent read the label for each work of art they viewed; 71 percent read all of the introductory wall texts. When asked to rate various aspects of the exhibition as well as the exhibition overall, 97 percent noticed the unusual organization by genre, and three-quarters considered that this structure facilitated learning. Only 13 percent would have preferred a different organization. Half of the respondents rated the exhibition 10 out of 10; the mean was 9.0.

We asked the visitors a series of questions about the development of Impressionism, the importance of the Salon in the 1860s, the Salon des Refusés, the personal interactions among the Impressionist artists, and the importance of Courbet on the development of Impressionism. The ratings before viewing the exhibition were quite low, but the post-viewing ratings were remarkably high. The largest gain regarded the role of the Salon and of Courbet. Visitors were quite alert also to the comparisons of works within a genre and to the differences between genres. Perhaps the most surprising result in the survey concerns the visitors' overall knowledge of the development of Impressionism. This category revealed the smallest increase in the difference between pre- and post-exhibition viewing. In other words, we succeeded in confusing our audience; to put it positively, we conveyed some of the complexity of the question and our uncertainty regarding cause and effect. Visitors indicated, however, that they left with more knowledge about the period than about the individual artists. They told us that after taking in the exhibition as a whole—as a historical survey—they would

have liked, upon leaving, to know even more about specific artists and specific paintings.

Finally, we asked a number of questions in order to understand viewing habits. One of the more interesting conclusions was that people who talk to a companion learn more, as do people who return to an earlier gallery to review material in an exhibition. Predictably, those who stay longer seem to learn much more than those who breeze through, but those who use the Reading Room are less likely to have specialized knowledge of the subject.

––––––––

To return, then, to the relation of blockbusters to the new art history, it seems that if the academy is preoccupied with theory and the museum is concerned with objects, then exhibitions, while vehicles for ideas, cannot easily reflect the new art history. As Greenblatt convincingly argues, it is difficult to promote resonance without compromising wonder, and as we learn from William H. Truettner's essay in this volume, the public can become quite hostile to assertive interpretative instruction and social or political polemic, thus short-circuiting the educational mission of the exhibition. Further, we must acknowledge the incompatibility of a set of beliefs held by certain art historians (who, among other things, seek to overthrow the "phallocentric" and "patriarchal" system) with the art museum, an institution that is the embodiment of the very system whose destruction they advocate. Nevertheless, any number of insights that have emerged from recent art historical studies—regarding, for example, an enlarged canon and a widened scope of inquiry—can and should be incorporated into museum practice. In fact, this is already apparent in "work-in-focus" exhibitions, and even in certain exhibitions devoted to Impressionism that have brought aspects of contemporary art historical concerns to the public in an informative and often enlightening manner.[25] The emphasis in all these cases, however, is on works of art, rather than art historical (or sociological) theory. The moment when theory becomes the driving force in an exhibition is the moment when wonder is eclipsed.

Pierre Rosenberg prefaced the publication of a controversial Théodore Géricault symposium with "Au musée d'offrir, au publique de choisir."[26] He is perfectly correct. It is for this reason, however, that there cannot be, at least today, a blockbuster of the new art history. For the definition of a blockbuster

is its inordinate popularity—people waiting in line. While the public wishes to learn and can appreciate "resonance" (as they do, for example, at the United States Holocaust Memorial Museum in Washington, D.C.), they will wait in line at an art museum only for "wonder"—and that goes for the critics too. I hope that our exhibitions will stimulate art historians of all kinds, if only to remind them that they went into the business because of the wonder. And I hope they will continue to find some of their insights reflected in the resonance that we attempt to introduce in our displays.

1. Jacob Burckhardt, *The Civilization of the Renaissance in Italy*, trans. S. G. C. Middlemore, 2 vols. (New York: Harper and Row, 1958).

2. Arnold Hauser, *The Social History of Art*, 4 vols. (London: Routledge and Kegan Paul, 1962).

3. Meyer Schapiro, "The Apples of Cézanne: An Essay on the Meaning of Still Life," *Modern Art: 19th and 20th Centuries. Selected Papers* (New York: George Braziller, 1978), 1–38.

4. Albert Boime, *Art in an Age of Revolution, 1750–1800* (Chicago: University of Chicago Press, 1987). The author claims (p. xx) that his book makes a distinct leap in art history studies by "moving beyond stylistic divisions and viewing developments in terms of major historical epochs." Further on (p. xxi), he writes: "My dream would be to culminate a book on twentieth-century art with an analysis of my ex-next-door neighbor in Binghamton, New York—a retired electrician who paint-ed in his garage. His life and work would tell us more about ourselves than a library full of tradi-tional art criticism." Nevertheless, Boime's book is illustrated with the standard canon (in paint-ing, sculpture, and the decorative arts of the period), and he treats the various styles (such as Neoclassicism) extensively.

5. See Stanley Fish, *Professional Correctness: Literary Studies and Political Change* (Oxford: Oxford University Press, 1995).

6. Ian Buruma, "The Joys and Perils of Victimhood," *New York Review of Books*, 8 April 1999, 8, 9.

7. Amelia Jones, "The Gendered Subject," in *The Art of Art History: A Critical Anthology*, ed. Donald Preziosi (Oxford: Oxford University Press, 1998), 392.

8. Robert Rosenblum repeated this remark in the course of the symposium.

9. *New York Review of Books*, 8 April 1999, 9. The source of the quotation was Margaret Talbot.

10. See, for example, Mieke Bal and Norman Bryson, "Semiotics and Art History," *Art Bulletin* 75, no. 2 (June 1991): 174–208

11. Gary Tinterow and Henri Loyrette, *Origins of Impressionism*, exh. cat. (New York: Metropolitan Museum of Art, 1994).

12. Mark Stevens, "Critic's Pick," *New York Magazine*, 12 September 1994, 54.

13. Adam Gopnik, "Beginning to See the Light," *New Yorker*, 10 October 1994, 98.

14. Michael Kimmelman, "A Decade That Remade the World in Paint," *New York Times*, 25 September 1994, 40.

15. Kimmelman, "A Decade That Remade the World."

16. John House, "Paris and New York: Origins of Impressionism," *Burlington Magazine* 136, no. 1099 (October 1994): 721.

17. House, "Origins of Impressionism."

18. Gopnik, "Beginning to See the Light," 98.

19. Kimmelman, "A Decade That Remade the World."

20. Stephen Greenblatt, "Resonance and Wonder," in *Exhibiting Cultures: The Poetics and Politics of Museum Display*, ed. Ivan Karp and Steven D. Lavine (Washington, D.C.: Smithsonian Institution Press, 1990), 42.

21. In the Williamstown symposium where this paper was read, Griselda Pollock confirmed that her preferences as an exhibition visitor were similar to those of the critics. She indicated how grateful she was to have works of art brought together from faraway places, while disavowing any interest in the texts or theories presented by the exhibition organizers.

22. Mark Stevens, "First Impressions," *New York Magazine*, 17 October 1994, 72.

23. Nina Athanassoglou-Kallmyer, review of *Delacroix: The Late Years*, *Burlington Magazine* 140, no. 1148 (November 1998): 774.

24. John House, ed., *Landscapes of France: Impressionism and Its Rivals*, exh. cat. (London: Hayward Gallery, 1995); Boston catalogue: *Impressions of France: Monet, Renoir, Pissarro, and Their Rivals* (Boston: Museum of Fine Arts, 1995). In her essay in this volume, Patricia Mainardi speculates that museums are unwilling to admit that Impressionism derived in part from popular imagery in order to envelop Impressionism with an aura of high culture. Yet popular imagery—whether French or Japanese—was often cited in our catalogue as an important source for the artists of the New Painting.

25. For example, in addition to House, *Landscapes of France*, see Theodore Reff, *Manet and Modern Paris: One Hundred Paintings, Drawings, Prints, and Photographs by Manet and His Contemporaries*, exh. cat. (Washington, D.C.: National Gallery of Art, 1982); Charles S. Moffett, ed., *The New Painting, Impressionism, 1874–1886*, exh. cat. (Washington, D.C.: National Gallery of Art, 1986); *A Day in the Country: Impressionism and the French Landscape*, exh. cat., ed. Andrea P. A. Belloli (Los Angeles: Los Angeles County Museum of Art, 1984); Juliet Wilson-Bareau, ed., *Manet, Monet, and the Gare Saint-Lazare*, exh. cat. (New Haven: Yale University Press, 1998).

26. Pierre Rosenberg, "Avant-propos," *Géricault*, tome 1, ed. Régis Michel (Paris: La documentation française, 1996), XIII.

Possibilities for a Revisionist Blockbuster:
Landscapes/Impressions of France

John House

Over a half million people saw *Monet in the 20th Century* in Boston in 1998 and 1999, and over 800,000 viewed it subsequently at the Royal Academy of Arts in London, where it stayed open for the entire final night of its run.[1] As one of the instigators of this show, I think that it offered more than a mere uncritical celebration. In both of its showings, the labels and wall texts invited viewers to consider the status of every picture whether Claude Monet saw it as finished, whether he put it on sale, and so on; we believed that such issues were fundamental to understanding the work. The exhibition was not revisionist, however, in any sense that I understand this idea. A monographic show of a Great Modernist Icon, no matter how sophisticated its apparatus, cannot challenge the hierarchy of values that modernism and museum culture have handed down to us. Monet's reputation is still more insulated and transcendent after *Monet in the 20th Century*, even if also a little more nuanced.

I want to consider briefly various exhibitions of nineteenth-century French art that can be considered in some sense revisionist, before focusing on a show for which I was myself responsible, *Impressions of France*, shown at the Museum of Fine Arts, Boston, in 1995–96 (it was titled *Landscapes of France* in London, but that is part of the story). But before proceeding, I want to distinguish between a number of different types of revisionism, so as to clarify the issues involved. First, there is a revisionism that rejects all hierarchies of value and can find interest—and value—in the widest range of art without any accounting for the criteria of judgment used. A second approach simply reverses the conventional modernist scale of values and finds transcendent value in academic art—whether in moral terms or in terms of aesthetics or technique. A third is one that recognizes that alternative value systems can coexist and seeks to explore different historically mediated positions and the different values for which they stood—and stand. It is this comparative, critical dimension that seems to me most fundamental in revisionism. This definition rejects the notion of transcendent values and insists that aesthetic judgment is historically grounded. There is then a fourth position that includes some nonvanguard work but simply as a foil to the vanguard; I would not consider this revisionist at all.

We can fit these four categories to exhibitions over the past thirty years. *Equivoques*, held at the Musée des Arts Décoratifs in Paris in 1973,[2] clearly falls into the first category. Although the show was opposed to hierarchies of value, its attempt at inclusiveness was, reportedly, thwarted by the refusal of the Jeu de Paume to lend Édouard Manet's *Olympia*; the museum apparently felt that its masterpiece would be tainted by this company. The title *Equivoques* is clearly significant as a comment on the organizers' attitude toward the paintings being exhibited, and it is relevant, too, that they were shown at a museum of decorative rather than "fine" arts.

Bouguereau, shown at the Petit Palais in Paris in 1984, is perhaps the best example of the second category, an attempt at a simple reversal of values; in the catalogue these claims were made—on both aesthetic and moral grounds—by Mark Steven Walker, in a case for William Bouguereau's transcendent artistic value, and by Thérèse Burollet, then chief curator at the Petit Palais, whose discussion of Bouguereau centered on his engagement with social issues.[3] Again, the location of the show is relevant—in a museum of the city of Paris, under the aegis of the then-mayor Jacques Chirac, not in the national Grand Palais, the domain of the socialist president François Mitterrand.

A key example of my third category is *Le Musée du Luxembourg en 1874*, held at the Grand Palais in 1974.[4] Here the criterion is clear: on view was state taste in modern art as exemplified by what was in the French national museum of modern art at that moment, with no attempt at superimposed value judgment of any sort. But this show also falls into my fourth category, since it was part-nered by—or rather, set against—*Centenaire de l'Impressionnisme*, in the adjacent galleries.[5] There the great masterpieces stood out, generously spaced, while the Luxembourg show was given a dense nineteenth-century-style hanging. And very few people went to see it, in contrast to the throngs viewing the Impressionists next door. The Luxembourg show did not accompany the Impressionist show when it transferred to the Metropolitan Museum of Art in New York.

One exhibition that shifted from one category to another with its change of venue was *The Second Empire* of 1978–79.[6] In Philadelphia it fell into my first category, with a splendid mixed hanging, together with velvet sofas and potted plants. There seems to have been no special criterion in the selection, beyond works in various media that the organizers found fascinating; there were Salon pictures and pictures for the dealer market, finished pictures, and studies. In Paris the same *Second Empire* show lost its revisionist edge, dropping to the

fourth category; the hanging made clear distinctions of type and value, and the Impressionists came at the end, the others serving as prelude to the Real Story—a bit like the permanent display now on view in the Musée d'Orsay. I see the first room in the *Origins of Impressionism* show of 1994–95 in much the same terms;[7] at both the Grand Palais and the Metropolitan Museum of Art it was devoted to the Salon of 1859, with the Impressionists-to-be after 1859 presented in splendid isolation, accompanied by only a few supporting works by their friends.

———

For the showing of *Landscapes of France* at the Hayward Gallery,[8] in 1995, our aim was to explore Impressionism in an entirely new context—one that would lead viewers to see the subject in fresh, and more historical, ways. The brief for the show, developed in collaboration with the Museum of Fine Arts, Boston, was to include representative groups of Impressionist landscapes and landscapes exhibited at the Paris Salon, both from the period 1860 to 1890, and to select French scenes only (including some by non-French artists). The landscapes that the Impressionists showed at the Salon were included in the Salon section. We well realized that this was not the whole story; for instance, we omitted oil sketches and more informal pictures by the Salonniers. But the binary contrast between the two groups of pictures seemed a clear way of focusing on the key difference between the two types of work as they appeared before the public in those years.

The show traced three chronological phases, both political and art historical, which can be summarized as follows: the emergence of the Young Turks inside and outside the Salon up to 1870, during the Second Empire; the sharp opposition between the Impressionists and the aesthetics of the "Moral Order" regime of the 1870s; and the contrast between the Impressionists as "independents" and the art of the opportunist republic from 1879 to 1890. Here I focus briefly on five aspects of the show that are central to the theme of revisionism: the principles behind the selection, the title of the exhibition, its actual contents, its installation, and responses to it.

My principles for selection changed significantly as the project developed. At first I thought that the Salon section should show examples of the artists who were bought most frequently by the state and who were the annual stalwarts of landscape at the Salon. After initial paper research, I set off with a list of names to include. As I visited the French provincial museums, where most of the state

purchases are housed, however, I realized that the effect of the show would be stronger if the selection were more personal and if I chose pictures that particularly struck me on my travels. Hence, for instance, the show included no paintings by Camille Bernier or Ernest Lavieille, two artists purchased regularly by the state. This clearly skewed the initial concept in an interesting way, by showing the Salon landscape in a more positive light than on balance it deserved. Viewers of this show should not think that there are large numbers of equally striking pictures in the reserve collections of provincial France, for that is not what I found. Many of the works in the museums, and especially those bought by the state, seemed to me routine and pedestrian; there were great numbers of variants on the stock Théodore Rousseau forest interior and the stock river scene by Charles-François Daubigny. I emphasize the personal—and late-twentieth-century—dimension in the selection because it seems to me a necessary compromise if we are representing this type of material now. Certainly the curatorial teams at the Hayward Gallery and in Boston supported my view.

The title of the show raised great problems. In London, the first idea was to call it *The Nature of France*; however, our colleagues in Boston considered this oblique and potentially confusing. We then thought of *Impressions of France*, and Boston agreed; but soon the London team got cold feet, thinking that emphasis on the "Impressionist" dimension was too transparently an attempt to sell tickets. Then both sides agreed on a compromise, *Landscapes of France*; London went ahead with the publicity on this basis, but at a late stage Boston decided on a unilateral change back to *Impressions of France*. The London team was left feeling that, if agreement could not be reached, we would have preferred to stick with *The Nature of France*, or perhaps *The French Landscape*. The subtitle, too, was much discussed. Both organizations rejected my idea of *Impressionism and Its Enemies*, although clearly this was the most apt in historical terms; but both press offices felt that the open conflict invoked by the word *enemies* does not sell shows. They agreed on *rivals*, though the Salonniers would never have seen themselves as the rivals of the Impressionists (because of the different headline titles, the subtitle was *Impressionism and Its Rivals* in London, but *Monet, Renoir, Pissarro, and Their Rivals* in Boston).

As for the content of the exhibition, London chose to include equal numbers of Salon and Impressionist paintings—approximately fifty of each. This was not possible in Boston, where, given the size of many of the Salon paintings, the special exhibition galleries at the Museum of Fine Arts could not house every-

thing. It was also clear from the start, however, that Boston wanted to weight the numbers of the pictures in the show—like the title—toward the Impressionists. To address perceived problems of both space and content, therefore, they omitted about a dozen of the largest Salon pictures and added about a dozen more Impressionist canvases. The catalogue was identical in both places (albeit with different covers and titles); thus the Boston book buyers could see what they had missed—even if only on the scale of the printed page.[9]

The Hayward installation space—with its alternating large, tall areas and lower, more intimate spaces—suggested that there be no head-to-head confrontations between Salon and Impressionist paintings (Impressionists could readily be dwarfed in the taller spaces, besides which I felt that awkward juxtapositions would diminish the effect of all pictures involved). I was determined that we should have a single red-based wall color throughout the installation at the Hayward, so as to heighten contrasts between the color schemes of the different types of picture; the cool blues of Impressionism gain their effect only when set against the warm-hued walls on which the painters expected their canvases would be hung. The tone was determined by the scale of the spaces, allowing for the total lack of daylight. It was clear that a rich nineteenth-century red would not be possible; the color we finally chose was a light terra-cotta.

The sequence of galleries began with a tall, monumental oblong space hung with the Second Empire Salon paintings. Next, three interconnecting lower galleries presented the primary selection of smaller canvases by the Impressionists, from the mid-1860s to the early 1880s. After this, two more large galleries, both square, showed Salon pictures from the 1870s and 1880s, respectively, and finally a smaller space housed the Impressionists from the mid- to later 1880s. This display of three distinct historical periods was accompanied in each room by succinct wall texts that presented the main thread of the argument—the commentary repeated in the free gallery guide. In a revisionist show of this type, we attached great importance to the text as a vital means for the viewer to make sense of the project.

Very different solutions were devised for Boston, where the Gund special exhibition galleries, with their honeycomb ceilings, allow walls to be moved to create spaces of different scale and shape. It was not possible, however, to make lofty, monumental spaces of the type that best suits large Salon paintings (ironically, the original building of the Museum of Fine Arts has splendid spaces of just this sort). The Boston installation, with which I was not involved, preserved the

same general alternation between Salon and Impressionists, but it diverged in a number of ways. Since there were fewer Salon pictures, those from the 1870s and 1880s were shown together in one room, which blurred the contrast between these decades that we were seeking to bring out. The Boston curators also decided to include some direct Salon/Impressionist contrasts, both in the small initial space and in a larger room near the end; these worked far better that I had anticipated, bringing home the arguments of the exhibition in a particularly vivid way. I was much less happy, though, about the inclusion of a few sculptures in the later Salon room—works that were not shown at the Salon and were not, of course, landscapes. Clearly at odds with the overall concept of the show, this departure threatened to turn the Salon display into a form of high-class bric-a-brac. Wall colors varied from one room to another, with a particularly pungent deep red in the second Salon room. They were well chosen, but I regret that constant variegation is so often felt to be necessary today; it is as if the pictures cannot sustain the viewer's interest on their own. Elaborate and extensive explanatory texts, written by Barbara Martin from the Boston museum's education department, were an excellent aid to the close study of the show.

In London the exhibition received an interesting and varied press response that extended beyond the standard art critics; some generalist columnists gave their views in the most robust fashion. Some were militantly pro-Impressionist, but others used the Salon pictures as a stick with which to beat Impressionism; for Paul Johnson, the Salonniers showed up "that huge imposture known as Modern Art,"[10] while A. A. Gill also abused the Impressionists, compared the project with the Nazi *Entartete Kunst* shows, and (rather unexpectedly) likened me directly to Hitler ("Like Adolf, the joke is all over Mr. House and the Hayward").[11] There was less (and less-heated) attention from the press in Boston, but this was, I think, because of the location. Attendance figures tell the opposite story. In London, despite the press coverage, the show attracted only an attendance totalling 105,000;[12] in Boston the visitor count was 197,000.[13]

My verdict is equivocal and slightly rueful. The strength of the Boston exhibition was its beautiful design and its thoughtfully presented text panels. But the physical experience of it was of an Impressionist show with two contextual rooms, as the title *Impressions of France* suggests. The London installation, by contrast, sustained the balance and the rivalry (or enmity?) throughout, along with presenting the revisionist argument as I conceived it to the full. Attendance

figures, however—double the number in Boston, despite less press coverage than in London—suggest what the public wanted.

Monographic shows cannot be seriously revisionist, even if presenting non-canonical artists. The comparative dimension is vital, and the only way to achieve this is, I think, through a show conceived thematically, whether this theme is genre-based, or grounded in institutional frameworks, or both, like *Landscapes/Impressions of France*. Only thus can we get a sense of the relative values for which different positions and approaches stand. But, as we know, institutions are less likely to mount thematic shows and to lend major works to them; and the public is less likely to visit them. That is my final paradox.

1. Paul Hayes Tucker with George T. M. Shackelford and Mary Anne Stevens, eds., *Monet in the 20th Century*, exh. cat. (New Haven: Yale University Press, 1998).

2. Olivier Lépine, ed., *Equivoques: peintures françaises du XIXe siècle*, exh. cat. (Paris: Union centrale des arts décoratifs, 1973).

3. *William Bouguereau, 1825–1905*, exh. cat. (Paris: Musée du Petit Palais, 1984). On this show, see John House, "Pompier Politics: Bouguereau's Art," *Art in America* 72 (October 1984); on versions of revisionism, see also Neil McWilliam, "Limited Revisions: Academic Art History Confronts Academic Art," *Oxford Art Journal* 12, no. 2 (1989).

4. Geneviève Lacambre, ed., *Le Musée du Luxembourg en 1874: peintures*, exh. cat. (Paris: Editions des Musées Nationaux, 1974).

5. Anne Distel, Michel Hoog, and Charles Moffett, *Centenaire de l'impressionisme*, exh. cat. (Éditions des Musées Nationaux, 1974).

6. *The Second Empire: Art in France under Napoleon III*, exh. cat. (Philadelphia: Philadelphia Museum of Art, 1978). The Philadelphia Museum of Art kindly supplied me with the figures comparing attendance for *The Second Empire* with previous shows, mostly monographic: *Cézanne* in 1996, 778,000; *Great French Paintings from The Barnes Foundation* in 1994, 477,000; *Van Gogh* in 1970, 410,000; *Delacroix: The Late Work* in 1998, 305,000; and *The Second Empire*, only 157,000.

7. Gary Tinterow and Henri Loyrette, *Impressionnisme: Les origins*, exh. cat. (Paris: Editions des Musées Nationaux, 1994); New York cat.: *Origins of Impressionism* (New York: Metropolitan Museum of Art, 1994). See the essay by Gary Tinterow above for further discussion of this show.

8. The initial plan called for creating a blockbuster for the Hayward Gallery—the brutalist concrete gallery on London's South Bank, never an easy space for the display of pre-1900 art.

9. John House, ed., *Landscapes of France: Impressionism and Its Rivals*, exh. cat. (London: Hayward

Gallery, 1995); Boston cat.: *Impressions of France: Monet, Renoir, Pissarro, and Their Rivals* (Boston: Museum of Fine Arts, 1995).

10. Paul Johnson, "Forgotten Masterpieces Resurface in the Concrete Hell of the Hayward," *Spectator*, 8 July 1995, 24.

11. A. A. Gill, "Too Soft-Centred," *Sunday Times: "The Culture" Magazine*, 4 June 1995, 8–9.

12. Compare other attendance figures at the Hayward Gallery: *Renoir* in 1985, 364,000; *Van Gogh* in 1968, 198,000. I am grateful to the South Bank Centre in London for supplying me with these figures.

13. Compare other attendance figures at the Boston Museum: two Monet shows and Renoir, each drawing between 515,000 and 566,000 visitors; then eight shows, each totalling between 218,000 and 284,000, from Rubens via Herb Ritts to Picasso; and then *Impressions of France*. I am indebted to the Museum of Fine Arts, Boston, for these figures.

A Tormented Friendship: French Impressionism in Germany

Michael F. Zimmermann

Without the Nazi terror, German museums could have become very rich in Impressionist paintings. That many examples existed in German private collections from around 1900 onward is becoming apparent through such sources as the archives of the art dealer Paul Cassirer (not yet fully known to the public), who founded his Berlin gallery in 1898. And the publications of Walter Feilchenfeldt on the acquisition of works by Paul Cézanne and Vincent van Gogh yield astonishing insights into the richness and quality of his country's private collecting of this era.[1]

Because of Nazi politics, however—that government's brutal suppression of any manifestation of modern art, as well as its devaluation, and also of even the French and German Impressionist paintings that were not denounced outright as "degenerate"—most of the works that had been in private collections in Germany never found their way into German public collections.[2] What remains in the museums of Berlin, Munich, Bremen, Hamburg, Mannheim, and Essen are the paintings that were acquired for public collections relatively early.

These acquisitions resulted from the close cooperation of an artistic elite among museum curators—including Alfred Lichtwark, Hugo von Tschudi, Gustav Pauli, Fritz Wichert, and Georg Swarzenski—and art critics and art historians such as Richard Muther and Julius Meier-Graefe. United by a strong belief in artistic progress as well as in the liberal spirit of art history, they were willing to encounter the opposition of conservative followers of the emperor Wilhelm II, whose aesthetic taste privileged neo-Romanesque grandeur and a neo-Stauffic "Nibelungen" style over what traditionalists regarded as naturalistic "gutter" art.[3]

While relatively rare, the first attempts to collect Impressionism in Germany were nonetheless an important precondition for the later acquisitions for public museums. The earliest such collection was that of the Berlin law professor Carl Bernstein, which was shown in 1883 at the Berlin gallery of Fritz Gurlitt.[4] From this point on, the better-informed artistic circles were able to get acquainted with the new painting. It took a long time, however, before the collecting of Impressionism became fashionable for the rich Berlin bourgeoisie who had made their fortunes during the *Gründerzeit*, the period of rapid industrial

Fig. 1. Eduard Arnhold in his home, Regentenstrasse 19, in front of Édouard Manet's *The Artist [Marcelin Desboutin]*, 1875, acquired in 1910 from the collection of Auguste Pellerin (today in the Museu de Arte Moderna, São Paolo). Photograph c. 1920, Ullstein Bilderdienst, Berlin

development that followed German unification in 1871. Prominent among them was Eduard Arnhold, who began as an apprentice and made his fortune from mining coal in Silesia. Initially he collected Arnold Böcklin, Hans von Marées, and the German artists in Rome and elsewhere in Italy; later he bought works of the Munich and Berlin Secessionists, and after 1898 he was one of the most regular clients of Cassirer's gallery. Occasionally, he was advised by Hugo von Tschudi. Views of Arnhold's apartment (figs. 1 and 2), dating from around 1920, say more about Impressionism in Germany than lengthy lists of paintings. Edouard Manet's portrait of Marcelin Desboutin, visible in both photographs, was acquired in 1910.[5]

Cassirer was also the highly influential secretary of the Berlin Secession, founded in 1898 and led by Max Liebermann. The Secessionist exhibitions almost always included foreign (mostly French) art along with works by Liebermann, Lovis Corinth, Max Slevogt, Walter Leistikow, and others. At his gallery, Cassirer offered the same program of the French and German avant-garde in smaller shows.

As important as the role of Cassirer was another factor that helped to form high-quality collections of Impressionism in Germany early in the last century—namely, a new type of professional museum director. Art history had only recently acquired the status of an independent discipline in universities. As the gradual evolution of rigorous stylistic analysis took place, spawning scholars with an entirely different approach, Hermann Grimm (professor in Berlin since 1875 and founding director of the university's department of art history) and Carl Justi were among the last writers to capture the artistic ethos of a period in the work of heroic figures such as Michelangelo or Diego Velázquez. Modern psychology, strongly influenced by recent research in the physiology of the senses and the nervous system, inspired new ways of describing stylistic

Fig. 2. A view of Eduard Arnhold's apartment, Regentenstrasse 19, featuring Manet's *The Artist [Marcelin Desboutin]* at far left. Photograph c. 1920, Ullstein Bilderdienst, Berlin.

consistency and developmental tendencies from linear to painterly modes, from closed to open forms, and so on.[6] This "scientific" study of "the history of vision" culminated in the book *Principles of Art History*, published in 1915 by Heinrich Wölfflin, who had succeeded Grimm as head of the art history department in Berlin.[7] For other art historians, however—those whose foundation was Jakob Burckhardt's all-encompassing vision integrating artistic and social history—a less progressive version of connoisseurship became the context of art historical professionalism.

Fig. 3. Leopold von Kalckreuth (German, 1855–1928), *Alfred Lichtwark*, 1912. Oil on canvas, 99 × 86 inches (251.5 × 218.4 cm). Hamburger Kunsthalle

Fig. 4. Hugo von Tschudi, c. 1910. Photograph by C. von Dühren, Berlin. Published in vol. 33 of *Jahrbuch der Königlichen Preussischen Kunstsammlungen* (1912), p. 1. Bildarchiv Preussischer Kulturbesitz, Berlin

The new approach to art history corresponded to a confidence in autonomous laws of artistic development and progress. Both of these phenomena lay behind the acquisition of important works by Manet at a relatively early date by German museum directors.[8] The leading officials often acted out of a deep professional consensus, sharing both friendship and common ideas on cultural policy. One of the first was Alfred Lichtwark, who from 1886 to 1914 served as director of the Kunsthalle in Hamburg (fig. 3). Aided in his task by the wealth of a relatively independent, liberal community, he put forward an ambitious program for collecting that encompassed medieval art from northern Germany as well as nineteenth-century art in Hamburg. It was toward the end of the century that Lichtwark's views of latter-day painting changed, leading him to purchase masterpieces by the best German artists of the era. As his interest deepened, he bought a still life by Manet in 1897. But it was not until 1907 that he became seriously committed to the modern French tradition, acquiring paintings by Jean-Baptiste Camille Corot, Charles Daubigny, and Gustave Courbet, as well as Pierre Bonnard and Edouard Vuillard.[9]

Although Lichtwark encouraged the civic pride of the wealthy Hanseatic

Fig. 5. Édouard Manet (French, 1832–1883), *In the Winter Garden*, 1878–79. Oil on canvas, 45 ¼ × 59 inches (115 × 150 cm). Staatliche Museen zu Berlin–Preussischer Kulturbesitz, Nationalgalerie

bourgeoisie, he gradually became more interested in affirming international artistic progress during the modern era. Undoubtedly a highly influential model was his Berlin friend Hugo von Tschudi (fig. 4), a scholar of Renaissance art who had made his career within the Berlin Nationalgalerie and was named its director in 1896.[10] Dedicated twenty years earlier as a temple of German art as well as honoring the glory of the ruling Hohenzollern family, the museum had long suffered from the contradictions of its dual role.[11] Tschudi's first step as director was a bold stroke—equivalent to a coup d'état: he immediately acquired a stock of important Impressionist paintings, among them Manet's *In the Winter Garden* (fig. 5). Even before the founding of the Berlin Secession, he managed to get the consent of the ministry, and of the kaiser, not only to accept the collection of Impressionist paintings but even to finance it. Apparently, he knew how to persuade Kaiser Wilhelm II, whose all-too-personal government was under ongoing pressure also from the Reichstag. Soon Tschudi rearranged the collections so as

Fig. 6. Tschudi's hanging from early 1907 in the third floor of the National Gallery, Berlin. Photograph by Albert Schwarz, 1908, Staatliche Museen zu Berlin—Preussischer Kulturbesitz, Zentralarchiv

to favor aesthetic criteria over ostentatious display and dynastic propaganda. When, in 1902, the kaiser ordered him to change this installation, Tschudi decided to divide the galleries that represented artistic progress from those illustrating Hohenzollern glories. His plans for a modern hanging were authorized only at the end of 1906; the new hanging was realized early in 1907. Foreign, mostly French, art was arranged in a soberly bright room under skylights (fig. 6).[12] Wilhelm II then tried openly to force Tschudi into submission, but others such as the Secessionists and Lichtwark encouraged him to resist.[13]

In 1908 the tension between Tschudi and the kaiser came to a head over a dispute about acquisitions—a conflict that finally made Tschudi's position impossible. Although handicapped by a serious disease, he accepted an offer to direct the Bavarian state collections in Munich. Here again, he purchased paintings for the museum such as Manet's *Lunch in the Studio* (fig. 7), acquired along with others from the holdings of Auguste Pellerin. This important collection had been sold by Cassirer and Paul

Fig. 7. Édouard Manet, *Lunch in the Studio*, 1868. Oil on canvas, 46 ⅝ × 60 ⅝ inches (118.3 × 153.9 cm). Bayerische Staatsgemäldesammlungen, Neue Pinakothek, Munich

Durand-Ruel, who sent it on tour to various cities in Austria and Germany. As in Berlin, where Tschudi had relied increasingly on private sponsorship in order to bypass government opposition, the new Munich collection was financed exclusively by generous friends; it entered the museum only in 1912, shortly after the director's death.

The passion of Tschudi's engagement, which helped break the joint resistance of conservative Munich artists and the government, was shared

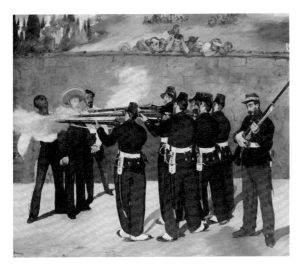

by Georg Swarzenski, who had been his colleague in the Berlin museums. Shortly after accepting the nomination as director of the Frankfurt Städelsches Kunstinstitut in 1906, Swarzenski built up the holdings of Impressionist art there. His intent was to acquire, for relatively modest prices, a collection of such significance as to have a positive influence on modern art.[14] Swarzenski served as mentor to Fritz Wichert, who, after receiving a doctoral degree in Berlin under Wölfflin, worked for him in Frankfurt for two years.

Fig. 8. Édouard Manet, *The Execution of the Emperor Maximilian* (3rd version), 1868–69. Oil on canvas, 99 ¼ × 118 ⅞ inches (252 × 302 cm). Städtische Kunsthalle, Mannheim

Wichert then became director of the Mannheim Kunsthalle in 1909, and the following year he purchased Manet's *Execution of the Emperor Maximilian* (fig. 8) from the Pellerin collection.[15] Both Swarzenski and Wichert were influenced by Lichtwark in encouraging modern and applied arts through the activities of their museums.

Another entrepreneurial spirit among directors was Gustav Pauli (fig. 9). He had studied with Burckhardt and worked in the Dresden museums before he became, in 1899, director of the Kunsthalle in Bremen. A champion of artistic innovation, he favored not only French and German Impressionists but also Expressionist art as well as the artists of the Worpswede colony, located near Bremen. One of Pauli's most out-

Fig. 9. Max Slevogt (German, 1868–1932), *Gustav Pauli*, 1924. Oil on canvas, 39 ⅜ × 34 ½ inches (100 × 87.5 cm). Hamburger Kunsthalle

standing acquisitions was Manet's portrait of Zacharie Astruc (fig. 10), from Durand-Ruel, via Cassirer. After Lichtwark's retirement in 1914, Pauli succeeded

him as director of the Hamburg Kunsthalle, and a decade later, against the massive opposition of the city council, he bought Manet's *Nana* (fig. 11), a painting the Paris Salon had refused in 1877. It had been part of the Pellerin collection, from which it was purchased by a Hamburg collector. Pauli could convince the city council only by arguing that the picture was a good investment and could be sold later for a lucrative price.[16]

The dates of German purchases of important Impressionist paintings are truly remarkable by comparison with those of France. A year after Antonin Proust had made Manet the hero of the art exhibition at the Paris world exposi-

Fig. 10. Édouard Manet, *Zacharie Astruc*, 1866. Oil on canvas, 35 × 45 ⅝ inches (89 × 116 cm). Kunsthalle Bremen

tion of 1889, the gift of *Le Déjeuner sur l'herbe* (Lunch on the grass) to the French state by a group of artists, intellectuals, and writers still caused major political turmoil. In the same way, the collection of the painter Gustave Caillebotte, bequeathed to the state in 1894, was rejected initially; two years would pass before half of the paintings were hung in the Palais du Luxembourg.[17] It was in that year that Tschudi acquired *In the Winter Garden* for Berlin.

The German museum directors who are rightly considered the founding fathers of modern art collections, in which Impressionism played and still plays a decisive role, were motivated in their acquisition strategy not merely by cultural rebellion or the predilections of naturalistic "gutter" literature,[18] but also by the writings of art historians. In 1893–94 Richard Muther, for example, published a highly ambitious three-volume history of nineteenth-century painting.[19] Refusing to categorize into national schools, he reconstructed artistic progress, in Emile Zola's famous phrase, "as seen through a temperament." Muther greeted Impressionism as the "final word in the monumental struggle for liberation of modern art."[20] Manet had replaced "artificial" or conventional means to reach pictorial unity by the "scientific" study of light, which, by its atmospheric power, unites the spectator and the scene in a higher harmony. Under the rubric "fiat lux," Muther

Fig. 11. Édouard Manet, *Nana*, 1877. Oil on canvas, 60 ⅝ × 45 ¼ inches (154 × 115 cm). Hamburger Kunsthalle

Fig. 12. Lovis Corinth (German, 1858–1925), *Julius Meier-Graefe*, 1917. Oil on canvas, 35 ⅜ × 27 ½ inches (90 × 70 cm). Musée d'Orsay, Paris

labeled Manet's art as the culminating point in a development that went from antiquity through Masaccio and Piero della Francesca to Courbet and the Barbizon painters. With harmony and intensity of perception as the central criteria the Impressionist had succeeded in linking art more closely to the all-encompassing movement of life.[21]

The art historian Georg Dehio attacked Muther's book as a subjectivist pamphlet influenced by Zola.[22] Indeed, Zola's belief in the independent individual emancipated to the highest degree from academic prejudice and old-fashioned conventions would dominate for a generation. The liberal cult of outstanding personalities would be accentuated, during the 1890s, by an undercurrent of Nietzscheanism penetrating critical language and rhetoric. Writing in this vein, and more influential than Muther, was Julius Meier-Graefe (fig. 12), who had been an early defender of Edvard Munch and who directed, after 1895, a modern applied-arts gallery in Paris. In 1904 he published the first edition of his book on modern art—a work that by far superseded Muther's in its emotional acuity as well as narrative precision. Meier-Graefe, too, hailed Impressionism as a triumph and a turning point in the history of art. He considered progress in the direction of subjective expression to be a consequence of advancing individual freedom and liberalism. French art, more genuinely pictorial than the introverted expressions of the Nordic people, was in his view destined also to serve as a model for German art.[23] In its formalism, Meier-Graefe's thinking had a source different from that of his colleagues; his aim was to be accepted not as a historian but as a critic who stood in the tradition of Charles Baudelaire, Théophile Gauthier, and other French writ-

ers of the Post-Impressionist and Symbolist generation. Indeed, he invented a sophisticated form of highly engaged and often polemical art criticism within the German culture. But with the university professors of art history, he fought for the independence of aesthetics from extra-artistic interests.[24] Meier-Graefe's frank aestheticism can be sensed as an underlying element in Tschudi's preference for Manet's *Lunch in the Studio* over *Bar at the Folies-Bergère* and *Nana,* which were also part of the Pellerin collection on sale through Cassirer. In a small monograph on Manet published in 1902, Tschudi mentioned *Bar at the Folies-Bergère* only for its beautiful still life, whereas he acclaimed *Lunch in the Studio* as a modern synthesis of the art historical tradition of portrait painting.[25] Tschudi's attitude would remain typical for the German reception of the *Bar at the Folies-Bergère.* The painting would be in Justin K. Thannhauser's Munich gallery in 1925. When it entered the Courtauld Institute galleries five years later, Wilhelm Hausenstein, an art critic of the expressionist generation, published his farewell to what had been, for him, the modern incarnation of the *éternel féminin.* Viewing the male spectator in the painting, represented as the client with the monocle in the mirror, as having transformed the seductive woman into a modern Olympia—not Manet's own but the beautiful mechanical doll in *The Sandman* by E. T. A. Hoffmann—Hausenstein regretted that Manet had reduced her life merely to her public existence.[26] In 1951, Hans Jantzen, rather influential in post–Second World War German art history, in an essay dedicated to Georg Swarzenski, praised Manet for having isolated the sculptural figure in the painting. He interpreted that isolation as a moral rescue of the innocent woman from her immoral, French surrounding.[27]

The formalistic preferences of Meier-Graefe and Tschudi were not strong enough, ultimately, to overcome the Germans' nationalistic and chauvinistic opposition to French art—especially the Impressionist idiom. Meier-Graefe's elitist aestheticism, although important in the intellectual debate, never became popular. His criticism had been influenced deeply by Friedrich Nietzsche's *Untimely Meditations,* in which his country's bourgeoisie was attacked for its cultural arrogance following victory over France in 1871, thereby translating German military superiority into an ostensible cultural superiority. In 1905 Meier-Graefe evoked the precedent of Nietzsche's critical book *Der Fall Wagner* (The case of Wagner, 1888) with a stinging polemic titled *Der Fall Böcklin* (The case of Böcklin), directed against the painter Arnold Böcklin, whom he dismissed as the hero of a beery half-educated bourgeoisie, the idol of a worthless cult of the

masses.[28] Henry Thode, professor of art history in Heidelberg and son-in-law of Cosima Wagner, responded with pamphlets opposing the deeper spiritual essence of German to the merely pictorial superficiality of French art, and defending Böcklin along with Hans Thoma as the heroes of Nordic painting.[29] It was *their* positions that became influential during the 1930s.

It would be too simplistic to label Meier-Graefe's, Tschudi's, and the pioneering curators' interest in Impressionism as motivated only by formalist aestheticism. Such an evaluation would amount to repudiating, on the grounds of the current rejection of formalism, the academic background that lay behind a decisive step of modernizing aesthetic culture in Germany. Instead, we should place that specific formalism in the ideological and institutional reality of the Kaiserreich. As we have seen, the ideas of the established museum curators were well grounded in the tradition of German art history. Although early scholars (such as Karl Friedrich von Rumohr, Karl Schnaase, and Jakob Burckhardt) had very different ideas about art and its development, they were all concerned with the question of artistic evolution as it relates to historical development. Their followers, the generation of art historians who started their careers during the last decades of the nineteenth century—Wilhelm von Bode, Anton Springer, Heinrich Wölfflin, and Aloïs Riegl—were still interested in the impact of historical context on the artwork, whether regarding social history, the history of ideas, or the spiritual progress of humankind. But they focused more on what artistic development meant in itself, independent of the influences of society. Whether inspired by connoisseurship or informed by philosophical discussions, art historians of that generation insisted mostly on an inner logic of artistic development: one form generating the offspring of the next, a formal problem of one work necessitating its solution in another one. While almost all agreed that art participated in the general historical progress and expressed the situation of its time, most of them (except Springer) had varying ideas about a sort of Zeitgeist that linked *Kunstwollen* (the will to art or style), and *Formgefühl* (the feeling for form) to other fields of society and progress. Often it was more a matter of vague belief than of methodology to assert that an artistic movement was an expression of contemporary spirit.[30]

If we try to characterize the formalistic interests of this generation according to Richard Wollheim's distinction, we would have to describe them as analytical rather than normative: the subject matter of painting or sculpture simply was analyzed predominantly in formal terms.[31] An appreciation in the

name of normative formalism would have been grounded in aesthetic laws that might or might not have been deduced from the works themselves. Furthermore, a normative formalism would insist on an autonomous development of art. The reason for that focus is partly institutional. Apparently, during the formative period of art history as a department in universities, it was important to insist on independent criteria and paradigms. Art history still had to be legitimized as a field of scholarship based on its own distinctive principles.[32]

Another feature of the formalism of art history during the Wilhelmine era is the fact that it was inspired fundamentally by art theory. The sculptor Adolf von Hildebrand had insisted on specific aesthetic requirements for pictorial narration within the surface of classical relief[33]—an analysis on which August Schmarsow based a theory of pictorial (instead of sculptural) space.[34] Following a discussion that had its origins in the eighteenth century—in Gotthold Ephraim Lessing's theories about Laocoön, for example—there was a keen perception for the distinctive character of the artistic media in painting, sculpture, and architecture.[35] Perhaps the most promising aesthetic theory associated with early formalism was the philosophy of Konrad Fiedler. According to the concept of expressive gesture (*Ausdrucksbewegung*), he analyzed the logic of transformation in the artwork. He defended the autonomy of art not only as based on specifically aesthetic interests but as determined by the various procedures and expressive strategies of different artistic media. The validation of an artwork can be established only by focusing on the process of its realization in the chosen material.[36] Fiedler's writings, as well as his endorsement of an artist such as Hans von Marées, were inspired by a strong opposition to meaningless anecdotal naturalism and to compositions overdetermined by historically accurate decoration and ideological retrieval of the past. His art theories are symptomatic of a generation inimical to the average production: painting that reflected the prejudices of a petty educated bourgeoisie and of nationalism. Art, he believed, must not be allowed to merge into mass culture, with nationalism as one of its principal catalysts.[37]

The achievements of Lichtwark, Tschudi, Pauli, and Meier-Graefe were possible only within a congenial alliance of divergent forces that defended an independent aesthetic distinctive of an urban, cosmopolitan society. Their fight for Manet and Impressionism was directed against nationalistic provincialism and petty bourgeois amateurism. In one way or another, all the defenders of Impressionism in Germany insisted that aesthetic invention must be distinctively contemporary. Implicitly, that attitude is directed against any ahistorical concep-

tion of formalism and art for art's sake. They all preferred themes of art that were not constructed according to extra-artistic principles but were somehow found in order to satisfy aesthetic necessities of modern experience. Therefore, art historians who admired Italian Renaissance art as well as Rembrandt could hold modern subjects and the Impressionists in high regard. As demonstrated in the example of Tschudi, however—his preference for *Lunch in the Studio* over *Bar at the Folies-Bergères*—they were partial to relatively neutral scenes from ordinary bourgeois life instead of noisy episodes from popular culture and Parisian amusements. Their formalism was thus linked to a collective mentality. Accepting cosmopolitanism and a society based on liberal exchange, they defended the rights and interests of aesthetic culture in a highly differentiated society. That their formalist beliefs did not develop into avant-garde utopias or into futurism probably explains why, to the post-modern art public, Tschudi and Meier-Graefe are more appealing than the true believers in pure aesthetics of the period following World War II.

The year 1933 marks the collapse of German aesthetic culture. During the 1950s, art historical writing about Impressionism in Germany slowly made a new beginning. In an era when Abstraction was considered the international artistic language of the Western world, the formalist understanding of Impressionism deepened. But it was not the formalism of Alfred Barr or Clement Greenberg; rather, it was colored by a specifically German penchant for suppressing the remembrance of national shame. The philosopher Martin Heidegger played a key role in the birth of a national school of art history that evaluated art on the tabula rasa of existentialism. In 1935, in his essay on the origin of the work of art, Heidegger had discussed Van Gogh's *Shoes* as a paradigm of a postmetaphysical aesthetics linking art to the essence of things (as, in this case, a pair of worn shoes).[38] Heidegger created the paradigm for Austrian and German art historians who tended to see Impressionism as the aesthetic expression of an existential attitude toward the world. Cézanne, as seen in 1956 by Kurt Badt, was an existentialist artist admired mostly for his almost religious contemplation of the fundamental problems of human existence.

To be sure, by the 1950s, the school of Kurt Badt, Lorenz Dittmann, and Max Imdahl can be credited with initiating a debate within German art history about modern artistic languages.[39] But they transformed the elitist formalism of the generation of Tschudi into an escapist vision of pure art considered almost as a second religion. In part, their position can be understood as a response to Hans

Sedlmayr, whose incendiary book *Verlust der Mitte* (The loss of the center), published in 1948, had interpreted modern art as an index of post-Enlightenment decadence.[40] The most intelligent art historian among those who had been infected by Nazi ideology, Sedlmayr suppressed the ideological past with a neo-Catholic pessimism. Badt reacted as if obliged to prove that art still belonged to the realm of spirituality. His book on Cézanne, published in 1956, made clear that Zola's notion of the artist's temperament was adequate to describe Manet's art but not that of Cézanne. Zola had used the term *temperament* to describe, according to Badt, merely a psychological attitude toward "a corner of nature"; in Cézanne, the approach evolved into a fundamentally aesthetic subjectivism contemplating not just aspects of reality but the world.[41] Cézanne's calm solitude triumphing over emotional turmoils was symbolized by the several versions of his *Card Players*. The closeness of the motif to Caravaggio's *Supper at Emmaus* gave a cryptic religious undertone to this aesthetic idolatry.

In 1996 and 1997 an exhibition on Tschudi and the paintings he acquired for Berlin and Munich drew massive crowds. The catalogue is an impressive résumé of research on the history of museums during the Wilhelmine era. On the one hand, the evocation of Tschudi and Meier-Graefe, in a diatribe against essentialist idolaters and aesthetic high priests, certainly had a liberating effect. But on the other hand, the organizers' attempt at reviving the spirit of elitist aestheticism seemed sterile. Impressed that the aristocratic origin of Tschudi's family was older than that of the Hohenzollern, they contrasted the seasoned nobility of the museum director with the vulgar tinsel aristocracy of Wilhelm II.[42] Perhaps the problem is that reviving the liberal aestheticism of former times inevitably neutralizes the emancipatory aspect of that same aestheticism. Similarly, an avant-garde that takes an elitist stance against the Kaiserreich cannot be a model for modern strategies for creating a refined aesthetic attitude. The fight for the Impressionists against the kaiser was a courageous act in the name of the freedom and autonomy of art. But today, only a genuinely liberal debate about the masterpieces by Manet, one that is not tied to the aestheticism of Meier-Graefe and Tschudi, can be faithful to their spirit.

Studies reconsidering the effect of Impressionism on the background of other German intellectual traditions—for example, that of Walter Benjamin—are still marginal, confined to strictly academic art history, and often regarded with suspicion. To be sure, there have been blockbuster shows on Impressionism and early modern art in Germany—such as the exhibitions

organized during the 1970s and early 1980s at the Kunsthalle Tübingen or the 1992 Van Gogh retrospective in Essen. And, as in France, England, and the United States, they are generally motivated by biographical, novelistic, and aesthetic ideas. But it would be impossible to oppose a broader current of "revisionist" scholarship to the early modernist trend. If they exist at all, revisionist art historical studies on Impressionism in Germany are linked to French intellectualism, to critical art history in England and the United States, and to models of literary history in the German context.

However we assess Germany's last generation of truly heroic internationalists, buying Impressionist masterpieces for their museums, we confront an ideological impasse. Centers such as Munich and Berlin are still not comfortable with "their" Manets, which remain among the most ambiguous of his works. A monumental exception to this estrangement of Manet's paintings from their sophisticated surroundings is Werner Hofmann's study of *Nana*, a highly intellectual book published in 1973 in a popular edition.[43] But it has had scarcely any successors. The provocative modernity of Manet is silenced under the weight of art history. If we fail to understand what Impressionism means for present-day Germans, we know at least what it meant for Hugo von Tschudi and the enlightened bourgeoisie of his time. But today Impressionism belongs to the two art histories, and only to them.

1. Walter Feilchenfeldt, *Vincent van Gogh and Paul Cassirer, Berlin: The Reception of Van Gogh in Germany from 1901 to 1914*, catalogue of the drawings, compiled by Han Venenbos (Zwolle: Uitgeverij Waanders, 1988); Walter Feilchenfeldt, "Zur Rezeptionsgeschichte Cézannes in Deutschland," in *Cézanne: Gemälde*, ed. Götz Adriani (Cologne: DuMont, 1993), 293–312. Feilchenfeldt generously made accessible to Verena Tafel the archives of Paul Cassirer for the study "Paul Cassirer als Vermittler Deutscher impressionistischer Malerei in Berlin: Zum Stand der Forschung," *Zeitschrift des Deutschen Vereins für Kunstwissenschaft* 42 (1988): 31–46. A useful survey on collecting and the art market is Robin Lenman, "Painters, Patronage, and the Art Market," *Past and Present: A Journal of Historical Studies* 123 (May 1989): 109–10. See also Robin Lenman, *Die Kunst, die Macht und das Geld: Zur Kulturgeschichte des kaiserlichen Deutschland, 1871–1918* (New York: Campus, 1994).

2. The Nazi shows on "degenerate" art of 1937—among them the most prominent "decadent art" exhibition in Munich—concentrated mostly on works by the generation of Expressionism, Dada,

and 1920s neo-Realism. Except Van Gogh, French Impressionist works were generally not seized as degenerate from German art museums. The only German Impressionist to be singled out as such was Lovis Corinth. As the examples of Munch and Ensor make clear, those artists reputed to be mentally or physically ill were included in the shows of 1937, and their works were confiscated from museums. The basic documentation for this practice is Franz Roh, "Die in den Museen beschlagnahmten Arbeiten," in *"Entartete" Kunst: Kunstbarbarei im Dritten Reich* (Hannover: Schmidt-Küster, 1962), 123–248. See also Paul Ortwin Rave, "Gemälde und Plastiken moderner Meister aus deutschen Museen: Verzeichnis der Auktion in Luzern am 30. Juni 1939, Galerie Fischer," in *Kunstdiktatur im Dritten Reich*, ed. Uwe M. Schneede (Berlin: Argon, 1987), 164–67. Background information on art politics and the institutional framework surrounding confiscations can be found in Otto Thomae, *Die Propaganda-Maschinerie: Bildende Kunst und Öffentlichkeitsarbeit im Dritten Reich* (Berlin: Mann, 1978); and Alan E. Steinweis, *Art, Ideology, and Economics in Nazi Germany: The Reich Chambers of Music, Theater, and the Visual Arts* (Chapel Hill: University of North Carolina Press, 1993). For a recent examination of the subject, including a list of artworks exhibited as "degenerate," see Stephanie Barron et al., *"Degenerate Art": The Fate of the Avant-Garde in Nazi Germany*, exh. cat. (Los Angeles: Los Angeles County Museum of Art; Chicago: Art Institute of Chicago, 1991), esp. the essays by Annegret Janda and Andreas Hünecke. The 1937 show in the Munich Hofgartenarkaden and many other exhibitions of "degenerate" art in several cities are discussed in Christoph Zuschlag, *"Entartete Kunst": Ausstellungsstrategien im Nazi-Deutschland* (Worms: Werner, 1995), 205–21. For introductory information about the confiscations, see Lynn H. Nicholas, *The Rape of Europe: The Fate of Europe's Treasures in the Third Reich and the Second World War* (London: Macmillan, 1994), 3–25. For literature on single museum collections and their fate during the Nazi years, see Annegret Janda and Jörn Grabowski, *Kunst in Deutschland, 1905–1937: Die verlorene Sammlung der Nationalgalerie im damaligen Kronprinzen-Palais. Dokumentation. Aus Anlass der Ausstellung Berlin, Alte Nationalgalerie, 1992* (Berlin: Mann, 1992); Günter Busch, "Die Verluste der Kunsthalle," in *Museum Heute: Kunsthalle Bremen* (Bremen: Hauschild, 1948), 3–11; Barbara Lepper, *Verboten, verfolgt: Kunstdiktatur im 3. Reich*, exh. cat. (Duisburg: Wilhelm-Lehmbruck-Museum; Hannover: Kunsthalle; and Wilhelmshaven: Wilhelmshaven Kunsthalle, 1983); Barbara (Katharina) Lepper and Jan-Pieter Barbian, *Moderne Kunst im Nationalsozialismus: Die Kampagne "Entartete Kunst" und die Sammlung des Wilhelm-Lehmbruck-Museums Duisburg, 1933–1945, Museumspädagogisches Begleitheft* (Duisburg: Wilhelm-Lehmbruck-Museum, 1992), 12–17; Hans-Werner Schmidt, "Die Hamburger Kunsthalle in den Jahren 1933–1945," in Sigrun Paas and Hans-Werner Schmidt, eds., *Verfolgt und verführt: Kunst unterm Hakenkreuz in Hamburg, 1933–1945*, exh. cat. (Hamburg: Kunsthalle, 1983), 50–67; Hans-Jürgen Buderer and Karoline Hille, *Entartete Kunst: Beschlagnahmeaktionen in der Städtischen Kunsthalle Mannheim, 1937*, exh. cat. (Mannheim: Stadtische Kunsthalle, 1987); Manfred Fath,

"Die 'Säuberung' der Mannheimer Kunsthalle von 'Entarteter Kunst' im Jahre 1937," in *Festschrift für Gerhard Bott zum 60. Geburtstag* (Darmstadt: Anthes, 1987), 169–86; Dagmar Lott, "Munichs Neue Staatsgalerie im Dritten Reich," in *Die "Kunststadt" Munich 1937: Nationalsozialismus und "Entartete Kunst,"* ed. Peter-Klaus Schuster (Munich: Prestel, 1987), 289–300; Peter-Klaus Schuster, ed., *Dokumentation zum nationalsozialistischen Bildersturm am Bestand der Staatsgalerie moderner Kunst in Munich: Eine Veröffentlichung aus Anla der Ausstellung "Entartete Kunst"* (Munich: Staatsgalerie moderner Kunst and Bayerische Staatsgemäldesammlungen, 1988); Heinz Schönemann, "Der Aufbau einer Modernen Galerie im Angermuseum Erfurt bis 1933 und deren Zerstörung in der Zeit des Faschismus," in *Angriffe auf die Kunst: Der faschistische Bildersturm vor 50 Jahren,* exh. cat., ed. Peter Fiedler and Rainer Krauss (Weimar: Kunstsammlungen zu Weimar, Kunsthalle am Theaterplatz, 1988), 20–22; Brigitte Reinhardt, ed., *Kunst und Kultur in Ulm, 1933–1945,* exh. cat. (Ulm: Ulm Museum, 1993), 70–95. As for a museum that acquired an important collection from the auctions of "degenerate" art in Switzerland, see Georg Schmidt, "Die Ankäufe 'entarteter Kunst' im Jahre 1939," in *Schriften aus 22 Jahren Museumstätigkeit* (Basel: Phoebus, 1964), 6–10.

3. Peter Paret, *The Berlin Secession: Modernism and its Enemies in Imperial Germany* (Cambridge: Harvard University Press, 1980). For discussion of Wilhelm II's predilections for neo-Romanesque styles, see Michael Bringmann, "Gedanken zur Wiederaufnahme staufischer Bauformen im späten 19. Jahrhundert," in *Die Zeit der Staufer: Geschichte-Kunst-Kultur,* supplement to exh. cat. (Stuttgart: Württembergisches Landesmuseum, 1977; Stuttgart: Cantz, 1979), 580–620. See also a monograph on the most influential "official" artist during the first years of the Wilhelmine era, Dominik Bartmann, *Anton von Werner: Zur Kunst und Kunstpolitik im Deutschen Kaiserreich* (Berlin: Deutscher Verlag für Kunstwissenschaft, 1985).

4. Nicolaas Teeuwisse, *Vom Salon zur Secession: Berliner Kunstleben zwischen Tradition und Aufbruch zur Moderne, 1871–1900* (Berlin: Deutscher Verlag für Kunstwissenschaft, 1986), 99–111; Barbara Paul, "Drei Sammlungen französischer impressionistischer Kunst im kaiserlichen Berlin— Bernstein, Liebermann, Arnhold," *Zeitschrift des Deutschen Vereins für Kunstwissenschaft* 42, no. 3, *Sammler der frühen Moderne in Berlin* (1988): 11–30.

5. Paul, "Drei Sammlungen," 19–26. The other paintings on the wall in fig. 2, as identified by Barbara Paul, are (from right to left): Alfred Sisley, *The Bridge of Argenteuil*, 1872 (private collection); Claude Monet, *The Bench*, 1873 (Collection of Mr. and Mrs. Walter Annenberg); Édouard Manet, *Young Woman in Spanish Dress Lying on a Sofa*, 1862 (Yale University Art Gallery); Camille Pissarro, *View of Marly-le-Roy*, 1872 (location unknown); and Claude Monet, *The Island La Grenouillère*, 1869 (location unknown). Hanging in an adjacent room is Paul Cézanne's *In the Oise Valley*, 1873–75 (Collection of W. Goetz, Los Angeles).

6. Wilhelm Waetzoldt, *Deutsche Kunsthistoriker* (Berlin: Spiess, 1986); Heinrich Dilly, *Kunstgeschichte als Institution: Studien zur Geschichte einer Disziplin* (Frankfurt: Suhrkamp, 1979);

Heinrich Dilly, ed., *Altmeister moderner Kunstgeschichte* (Berlin: Reimer, 1990).

7. Michael Podro, *The Critical Historians of Art* (New Haven: Yale University Press, 1982); Michael Ann Holly, *Panofsky and the Foundations of Art History* (Ithaca: Cornell University Press, 1984); Joan Goldhammer Hart, *Heinrich Wölfflin: An Intellectual Biography* (Ann Arbor, Mich.: University Microfilms, 1988).

8. To mention only Manet's most famous paintings in German collections: Tschudi's spectacular acquisitions of Manet's *In the Winter Garden*, 1878–79, for the Berlin National Gallery, and of *Lunch in the Studio*, 1868, for the collections of Bavaria in Munich, date from 1896 and 1910, respectively. See Barbara Paul, *Hugo von Tschudi und die moderne französische Kunst im Deutschen Kaiserreich* (Mainz: Zabern, 1993), 82–88, 298–300. Also in 1910, when the collection of Auguste Pellerin was put up for sale, Fritz Wichert acquired Manet's *The Execution of the Emperor Maximilian* (third version), 1868–69. See Barbara Lange, "'Eine neue Art von Kunstgeschichte: Eine neue Art von Geschichte,' *Die Erschiessung Kaiser Maximilians* von Edouard Manet in der Diskussion um Moderne in Deutschland," in *Edouard Manet: Augenblicke der Geschichte*, exh. cat., ed. Manfred Fath and Stefan Germer (Mannheim: Städtische Kunsthalle, 1992), 171–81.

9. Margrit Dibbern, "Die Hamburger Kunsthalle unter Alfred Lichtwark, 1886–1914: Entwicklung der Sammlungen und Neubau" (Ph.D. diss., 1980); and Hans Präffcke, *Der Kunstbegriff Alfred Lichtwarks* (New York: Olms, 1986).

10. Lichtwark, who was invited to fill the position, declined, mostly because he knew that his role under the Hamburg city government gave him infinitely more freedom than that of a Berlin museum director.

11. Françoise Forster-Hahn, "Weihestätte der Kunst oder Wahrzeichen einer neuen Nation? Die Nationalgalerie(n) in Berlin 1848–1968," in *Berlins Museen: Geschichte und Zukunft*, ed. Michael F. Zimmermann (Munich: Deutscher Kunstverlag, 1994), 155–64.

12. The paintings, as identified by Barbara Paul, are still in the National Gallery (from left to right): Manet's *In the Winter Garden*, 1878–79, and *Country House in Rueil*, 1882; Auguste Renoir's *Summertime*, 1868, *Flowering Chestnut-Tree*, 1868, and *Children During an Afternoon in Wargemont*, 1884; Camille Pissarro's *Country House in the Hermitage at Pontoise*, 1873; Claude Monet's *View of Vétheuil*, 1880; Paul Cézanne's *The Mill at the River Couleuvre near Pontoise*, c. 1881; Edgar Degas's *Conversation*, c. 1884; Cézanne's *Still Life with Flowers and Fruit*, c. 1888–90; and Monet's *Summertime*, 1874. The sculptures are by Auguste Rodin.

13. Paul, "Hugo von Tschudi," 217–30; Barbara Paul, "Der französische Impressionismus in der Nationalgalerie: Vom Streitobjekt zum Publikumsliebling," in Zimmermann, *Berlins Museen*, 165–80; and Johann Georg Prinz von Hohenzollern and Peter-Klaus Schuster, eds., *Manet bis van Gogh: Hugo von Tschudi und der Kampf um die Moderne*, exh. cat. (Berlin: Nationalgalerie; Munich: Bayerische Staatsgemäldesammlungen—Neue Pinakothek, 1996). Early in 1904, when the budget

for the German contribution to the world's fair in St. Louis came up for a vote in the Reichstag, Manet's painting in the Nationalgalerie (*In the Winter Garden*) became the topic of a heated parliamentary debate. See Andreas Blühm, "'Ist der Ruf erst ruiniert...': Manet im Blick der Deutschen," in *Jenseits der Grenzen. Frenzösische und deutsche Kunst vom Ancien Régime bis zur Gegenwart. Thomas W. Gaehtgens zum 60. Geburtstag*, 2nd vol., ed. Uwe Fleckner, Martin Schieder, and Michael F. Zimmermann, *Kunst der Nationen* (Cologne: DuMont, 2000), 401–13.

14. Beatrice von Bismarck, "Georg Swarzenski und die Rezeption des Französischen Impressionismus in Frankfurt: Eine Stadt im 'Kampf um die Kunst?'" in *ReVision: Die Moderne im Städel, 1906–1937*, exh. cat., ed. Klaus Gallwitz (Frankfurt: Städtische Galerie im Städelschen Kunstinstitut, 1992), 31–41.

15. Lange, "'Eine neue Art von Kunstgeschichte.'" See also Jenns Eric Howoldt, *Der Freie Bund zur Einbürgerung der bildenden Kunst in Mannheim: Kommunale Kunstpolitik einer Industriestadt am Beispiel der "Mannheimer Bewegung"* (Frankfurt: Lang, 1982).

16. Carl Georg Heise, "Gustav Pauli zum Gedächtnis," *Jahrbuch der Hamburger Kunstsammlungen* 11 (1966): 7–14; and Siegfried Salzmann, "Gustav Pauli und das moderne Kunstmuseum," in *Avantgarde und Publikum: Zur Rezeption avantgardistischer Kunst in Deutschland, 1905–1933*, ed. Henrike Junge (Cologne: Böhlau, 1992), 235–42.

17. Pierre Vaisse, *La Troisième République et les peintres* (Paris: Flammarion, 1995); and Pierre Vaisse, "Le legs Caillebotte d'après les documents," in *Bulletin de la Société de l'Histoire de l'Art Français* (1983): 201–8.

18. A telling panorama of literature between naturalism and new aesthetics in Berlin is chronicled in Janos Frecot, "Literatur zwischen Betrieb und Einsamkeit," *Berlin um 1900*, exh. cat. (Berlin: Berlinische Galerie and Akademie der Künste, 1984), 319–53.

19. Richard Muther, *Geschichte der Malerei im XIX. Jahrhundert* (Munich: Hirth, 1893–94).

20. Muther, *Geschichte der Malerei im XIX. Jahrhundert*, 2:646.

21. Richard Muther, *Ein Jahrhundert Französischer Malerei* (Berlin: Fischer, 1901). For discussion of Muther, see Eduard Hüttinger, "Richard Muther—eine Revision," in *Schweizerisches Institut für Kunstwissenschaft, Jahrbuch*, 1984–86, *Beiträge zu Kunst und Kunstgeschichte um 1900*, 9–24; and Paul, *Hugo von Tschudi*, 38–60.

22. Georg Dehio, "Die Malerei des neunzehnten Jahrhunderts beleuchtet von einem 'Jungen,'" in *Preussische Jahrbücher* 76, no. 1 (April 1894): 122–33. Quoted by Paul, *Hugo von Tschudi*, 57

23. Julius Meier-Graefe, *Entwickelungsgeschichte der modernen Kunst: Vergleichende Betrachtung der bildenden Künste, als Beitrag zu einer neuen Aesthetik* (Stuttgart: Hoffmann, 1904). The English edition, first published in 1908, is *Modern Art*. For discussion of Meier-Graefe, see Kenworth Moffett, *Meier-Graefe as Art Critic* (Munich: Prestel, 1973); and Thomas W. Gaehtgens, "Les rapports de l'histoire de l'art et de l'art contemporain en Allemagne à l'époque de Wölfflin et de Meier-Graefe,"

Revue de l'Art 88 (1990): 31–38. The perspective of the present essay is indebted to Gaehtgens's interest in art history and contemporary art.

24. Catherine Krahmer, "Meier-Graefes Weg zur Kunst," in *Hoffmansthal Jahrbuch zur europäischen Moderne* 4 (1996): 169–226.

25. Hugo von Tschudi, *Edouard Manet* (Berlin: Cassirer, 1913), 32–34, 57.

26. Wilhelm Hausenstein, "Die Bardame," in *Meister und Werke: Gesammelte Aufsätze zur Geschichte und Schönheit bildender Kunst* (Munich: Knorr and Hirth, 1930), 189–91.

27. Hans Jantzen, "Edouard Manets *Bar aux Folies-Bergère*," in *Beiträge für Georg Swarzenski zum 11.1.1951* (Berlin: Mann, 1951), 228–32.

28. Julius Meier-Graefe, *Der Fall Böcklin und die Lehre von den Einheiten* (Stuttgart: Hoffmann, 1905).

29. Henry Thode, *Böcklin und Thoma: Acht Vorträge über neudeutsche Malerei* (Heidelberg: Winter, 1905). See also Adolf Grabowsky, *Der Kampf um Böcklin* (Berlin: Cronbach, 1906). For modern literature on the debate around Böcklin, see Paret, *The Berlin Secession*, 245–61; and Gaehtgens, "Les rapports de l'histoire de l'art."

30. Michael Podro, *The Critical Historians of Art* (New Haven: Yale University Press, 1982), 61–158; see also the essay on Bode (Wolfgang Beyrodt) and the excellent discussion of Aloïs Riegl (Wolfgang Kemp) in Dilly, *Kunstgeschichte als Institution*, 19–34, 37–60.

31. Richard Wollheim, *On Formalism and Its Kinds: Sobre el formalisme i els seus tipus* (Barcelona: Fundació Antoni Tàpies, 1995). See also "Wollheim on Pictorial Representation," *Journal of Aesthetics and Art Criticism* 56, no. 3 (summer 1998): 217–40 (essays by Richard Wollheim, Jerrold Levinson, and Susan L. Feagin). Concerning the historical perspective that should be taken into account for any discussion about modern formalism, see Willibald Sauerländer, "From 'Stilus' to Style: Reflections on the Fate of a Notion," *Art History* 6 (1983): 253–79. The recent debate on Heinrich Wölfflin is rich in reflections about the autonomy of art as it relates to the formalistic inquiry into aesthetic evolution. See Matthias Waschek, ed., *Relire Wölfflin* (Paris: École Nationale Supérieure des Beaux-Arts, 1995), esp. the essays by Roland Recht and Martin Warnke, 31–60, 95–119. For discussion of Erwin Panofsky's critique of Wölfflin, see Holly, *Panofsky and the Foundations of Art History*, 46–68; and Andreas Eckl, *Kategorien der Anschauung: Zur transzenden-talphilosophischen Bedeutung von Heinrich Wölfflins "Kunstgeschichtlichen Grundbegriffen"* (Munich: Wilhelm Fink, 1996), 37–40. The latter is a modern attempt at reappraising Wölfflin's fundamental concepts of art history on the ground of neo-Kantian reflections.

32. For an important book on the early institutional development of German art history until around 1880, see Dilly, *Kunstgeschichte als Institution*. See also Willibald Sauerländer, "L'Allemagne et la 'Kunstgeschichte': Genèse d'une discipline universitaire," *Revue de l'Art* 45 (1979): 4–8.

33. Adolf von Hildebrand, "Das Problem der Form in der bildenden Kunst," in *Gesammelte Schriften zur Kunst*, ed. Henning Bock (Cologne: Westdeutscher, 1969), 199–265.

34. August Schmarsow, *Beiträge zur Ästhetik der bildenden Künste*, vol. 1, *Zur Frage nach dem Malerischen* (Leipzig: Hirzel, 1896).

35. Gotthold Ephraim Lessing, *Laokoon, oder Über die Grenzen der Malerei und Poesie*, ed. Hugo Blümner (Berlin: Weidmann, 1880); a modern English edition has been translated by Edward Allan McCormick (Baltimore: Johns Hopkins University Press, 1984).

36. Konrad Fiedler, *Schriften zur Kunst*, ed. Gottfried Boehm, 2nd ed. (Munich: Wilhem Fink, 1991). The two introductions by Boehm are "Anschauung als Sprache—Nachträge zur Neuauflage," (7–24), and "Zur Aktualität von Fiedlers Theorie" (45–97). See also Philippe Junod, *Transparence et opacité: Essai sur les fondements théoriques de l'art moderne—Pour une nouvelle lecture de Konrad Fiedler* (Geneva: L'age d'homme, 1976).

37. John Breuilly, "Approaches to Nationalism," in *Formen des nationalen Bewusstseins im Lichte zeitgenössischer Nationalismustheorien*, ed. Eva Schmidt-Hartmann (Munich: Oldenbourg, 1994), 15–38.

38. Martin Heidegger, *Der Ursprung des Kunstwerks*, intro. Hans-Georg Gadamer (Stuttgart: Reclam, 1967). My remarks are directed to certain aspects of the reception of Heidegger in German postwar art history. For the modern discussion concerning Heidegger's aesthetics, see *Martin Heidegger: Kunst, Politik, Technik*, ed. Christoph Jamme and Karsten Harries (Munich: Fink, 1992). See also Meyer Schapiro, "The Still Life as a Personal Object—A Note on Heidegger and van Gogh," in *Theory and Philosophy of Art: Style, Artist, and Society* (New York: Braziller, 1994), 135–42. In 1968 Schapiro rejected Heidegger's proposition that an unconscious presence of useful things can be seen to lift them outside the reality of earthly existence.

39. For a highly refined and modern position in that context, see Max Imdahl, *Farbe: Kunsttheoretische Reflexionen in Frankreich* (Munich: Fink, 1987).

40. Hans Sedlmayr, *Verlust der Mitte: Die bildende Kunst des 19. und 20. Jahrhunderts als Symbol der Zeit* (Salzburg: Müller, 1948).

41. Kurt Badt, *Die Kunst Cézannes* (Munich: Prestel, 1956).

42. Hohenzollern and Schuster, *Manet bis van Gogh*, 21.

43. Werner Hofmann, *Nana: Mythos und Wirklichkeit* (Cologne: DuMont, 1973).

Afterword

Richard Brilliant

I have never believed that exposure to actual works of art was bad for academic art historians, whether or not they were preoccupied by matters pertaining to connoisseurship and to questions of authenticity and historical attribution. Repeated confrontation with the "real things" is surely a tonic for the imagination and should be a source of pleasure, separate from the exigencies of professional work. For that reason, and because contemporary art is the art of my time, for decades I have made a circuit of the commercial galleries in New York City, not only to see "what's out there" and "what's out there for me," but to confront works of art with little or no pedigree, unburdened by prior criticism or scholarship. Without question, that experience has enriched my own professional, scholarly work, with the additional benefit that it has also made me concentrate on the effectiveness of display on the coherence of the ensemble of works shown. From such concerns, I was led to analyze the concepts that govern the formation of collections, both public and private, and their particular modes or strategies of presentation. As many of the contributors to this volume have recognized, there exists a hermeneutic of display, controlling the dissociation and reassociation of works of art on display or presented on the printed page, which is worthy of the closest study in its own right.

To develop a greater awareness of the importance of display, I used to ask each of my graduate students in the mandatory Pro-Seminar at Columbia to create a modest art exhibition at a fictional, midwestern institution, Siwash University, to plan and design the display, write an explanatory brochure, and justify the exhibition's expense and educational value to Siwash's board of trustees, consisting of all the other students with myself as chairman. The discussions that followed the students' presentations were always productive, revealing their discovery of the complexity inherent in exhibition design, selection, and reception—matters frequently taken for granted before this exercise, but not subsequently. Perhaps the origins of this exercise can be found in my own experience as a graduate student at Yale in the 1950s, where I was involved in an exhibition of Mimbres pottery at the art gallery; I wrote my first art historical essay for the exhibition catalogue on the design of the pots' interior decoration, unaware that the task differed in any way from whatever else I might go on to do as an academic art historian.

My interest in the dynamics of gallery or museum display, in the formation of collections, and in the diverse agendas of their modes of presentation, including publication, complements my preoccupation with the historiography of art history itself. The academic discipline, too, is so profoundly determined by its own agendas and traditions of (re)presentations and discourse. Although the gallery director, the museum curator, the professor, and the collector-patron may often exchange roles (and relations with the art market), the works of art in their care or purview occupy different realms of being and reception; the audiences for them may be more than contingent, while the degree and direction of accountability vary considerably. In 1991, I was invited to speak at the British Museum on "A Question of Belief: The Display of Greek Vth and IVth Century Architectural Sculpture"; I gave a serious critique of the ways the museum exhibited the Parthenon Marbles in the Duveen Gallery and described some of the problems evident in the "hanging" of the frieze from the Temple of Apollo at Bassae. The large audience was hardly sympathetic to this American's challenge to the establishment—it may be that resistance to the Greek claims for restitution of the marbles stiffened the resolve to maintain the status quo, or that redesigning the galleries for the display of the Parthenon sculptures would have entailed considerable expense and would have been difficult to justify in the face of disagreements about what arrangement, if any, would be best, or even better—but the challenge I presented eventually led to a later conference at the museum on proper ways of displaying these famous ancient monuments that would satisfy both the archaeologists and the public.

My own direct involvement in museum-placed exhibitions follows a particular trajectory, passing from frustration to a high degree of control. I was a participating scholarly resource in the great *Age of Spirituality* exhibition, curated by Kurt Weitzmann for the Metropolitan Museum of Art in 1979. I wrote three short essays and thirty-eight entries for the catalogue, but had no say whatsoever in the conception of the exhibition or the selection of objects; my actions were governed by my respect for Professor Weitzmann, a former teacher, and his view of Late Antiquity/Early Christianity. Some years later, the Africanist Jean Borgatti asked me to participate with her in planning an exhibition on portraits to be held at the Center for African Art in New York City in 1990; given her knowledge of African art and her curiosity about the representation of persons and identities in sub-Saharan art, and my established work on portraiture, we collaborated very well, writing essays for the catalogue *Likeness and Beyond*. We

also carefully planned the layout of the objects to complement the issues that informed the exhibition—to expand concepts of portraiture and identity in images—and to make the viewer aware of them without recourse to the catalogue. The Center, however, relied on a designer whose arrangement almost completely vitiated our conception of the exhibition, subtle and complex as it was, although the display probably "looked better" his way than ours. It reminded me of the time when some of the illustrations of my book *Arts of the Ancient Greeks* were rearranged by the book's designer for aesthetic reasons (after I had seen final page proofs), without changing the figure numbers or captions and, thereby, confused the readers as well as the author.

In 1997, I served as the guest curator for an exhibition entitled *Facing the New World: Jewish Portraits in Colonial and Federal America*, held at the Jewish Museum in New York City. I was able to conceptualize the exhibition, select the works of art to be shown, control the order and arrangement of the display (with creative input from the museum's people), and function, in effect, as the author with the full support of the museum. Heaven! Both portrait exhibitions amplified my idea of portraiture and of the social, ideological context of its appearance as an artistic genre, while the exhibition at the Jewish Museum led me to an unexpected discovery that the portraits of American Jews in the period were not distinguishable from the portraits of their non-Jewish contemporaries of the same mercantile class, painted by the same artists with the same ethnically neutral, status-driven indicators.

The relationship between an exhibition's originating concept and its ultimate realization in a "show" may constitute a story full of surprises and disappointments. Yet, given the desired subordination of verbal language, the transition from idea to a collection of artworks requires an effort of visual imagination that offers the curator a special insight that s/he hopes to share with a viewing audience existing at the receiving end of visual communication. How disturbing, then, it is if that same audience's attentiveness to labels and placards, however informative they might be, distances the viewer from the objects waiting to be seen. Reliance on the printed catalogue may give greater access to the exhibition's concept and serve as a long-lived substitution for the assembled works, but between exhibition and catalogue lies the gulf between seeing the objects on one's own space and reading about them. Different sites, different mental experiences, different paces and rhythms of reception, to be sure, but neither exhibition nor catalogue is devoid of calculated arrangement, or of the priorities

of representation not always openly acknowledged. And catalogues of any kind are rarely innocent.

Unfortunately, the exhibition as a calculated construct is seldom subjected to a thorough criticism of its agenda, nor are the aesthetics and didactic intentions of display put into question, nor are the experiential factors present in sequential viewing, when work A is seen in the same field of vision as work B. The viewer's perception of each or both may be enriched or contaminated by interference, just as may occur when a number of illustrations congregate on the same printed page. Exhibition catalogues, especially substantial, apparatus-laden volumes, are usually much more subjected to detailed criticism, probably because they enter into the art historiographical record and may be replete with otherwise hard-to-find information and reproductions, or because they advance contentious scholarly positions. Still, the relative independence of such catalogues from the exhibitions they accompany rarely is a cause for concern, perhaps because of some (misplaced?) faith in their representative capacity after the show has been taken down.

I remember the great Council of Europe exhibitions of past years, especially those located in significant sites, such as Würzburg for the Rococo or Aachen for the Age of Charlemagne. Architecture of the period still survived in Aachen, and almost all of the portable, not-too-fragile major (even canonical) objects of the age were assembled in an enormous room, and I could pass from one to another at will. The fine catalogue produced for that exhibition now seems to me more of an aide-mémoire of that experience in 1965 than a basic resource for the period, not least because its scholarship has been superseded, if not the collection of illustrations. Yet, I still feel myself more constrained by the catalogue's organization now than I ever did at Aachen, where, in moving from one great treasure of the Carolingian Age to another, I created my own paths of discovery and delight.

This internal narrative of the viewing experience was profoundly influenced by the routes of reference programmed into the exhibition, by the collection of objects in a vitrine, by the succession of vitrines and of defined spaces and lighting that altogether conditioned my movements and responses. The presence of many small, precious, and prestigious objects required close, concentrated attention. Perhaps, I was more aware of the effects of placement in vitrines below eye-level than I might have been had the objects been paintings hung on a wall, although I am familiar with changing fashions in hanging and their affect. From vitrine to wall to the enveloping edifice, all of them contribute

to the framing experience of the viewer, sometimes overwhelmingly, as in Frank Lloyd Wright's New York Guggenheim Museum or Frank Gehry's new museum in Bilbao, where the architecture seems to assert itself as the prime aesthetic object. The recent development of museology with its potential for the systematic study of the museum experience, both in its constitution and in its reception, parallels the emergence of a "new" or revisionist art history, whose agendas, operating propositions, and directions of inquiry have similarly transformed the discipline, or attempted to do so.

The convergence of the museum world and the academy has been partly effected by a comparable response to the public's role and the institution's responsibility to it, and partly by the movement of some principal actors from one environment to the other. Their enhanced sensitivity to matters of common interest may find different expression, but I would like to identify some of them here:

(a) In the nineteenth century, one could ask and readily answer the questions "What is a work of art?" and "Does this object, or class of objects qualify, and should it (they) be included in the museum or in scholarly art historical publications?" Flexible institutional definitions of an "artwork" now are in the ascendance, while a very permeable boundary seems to exist between artworks, so called, and other objects of perceived historical interest. The twentieth-century expansion of the fundamental category *artwork*, the incorporation of historically significant objects and texts, the involvement with "material culture," which seems to exclude little of actual or potential use to mankind, and the absence of censorious arbiters of taste have combined to create an inexhaustible warehouse for the material and even ephemeral products of culture. And, why not? We are all active, even rabid consumers of cultural products, with lessening powers of discriminating among competing claims for attention, with the result that efforts to establish meaningful and generally accepted criteria for judgment seem weakly grounded, once the traditional hierarchies have been abandoned. But, then, those hierarchies of medium and genre were, themselves, cultural products of another time and place and may be sanctified by tradition, though they are hardly immutable.

When everything is deemed "collectible" and worthy of serious historical analysis and attentive criticism, it is very difficult to decide which is more worthy, or whether that question is valid, let alone determining which objects properly belong in an art museum, if one can agree on the identity and function of art

museums in the twenty-first century. Yet, in traditional museums and in well-established historical societies in America, the presence of the "period room" as an artificially (re)constructed *Gesamtkunstwerk* has long been construed as a legitimate, if theatrical, display of the arts *and* other associated cultural products of a singular age. Such rooms exemplify the configuration and declassification of different kinds of objects, bound closely together by time and place and public acceptance; their constitution resembles the premises of much contemporary art historical practice which, if anything, appears to stress the cultural contexts of artistic production and its consumption rather than the products themselves, no longer existing in splendid isolation. Whether or not one supports such a sociological or anthropological conception of art history, priorities in the discipline have clearly shifted away from a focus on objects of aesthetic distinction toward a more encyclopedic in-gathering of artifacts in the hands of their users. In this way, perhaps the "period room" may serve as a model for a larger, all-encompassing version of the museum, conceived as a means of preserving the material fullness of the past as much as possible, and thereby justifying its continued existence as an important cultural institution. The conference speakers, many of whom are engaged with French Impressionist and Post-Impressionist paintings, the prime importance of which, historically and aesthetically, they seem to take for granted, may not be prepared to see them competing for attention in a nineteenth-century period room. But what if that room were designed to replicate the salon or gallery in which these paintings were first exhibited, first exposed to the public and to the market for which they were intended?

(b) The pervasive effect of reproductions as increasingly independent surrogates for the originals may be contributing to the dehistoricization of art on one hand and the dilution of its aesthetic power on the other. I do not mean to take up Walter Benjamin's famous essay, but rather to pose the problems created by reliance on reproductions, on substitutional, dematerialized photography or video, and by the commercialization of imagery, widely diffused and often carried by new instruments of show, such as T-shirts. These departures from the original inevitably interfere with perception, not only because of the transfer of medium and scale, but also, because of the derivative circumstances of use. Even the commercial success of museum reproductions, extending back in time to Grand Tour Bronzes and the graphic reproduction of paintings in the eighteenth and nineteenth centuries, compromise the integrity of the original, especially when the reproduction comes to be the stimulus of memory.

Years ago André Malraux advocated the importance of the photographic collection of works of art, which he called *A Museum Without Walls*, encyclopedic in nature and accessible to all without respect to geography. Retaining the original may not be as important as it once was considered to be, but there are many who would agree, as Benjamin himself did, that the demonstrable authenticity of the artwork possesses an inalienable *aura*: the original bears witness to history in itself and provides, more prosaically, reliable evidence for the conservator and connoisseur to whom authenticity must matter. Such objects establish the fulcrum of time, giving structure and points of reference to the definition of the dependent realities of past and present. This is not to say that the great nineteenth- and early-twentieth-century cast collections, surviving, for example, in the Slater Museum in Norwich, at the Carnegie Museum of Art in Pittsburgh, and in London's Victoria and Albert Museum, do not have value for the student and the artist, especially in the sheer materiality of their existence. Ironically, many cast collections were destroyed or disposed of in the 1950s, '60s, and '70s because they were considered inauthentic, or photography was held to be a more than adequate substitute, or ease of travel made access to the original more available. And, now, cast collections have once again been prized, their objects cleaned and restored, and the former rejects rehabilitated because of their potential as historical indicators of taste and as records of the prior condition of works of art in stone no longer well preserved. Perhaps, this history of the cast collections makes a strong argument for the importance of reproductions as evidence for taste and desire, those prime motivating factors in the generation and possession of artworks at any time.

(c) The relationships between public and private collections, the role of money and patronage in their formation and in their dependence on the art market, and, finally, the transmittal of the private collection into the public domain are increasingly topics of study, often as the basis for an arts policy. These studies, however, are not usually sympathetic to the private collector, who may be viewed as an opportunistic exploiter or, worse still, a despoiler of other countries' cultural heritage. Whether or not these depictions are justified, restrictions imposed by patrimonial protectionist laws that limit or prevent the exportation of artworks and archaeological materials have negatively impacted collection formation in the West. Artworks without "adequate" provenance still enter the art market, but more and more often public collections refuse to acquire them, sometimes to the detriment of their own holdings, while scholars have become unwilling to

include them in their studies or publications, even if they would contribute substantially to knowledge. The scholars' reluctance may be based on a legitimate desire not to add to an object's value in the market through publications that establish authentication, while uncertainties about provenance can obscure the object's position in history. How to incorporate such objects into the body of knowledge without endorsing the art trade seems insoluble at present, especially for archaeological materials or ethnographically significant artifacts.

Possession of important works of art carries prestige but also the assumption of some responsibilities of ownership to the general public. Too often, access to collections can be denied or severely restricted, even to the "worthy applicant," or very costly permissions to publish may seriously inhibit scholarly research. If, at some future time, major museums will have completed comprehensive on-line catalogues of their respective collections and have refrained from selling reproductive rights to for-profit entities, it should be possible to develop a reliable system of image delivery and make available to responsible individuals the right to publish at reasonable prices. The archive of more than one million photographs of artworks, in active collection by the Getty, is very useful, but copyright restrictions make them unavailable for publication; here the legally protected interests of the owner(s) of the artwork and of the photograph intervene. We should not be surprised at this assertion of property rights when, it was recently decided, photographs of the famous Chrysler Building, long a staple of the New York scene, could not be used in advertisements without the compensated permission of the building's owners, no matter who had taken the photograph. Some development in property law in relation to an expansive definition of the public domain may be needed, grounded in the idea that knowledge about works of art forms an essential part of our intellectual and cultural heritage. It is encouraging to note the creation of the not-for-profit Art Museum Image Consortium (AMICO), a vast on-line resource that provides access to images in the collections of member institutions and also includes links to facilitate permissions.

(d) Recognizing that the parameters for the conference that inspired this volume were set by the organizers to achieve a meaningful focus, it is nevertheless worth noting the omissions from the works discussed in the conference. The exclusion of works from Prehistory, from the Mediterranean and Near Antiquity, from Byzantium, Islam, and the Middle Ages, from Iran, India, China, Japan, pre-Columbian America, sub-Saharan Africa, Oceania, and so forth exemplifies a kind of cultural chauvinism that seems strangely out of place. This absence of

an ecumenical posture may be attributable to efficiency, thereby giving greater coherence to the conference, but it also led to a reductive mode of analysis, implicitly representing that the observations issuing from the conference would have general applicability to these diverse and particular artistic cultures. Perhaps there was another reason, as well: the conference speakers were, in fact, addressing contemporary academic and museum practices as contemporary cultural products, symbolic representatives of current attitudes, as if historical and cultural particularities were implicitly erased by the globalization of access to all artistic cultures through modern technology—an aspect of deconstruction writ large. I believe that academic scholars and curators of Chinese art, for instance, might have something to say about this last assumption.

(e) Historical analysis and iconographic explanation have long been at the center of the art historical exegesis of works of visual art. Rightly so, because the procedures of argument can be presented at length in a written text, and if the reader is puzzled s/he can review the printed demonstration with accompanying illustrations and make reasoned decisions about the argument's validity. Curators of exhibitions, whatever their intentions, are more limited by the exhibition's protocols of display, by financial constraints, space, the availability of objects and its effect on selection, and, probably most of all, by the desire to focus attention on the works of art themselves rather than on supportive texts. The more an exhibition is expressed in terms of a general concept, with the possible exception of questions of connoisseurship and attribution, the more difficult it is to make that concept visually accessible, because, unlike reading, control of the viewer's mind's eye is uncertain. It seems to me that the different strategies of presentation need to be more critically analyzed, because the ready changeability of the structure of an exhibition and of a printed, interpretive essay cannot be presumed. That is not to deny that artworks, like buildings, have and can directly convey meanings, but their traffic in ideas follows very different signals and at very different speeds.

(f) Art historical texts may be educational, even intellectually enriching, but rarely are they entertaining. Like the museum exhibition, however, such texts attempt to manage the audience's cognitive processes and enjoy greater or lesser success in doing so, although measuring relative degrees of effectiveness can be problematic: for the exhibitor, immediate critical (dis)favor, attendance figures, the sales of catalogues and other related paraphernalia; for the text, a slower form of critical reception, frequency of citation in the literature, and promotion of the author in the academic world. The coffee-table book and the blockbuster exhi-

bition share many common features and may appeal to similar audiences; the marketability of the former is now jeopardized by interactive, encyclopedic video discs and by the barrage of images and information available on the Internet. This new kind of casual exhibition space is even less shaped by some knowledgeable authority and exists far removed from the institutional character of the museum, still further from the stolid tendentiousness of many art historical monographs.

Deciphering cultural artifacts in an exhibition or in the museum as a whole is a very sophisticated enterprise, requiring a high degree of prior knowledge, as well as a good deal of skepticism about the appearance of the display and its dependence on a variety of factors, many of them invisible to the museum-goer. Still, the collective may allow the visitor to move about the past and/or present with some confidence and with a sense of wonder, stimulated by the discovery of objects assimilated less as sources of ideas than of pleasure.

Ultimately, the museum professional, the curator, the critic, and the academic art historian are all accountable to two very different audiences or constituencies. One, made up of their peers, is rather small and shares accepted standards of behavior and of honor; this is so even when those standards are breached or shift openly under the pressure of internal politics or competing ideologies. The other audience, the general public whose interests and expectations are diverse, whose social or class divisions particularize taste, whose consumerist values may prioritize immediate rather than reflective response, whose visit to the museum may be considered a social activity dedicated to the pursuit of culture, that public too must be served. For that public, the museum has become the repository of culture's materials that form the objective basis for the constitution of an ongoing, participatory, humanistic tradition. Without it, we are truly lost in "once upon a time."

Contributors

Dawn Ades, Professor of Art History and Theory at the University of Essex, specializes in Dada, Surrealism, and Latin American art. She has organized exhibitions including *Dada and Surrealism Reviewed*; *Art in Latin America: The Modern Era 1820–1980*; *Fetishism*; *Art and Power*; and *Salvador Dalí*.

Andreas Beyer is Professor of Art and Architectural History at the Rheinische-Westfälische Technische Hochschule Aachen. He has published widely on Italian Renaissance art and is also an authority on Wolfgang von Goethe and the visual arts. He is coeditor of the *Deutsche Zeitschrift für Kunstgeschichte*, the leading German-language scholarly journal in the discipline.

Richard R. Brettell is an independent curator and Professor of Aesthetic Studies in the School of Arts and Humanities at the University of Texas at Dallas. Formerly Director of the Dallas Museum of Fine Arts and a curator at the Art Institute of Chicago, he has curated numerous exhibitions, including *A Day in the Country: Impressionism and the French Landscape* and *Impression: Painting Quickly in France, 1860–1890*. He is the author of *Modern Art, 1851–1929: Capitalism and Representation*.

Richard Brilliant is Professor of Art History and Archaeology and the Anna S. Garbedian Professor in the Humanities at Columbia University. His most recent book is *My Laocoön: Alternative Claims in the Interpretation of Artworks,* and he is presently at work on a book on "The Concept of Style and the Problem of Roman Art."

Stephen Deuchar is Director of the Tate Britain. His publications include *Sporting Art in Eighteenth-Century England: A Social and Political History.*

Sybille Ebert-Schifferer is Director of the Bibliotheca Hertziana in Rome and was formerly General Director of the Staatliche Kunstsammlungen (State Art Collections) in Dresden, which includes eleven museums. She is the author of *Still Life: A History.*

Ivan Gaskell, the Margaret S. Winthrop Curator of Paintings, Sculpture, and Decorative Arts at Harvard University Art Museums, is the author of *Vermeer's Wager: Speculations on Art History, Theory, and Art Museums,* is editor of *Vermeer Studies,* and has published widely on Vermeer and the work of other seventeenth-century Dutch and Flemish artists. He is joint general editor of *Cambridge Studies in Philosophy and the Arts.*

Eckhart Gillen is Director of the Division of Exhibitions on Art and Art Historical Collections and head of the scientific program at the Museums-pädagogischer Dienst, Berlin. He organized the exhibition *Deutschlandbilder: Kunst aus einem geteilten Land* for the Berliner Festwochen in 1997, and is currently organizing *Kurzschluss,* an exhibition on the art of the 1980s in Germany.

Charles W. Haxthausen is the Faison-Pierson-Stoddard Professor of Art History and Director of the Graduate Program in the History of Art at Williams College. He was formerly the Curator of the Busch-Reisinger Museum at Harvard University and has published widely on twentieth-century German art and criticism.

John House is Professor of Art at the Courtauld Institute of Art. A specialist-expert in French and British art of the nineteenth century, he is author of *Landscapes of France: Impressionism and Its Rivals* and *Monet: Nature into Art.*

Richard Kendall is a leading Degas scholar. Formerly a senior lecturer in the Department of History of Art and Design at Manchester Polytechnic, he is now a freelance art historian and independent curator.

Patricia Mainardi is Professor of Eighteenth- and Nineteenth-Century European Art at the Graduate Center, City University of New York. She is the author of *Art and Politics of the Second Empire: The Universal Expositions* and *The End of the Salon: Art and the State in the Early Third Republic.* She has published widely in nineteenth-century European art history. Her current interests include the work of Corot and the interrelationship of art, art institutions, and the state.

Griselda Pollock is Professor of Social and Critical Histories of Art in the Department of Fine Art at the University of Leeds, where she is also director of the Centre for Cultural Studies. She has written extensively on the feminine in the social history of art and in cultural and psychoanalytic theory. Her publications include *Generations and Geographies in the Visual Arts*, *Avant-Garde Gambits: Gender and the Colour of Art History*, and *Differencing the Canon: Feminist Desire and the Writing of Art Histories*.

Mark Rosenthal is Adjunct Curator of Twentieth-Century Art at the Menil Collection, Houston. He has organized numerous exhibitions as a curator at the Philadelphia Museum of Art, the National Gallery of Art, and the Solomon R. Guggenheim Museum, and is currently at work on a book on twentieth-century exhibition installation. Among the exhibitions he has organized was the 1998 Mark Rothko retrospective.

Barbara Maria Stafford is the William B. Ogden Distinguished Service Professor of Art History at the University of Chicago. She is the author of *Good Looking: Essays on the Virtue of Images; Artful Science: Enlightenment, Entertainment, and the Eclipse of Visual Education; Visual Analogy: Consciousness as the Art of Connecting;* and *Devices of Wonder: From the World in a Box to Images on a Screen*.

Gary Tinterow is the Engelhard Curator of European Paintings at the Metropolitan Museum of Art. He has curated numerous exhibitions, including *Degas; From Delacroix to Matisse; Corot; The Private Collection of Edgar Degas;* and *Portraits of Ingres: Image of an Epoch*.

William H. Truettner is Senior Curator of Painting and Sculpture at the Smithsonian American Art Museum, Washington, D.C. His most recent exhibition is *Picturing Old New England: Image and Memory*. He is coeditor of *Thomas Cole: Landscape into History*.

Michael F. Zimmermann has been Deputy Director of the Zentralinstitut für Kunstgeschichte in Munich since 1991. His book on Georges Seurat has been published in four languages.

Photography Credits